MW00563972

PATH OF THE **PANTHER**

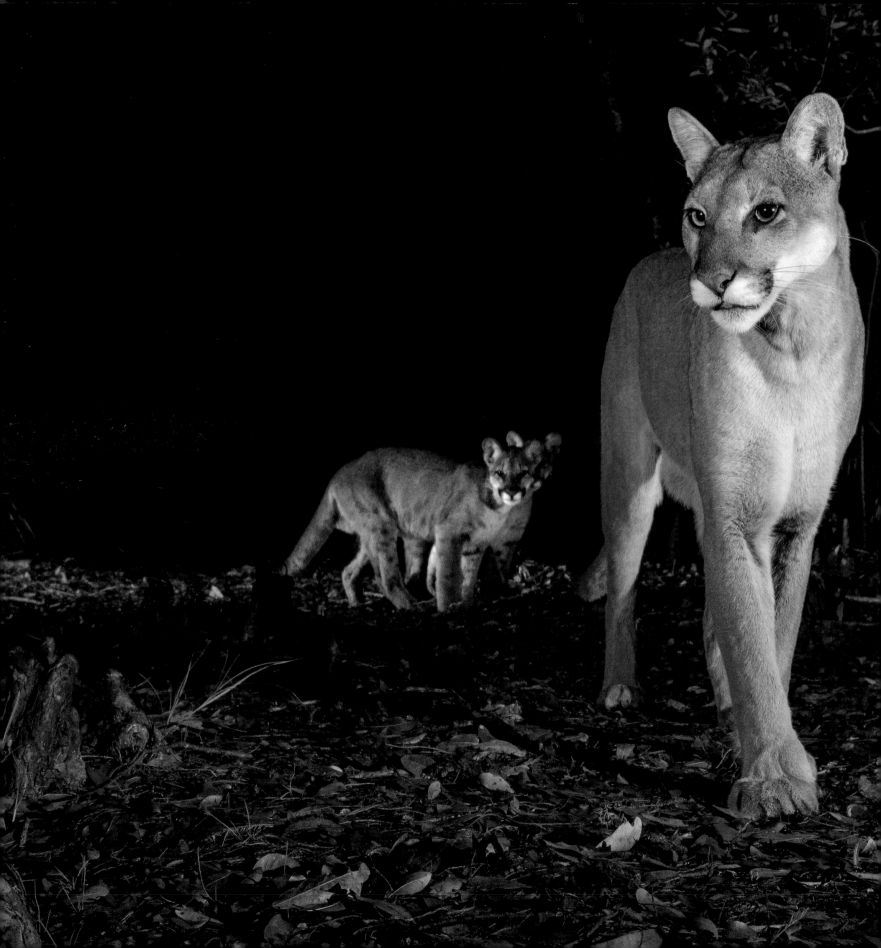

Trailed by her two cubs, a female panther strides through a forested trail on Babcock Ranch State Preserve east of Fort Myers. She is the first female panther documented north of the Caloosahatchee River since 1973. By reclaiming historic panther territory north of the Everglades for the first time in nearly five decades, this pioneering panther represents new hope for the recovery of her species. The photo was taken by camera trap in January 2018.

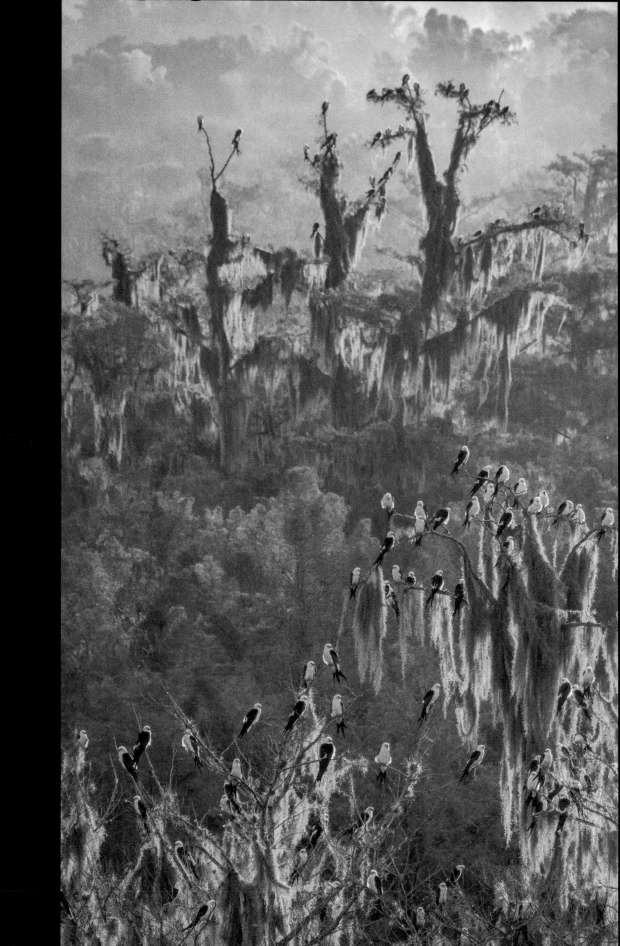

Swallow-tailed kites roost in cypress trees near Fisheating Creek, an important stopover in their annual migration from the southeastern United States across the Caribbean and Andes to the Pantanal of Brazil. Kites and thousands of other species that live in the panther's wide-ranging domain become environmentally protected when habitat for the panther is conserved.

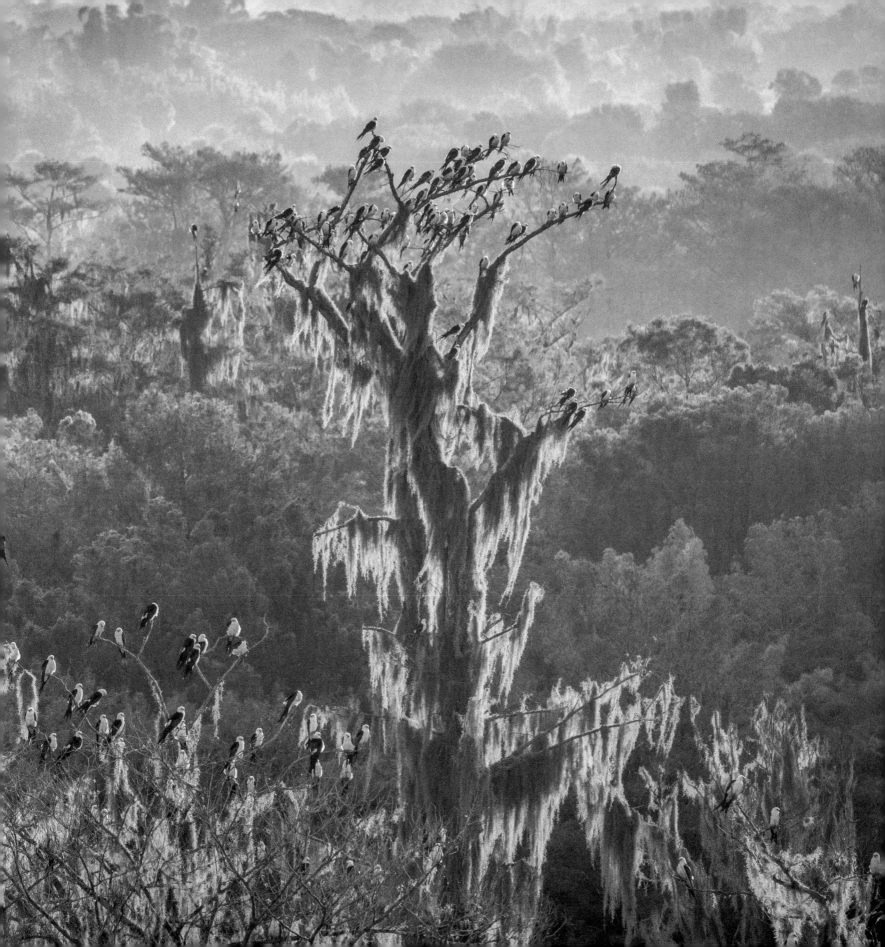

Habitat loss from expanding development is one of the leading threats to the panther's survival. Florida's human population has been growing by nearly a thousand new residents a day. New roads, houses, and commercial buildings are consuming an average of 100,000 acres (40,470 ha) of wildlife habitat every year, far outpacing the recent rate of land conservation. This aerial photo shows new homes on the periphery of Orlando, configured into a mega-subdivision that encroaches on the Florida Wildlife Corridor. Parts of the corridor are protected lands; others are yet to be protected.

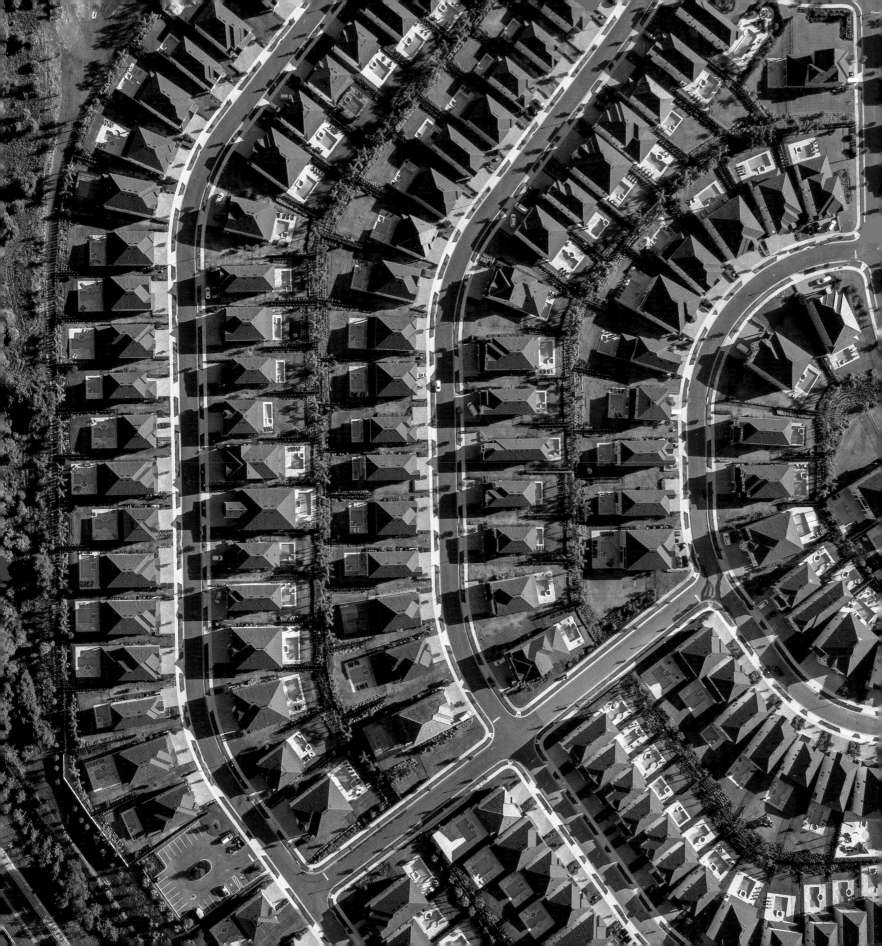

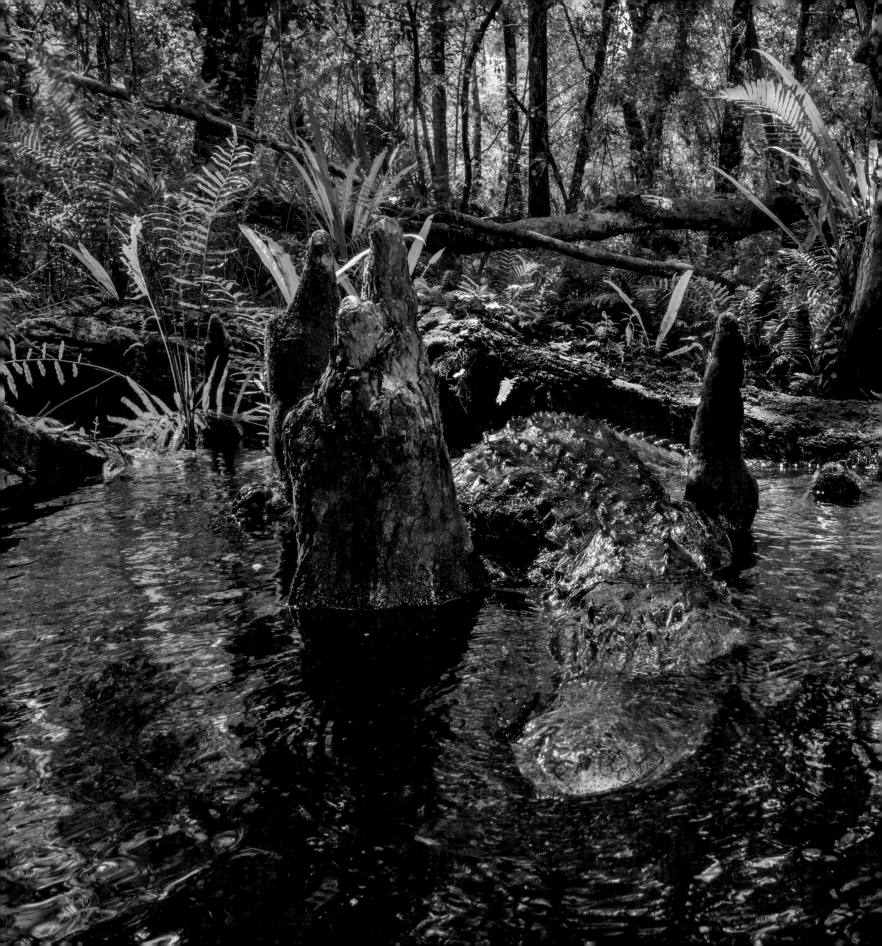

An American alligator winds between cypress knees—distinctive outgrowths above the roots of the tree—in the northern reaches of the Fakahatchee Strand, within Florida Panther National Wildlife Refuge, east of Naples. The Florida panthers' ability to survive in South Florida swamps, away from the habitat destruction and hunting of the past century, is a main reason they persevere as the last remaining population of pumas in the eastern United States.

9

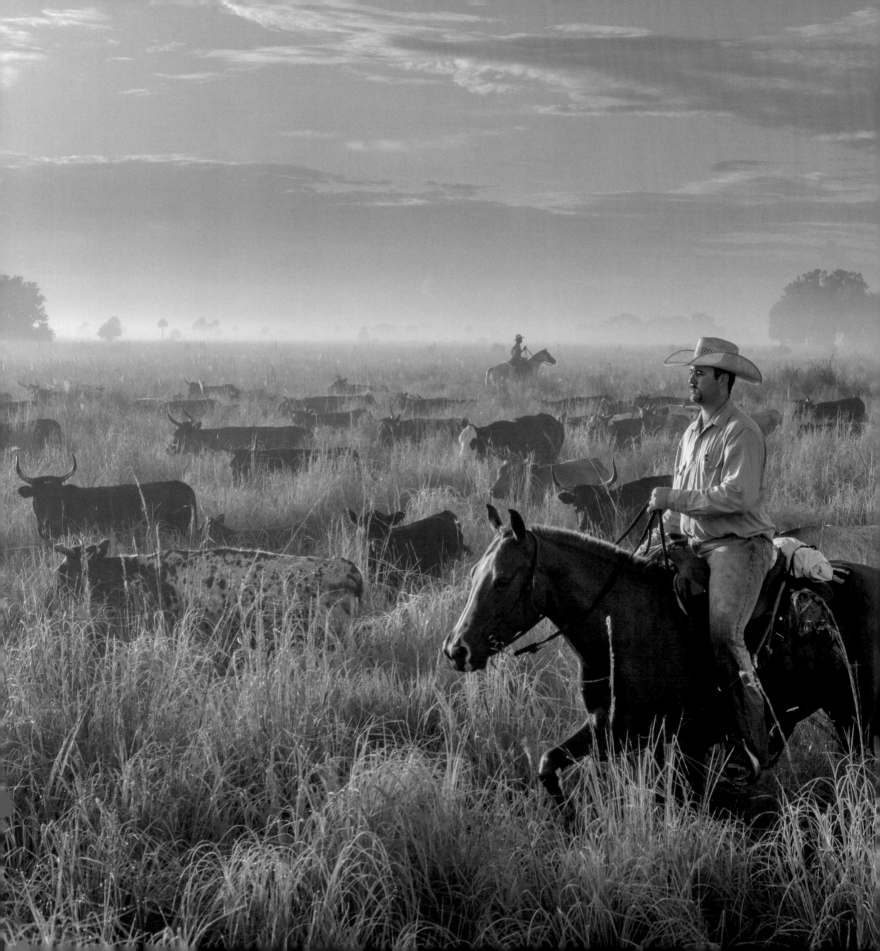

Cowboy Laurent Lollis steers a herd of legacy Spanish cattle across Buck Island Ranch west of Lake Okeechobee. As the Florida panther population expands northward, the cattle ranches of the Northern Everglades are the next frontier for recovery of the species. With development threatening their way of life, many ranchers are recognizing that funding for conservation easements, motivated by public support for panthers, may be the best hope for protecting their land.

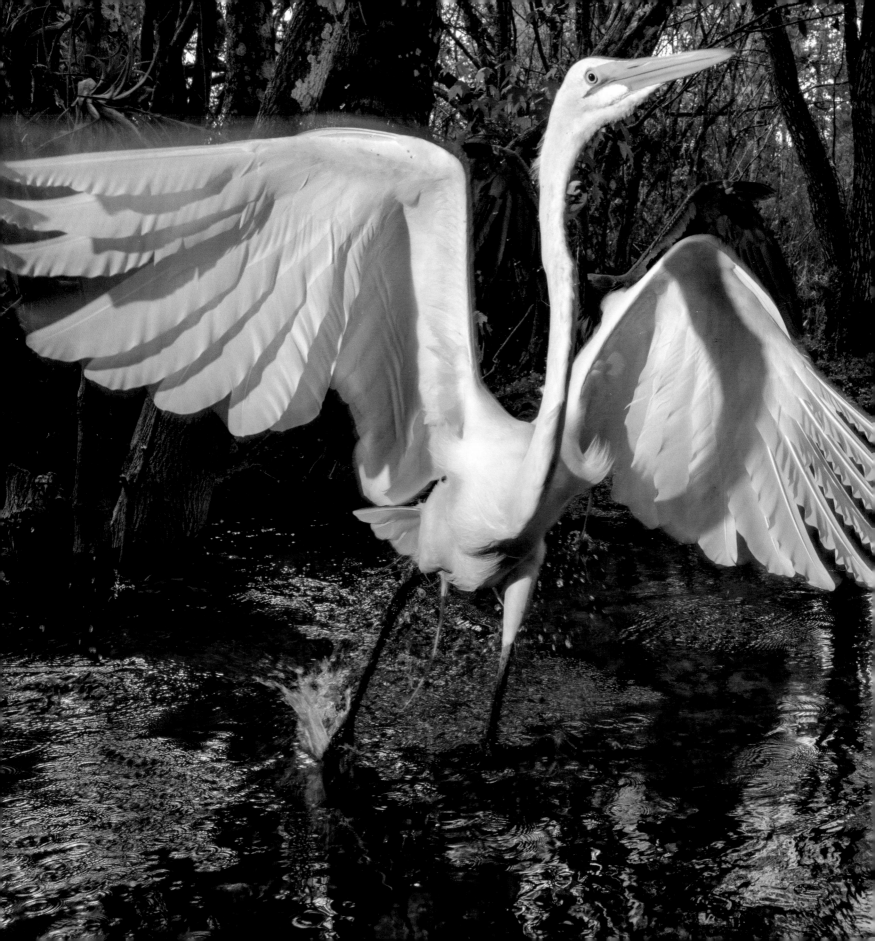

Camera traps targeting panthers
provide an exciting look at some of the
other species that share the same trail.
Here, on a flooded trail through a pond
apple and pop ash swamp in Florida
Panther National Wildlife Refuge,
wading birds trigger the camera.

NEXT PAGES: After more than a year in
the wild, the camera trap catches a
glimpse of the "lord of the Everglades"
at the same location the birds visited i
the watery world that has set the stage
for the panther's revival.

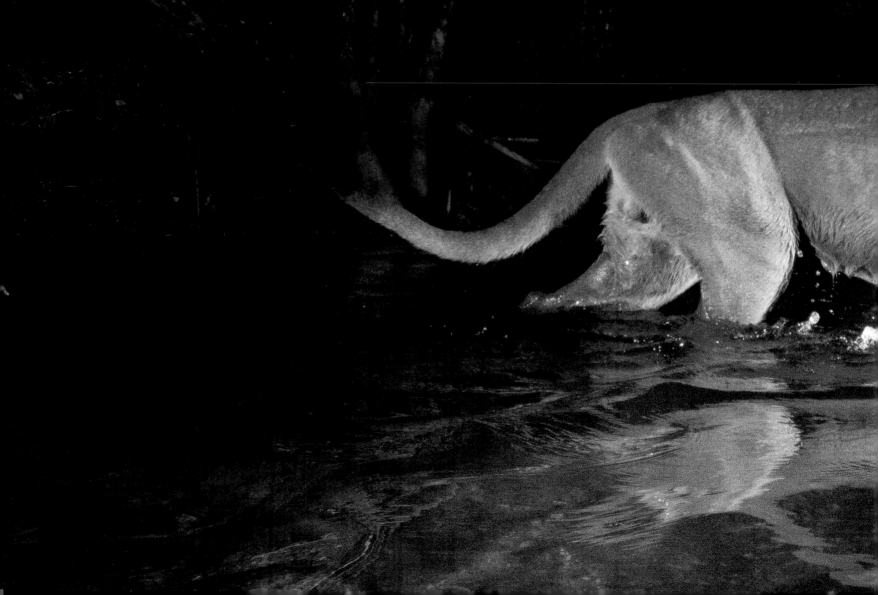

PATH OF TH

E PANTHER

NEW HOPE FOR WILD FLORIDA

CARLTON WARD JR.

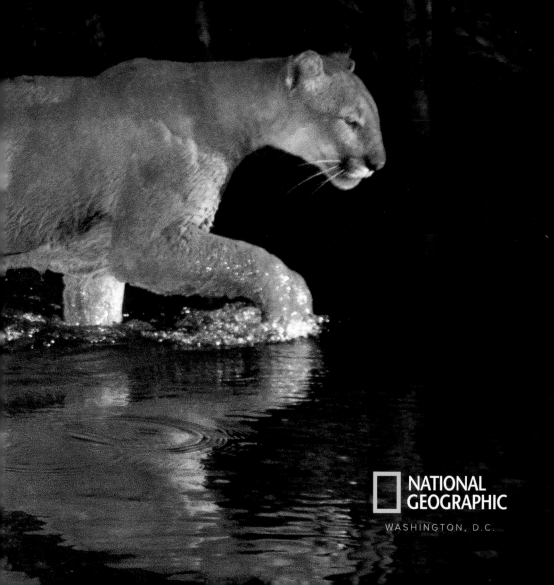

NATIONAL
GEOGRAPHIC
WASHINGTON, D.C.

*To Suzie and our children, Eldridge, Nell, and Carlton III,
for giving me the years needed to chase this story.*

*To all the people who laid the stepping-stones for the
panther's path and are carrying it forward.*

Since 1888, the National Geographic Society has funded more than 14,000 research, conservation, education, and storytelling projects around the world. National Geographic Partners distributes a portion of the funds it receives from your purchase to National Geographic Society to support programs including the conservation of animals and their habitats.

Get closer to National Geographic Explorers and photographers, and connect with our global community. Join us today at nationalgeographic.org/joinus

For rights or permissions inquiries, please contact National Geographic Books Subsidiary Rights: bookrights@natgeo.com

Library of Congress Cataloging-in-Publication Data
Names: Ward, Carlton, Jr., author.
Title: Path of the panther : new hope for wild Florida / Carlton Ward Jr.
Description: Washington, D.C. : National Geographic, [2023] | Summary:
 "This story of hope for the iconic endangered
 Florida panther shows how protecting wildlife sustains us all"--
 Provided by publisher.
Identifiers: LCCN 2022048408 | ISBN 9781426223624 (hardcover)
Subjects: LCSH: Florida panther. | Wildlife conservation--Florida.
Classification: LCC QL737.C23 W365 2023 | DDC 599.75/24--dc23/
 eng/20221011
LC record available at https://lccn.loc.gov/2022048408

Financially supported by the National Geographic Society.

Editor: Victoria Pope
Designer and photo editor: David Griffin

ISBN: 978-1-4262-2362-4

Printed in Canada
23/FC/1

CONTENTS

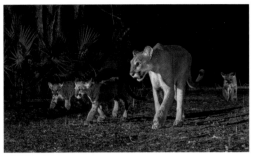

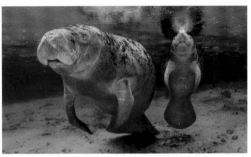

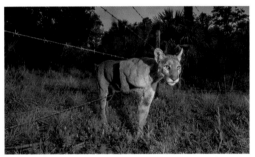

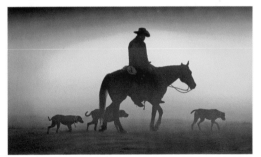

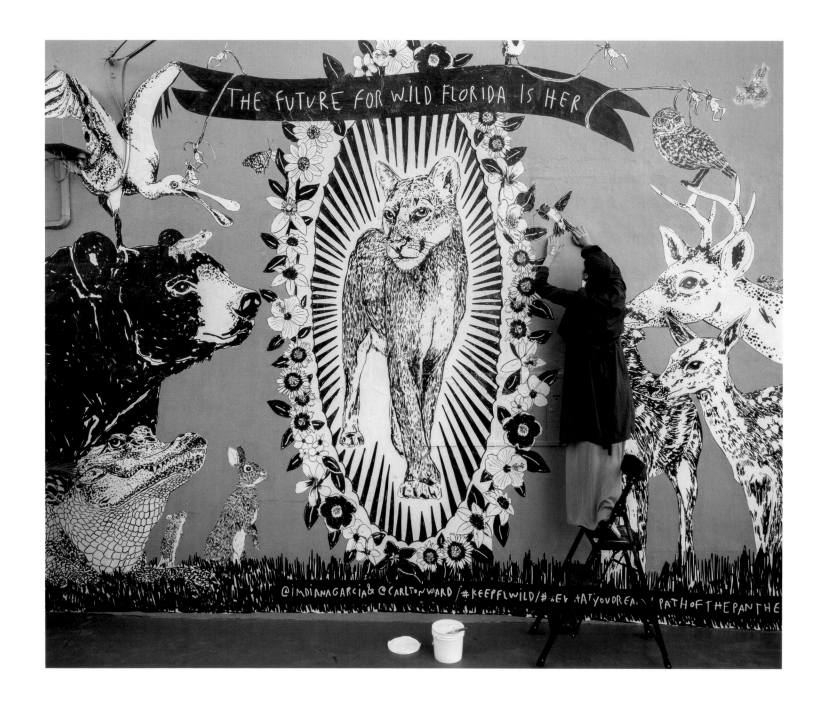

During Art Basel Miami 2018, Diana Garcia puts finishing touches on her mural honoring the first female Florida panther to reclaim territory in the Northern Everglades. The work was inspired by the photograph on pages 2–3.

THE MYTHIC AURA of the Florida panther is well deserved. The cats are heart-stoppingly beautiful and famously elusive, apex phantoms on the run from mad suburban sprawl.

They avidly want nothing to do with humans. It's ironic, then, that the only thing standing between these animals and extinction is the heedless two-legged species that drove them to that brink. Thanks to decades of challenging research—and pressure from an awakened public—more panthers now roam South Florida than probably at any time in the past 50 years. There are still too few of them, of course, but the fact they're here at all is no small miracle.

Most people will never lay eyes on a panther in nature, but the striking pictures in this book are the next best thing. Wildlife photographer Carlton Ward Jr. located remote trails used by the skittish cats, positioned his cameras there, and over years compiled the unique close-up images in these pages.

What Ward learned on the secret paths of the panther galvanized his campaign to preserve and connect vital habitats before they vanished under concrete. The project became the Florida Wildlife Corridor, a contiguous swath of wildlands winding from the Everglades all the way to the panhandle. That such a concept was unanimously approved by Florida lawmakers is astonishing to those of us who follow our state's developer-friendly politics.

I remember when the demise of the panther seemed a foregone conclusion, the cat's population having grimly dwindled to fewer than 20. And while the marathon effort to rescue the species hasn't been free of discord and controversy, it's impossible not to admire those early researchers who tackled what others believed was a lost cause.

One was the late David Maehr, who let me and photojournalist Tim Chapman accompany his team in the Fakahatchee Strand on a mission to sedate a young female panther that needed antibiotics. She turned out to be pregnant, a discovery we celebrated in hushed tones while waiting for the cat to wake up and lope off. The year was 1988.

During an outdoor lifetime in Florida, I've come across only one panther in the wild—a full-grown male wearing an electronic collar. It had been among the first to be darted and fitted with telemetry devices, a program that proved crucial in protecting the small number of panthers that existed at the time.

That biologists were already monitoring the cat I saw didn't diminish the excitement I felt on that long-ago rainy evening. The high stayed with me throughout the writing of *Scat,* a novel for young readers in which I tried to put into words what it's like to encounter a panther, however fleetingly.

This book places you right there, nose to nose with a spectral predator that spends every waking hour trying not to be seen. The glimpses captured in Ward's photographs justify our awe of panthers and make more compelling the fight to forever secure the places where they still run wild, gloriously out of sight. ●

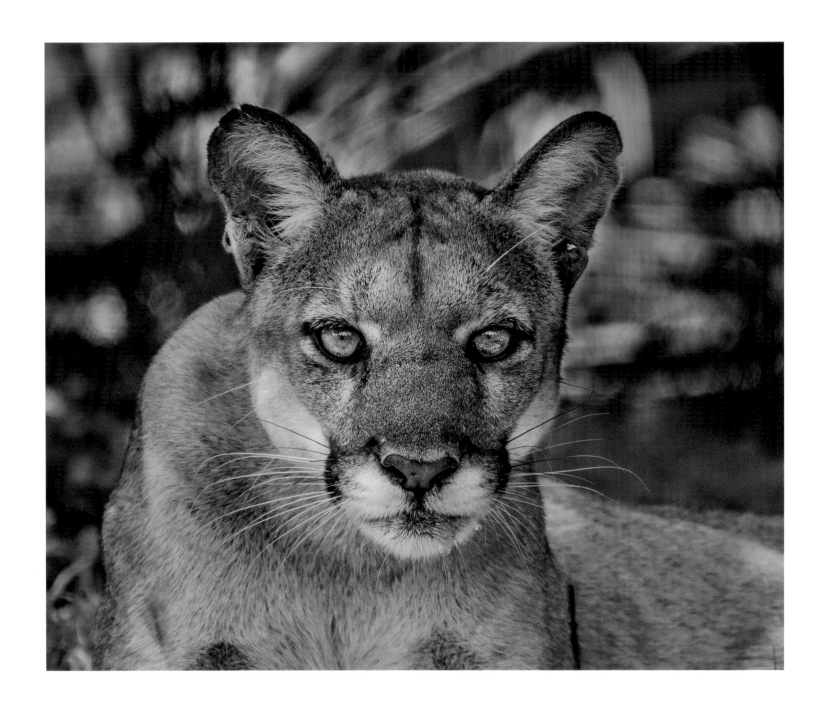

The photographer took this picture of a Florida panther—the only time he had a camera in hand when seeing one in the wild—at Audubon's Corkscrew Swamp Sanctuary.

DRIVING SOUTH from Immokalee, farm fields and cattle pastures give way to pine stands and cypress domes. Every mile or so, the road rises to make way for a wildlife crossing below, leading deeper into a wilderness as unbroken as any you will find in the eastern United States. This is Florida panther territory—the Everglades—where four million acres (1.6 million ha) of contiguous public lands encompass an area twice the size of Yellowstone National Park. National Geographic Travel has sent me here to photograph Florida Panther National Wildlife Refuge. Rather than take a landscape photo, I decide to set up a camera trap. That's when a one-day assignment in 2015 turned into a seven-year mission to tell the story of the Florida panther.

My goal for the assignment is to show a panther in a cypress swamp, a puma habitat today unique to South Florida. I meet David Shindle, the lead biologist for U.S. Fish and Wildlife's panther program, who suggests placing a camera trap west in the Fakahatchee Strand. The relatively high road from his office weaves through the palmettos and pines before dropping down toward a ledge of cypress trees, where an elevated trail from an old logging tramway carries us deeper beneath the canopy. Once we cannot drive any farther, we begin searching for tracks on foot. David points out bear and deer tracks in the heavy peat soil and says it's a good spot for a panther. I find a picturesque stretch of trail nearby, with the added interest of a downed tree that is slightly worn in the middle, which I hope comes from animals crossing over. When I set up a camera trap there, the viewfinder frames the primordial world of cypress knees and strap ferns that I imagine to be

the realm of the panther. I adjust the exposure, tape the focus, aim the flashes, test the infrared trigger beam—and leave the camera to do its job.

That summer, the rainy season holds off longer than normal, giving me nearly two months of dry trails before the water rises and drowns parts of the camera trap. The results are one good photo of a bear walking over the log toward the camera and another of an alligator half swimming over that log as the swamp is rising. My blog about the assignment for National Geographic Travel is titled "Cooperative Bear, Frustrating Panther." That's because, in addition to the bear and alligator, there is also one photo of a beautiful female panther—only she's walking away from the camera, showing little more than her tail and haunches. That fleeting glimpse stays with me, as if she is daring me to follow her into a hidden world. I grow obsessed by the potential of the project and follow up with Shindle to begin learning more about the panther's plight.

Panthers have been stalking through Florida since the last ice age. When Europeans arrived in America, panthers still roamed an unbroken territory from the Everglades to the Appalachians to the Adirondacks to the Mississippi River. That was before hunting, persecution, and habitat loss wiped them out everywhere in the eastern United States—except for the swamps of South Florida. Here, amid the untamed wilderness where the Miccosukee and Seminole people found refuge from the wars waged upon them, a small number of panthers also survived.

By the 1960s, panther numbers had dropped to fewer than 20. Isolated and inbred, the population was

sliding toward extinction. At the same time, a conservation ethic was growing in the United States, and the panther became one of the first animals to receive protection from the Endangered Species Act. Since then, through habitat conservation and genetic rescue, panthers have rebounded to nearly 200, but they are still isolated mainly to South Florida. Panthers are now on the brink of recovery, but only if they can reclaim more of their historic territory farther north in Florida.

MY TIME WITH David Shindle at Florida Panther National Wildlife Refuge helped clarify my focus. When I learned that the key to panther recovery is access to more land, my thoughts quickly turned to the 18 million acres (7.3 million ha) of the Florida Wildlife Corridor, a project I'd spent the previous six years developing with a team of conservationists. Now I realized it could be a lifeline for the panther.

The purpose of the Florida Wildlife Corridor is to keep a connected swath of wildlife habitat throughout the Florida peninsula and panhandle. Florida is blessed with 10 million acres (4 million ha) of public conservation lands. But these parks and preserves will nearly all become islands surrounded by development, to the detriment of wildlife, water, and people, if the green spaces that connect them aren't protected. The fabric holding the patches of public lands together is made up of ranches, farms, and working forests. But this connective tissue is rapidly being transformed into subdivisions.

The more I learn, the more the panther jumps out as the ultimate symbol of the corridor. The most compelling reason is how much land panthers need. The

average home range for a single male panther is 200 square miles (520 sq km)—an area four times the size of Miami. That means multiple connected properties are almost always necessary to support the territory needs of even a single panther. Add the fact that South Florida doesn't have enough land to support enough panthers to have a genetically viable panther population. That means protecting the Florida Wildlife Corridor is the only way panthers can reclaim enough of their historic range throughout Florida to ever reach sustainable numbers.

Once I see that the panther is the lead character for making the case for the corridor, I need to figure out how to photograph what is essentially a ghost. At the beginning of the project, despite having spent much of my life in the Florida woods, I have never seen a panther in the wild. In addition to being rare and wide-ranging, panthers are nocturnal, solitary, and elusive. The only way to reliably photograph them in the wild will be with camera traps. I had worked with camera traps in Gabon and Mali to photograph leopards and elephants, and in Central Florida to get pictures of bears. Now it is time to try for panthers.

With a new grant from the National Geographic Society, I return to Florida Panther National Wildlife Refuge in 2016 to start the Path of the Panther project.

I begin with four camera trap systems on loan from National Geographic and build two more of my own. A camera trap is essentially a photo studio you set up in the woods with an invisible trip wire for an animal to take its own picture. Mine are built around professional DSLR cameras triggering a combination of three or

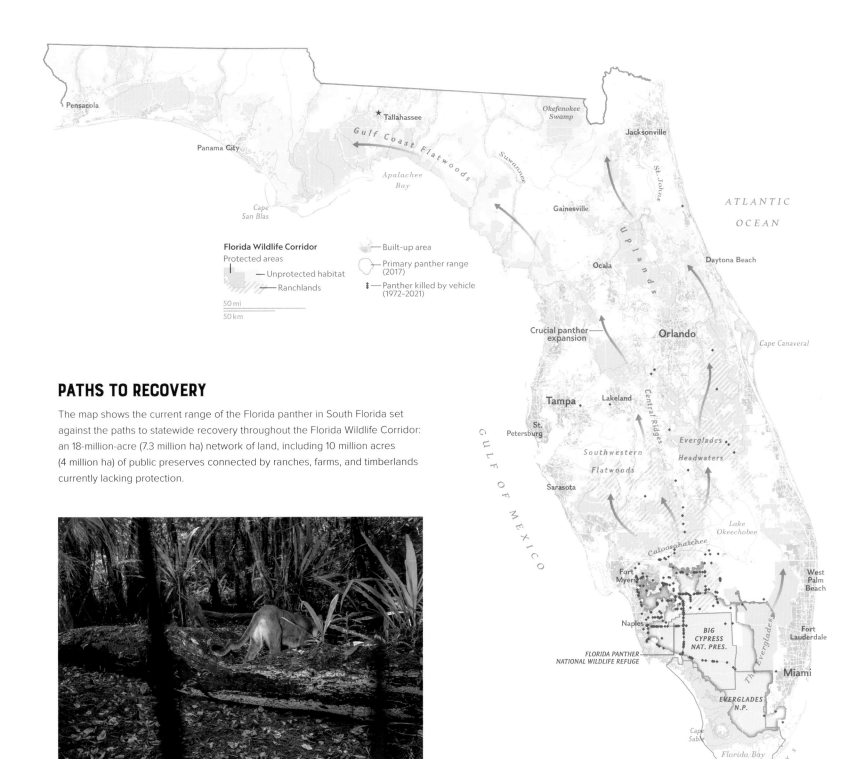

PATHS TO RECOVERY

The map shows the current range of the Florida panther in South Florida set against the paths to statewide recovery throughout the Florida Wildlife Corridor: an 18-million-acre (7.3 million ha) network of land, including 10 million acres (4 million ha) of public preserves connected by ranches, farms, and timberlands currently lacking protection.

Florida Wildlife Corridor
Protected areas
— Unprotected habitat
— Ranchlands

50 mi
50 km

Built-up area
Primary panther range (2017)
Panther killed by vehicle (1972–2021)

A female panther with an injured tail walks away from the camera in Florida Panther National Wildlife Refuge in the summer of 2015. It is the only panther photo captured during two months of work in the preserve.

more flashes, all in custom waterproof cases. These camera traps are capable of beautiful photos, but when working in a subtropical environment, where it can rain more than 100 inches (250 cm) in a year and plants can grow in front of your lens in a matter of days, the odds of failure start to stack up against you. That's before you factor in the improbability of a panther stepping right where you want it to, in the right light, and with all the components working together in a fraction of a second. Or mice chewing through trigger wires, scorching wildfires, ants invading battery bays, curious bears toppling tripods, floodwaters drowning cameras, trespassers stealing cameras, and, on one occasion, a poacher shooting a camera with a rifle.

During the first few months, I check each camera with great anticipation. But disappointment soon becomes the norm. My hopes are dashed so many times during the first year that I start to gird myself for defeat. After nearly two years of failures, when I first see the image on the back of the camera that is now on the cover of this book—a panther flying through the air with wild eyes staring at the camera—it takes me a few days to appreciate the achievement.

At that location, a panther was coming by the camera on average about once a month, only half the time facing toward the camera, half the year with water in the swamp, and mostly all at night. The elements in the cover photo with the panther's eyes in focus, water in the creek, and daylight to add depth to the scene, might happen once a year. The scene is lit by seven flashes and triggered by an array of three infrared laser beams set at different angles and powered by a car battery and

I SET MY PHONE ON A LOG AND CARY LIGHTSEY'S WORDS REVERBERATE THROUGH THE SPEAKERPHONE AND ECHO THROUGH THE SWAMP: "CARLTON, **THE PANTHER IS GOING TO HAVE TO HELP US** SAVE FLORIDA."

solar panel. Having it all work at the instant the panther flies through the air is a gift from the swamp. A couple weeks later, Hurricane Irma destroyed the whole system, making landfall as a Category 4 storm a few miles away. After recovering from the storm, my team and I set up again in the same place for another two years, but the moment in this photo never repeated itself.

FOR THE RECOVERY of the Florida panther, the biggest hope comes in November 2016, when biologists from the Florida Fish and Wildlife Conservation Commission (FWC) get a trail-camera photo as well as a footprint at Babcock Ranch State Preserve. They are the first evidence of a female panther north of the Caloosahatchee River since 1973. The Caloosahatchee cuts from Lake Okeechobee to Fort Myers and had been the northern boundary to the panther's known breeding range for 43 years. Male panthers, escaping lethal competition with other males in the south, had been swimming north across the river in previous decades. One male born in South Florida was killed by a hunter in 2011 in western Georgia, halfway to Tennessee. But before 2016, any male wandering north of the Caloosahatchee would never find a mate. News of the female panther at Babcock Ranch is the first glimmer that the panthers' breeding population might be able to naturally expand beyond South Florida.

Biologists from the FWC allow me to set up one of my camera traps near where they had captured their historic photo, and in January 2017, my camera takes a full-color photo of the beautiful female panther at Babcock Ranch striding through the edge of an oak hammock, green eyes glancing toward the camera. When I show that photo to David Shindle, he says, "I have been dreaming about her for 18 years!" For his entire career as a panther biologist, the idea of a female panther north of the Caloosahatchee had been a goal propelling him and his colleagues ahead in their work.

Later that week, I share the photo with rancher Cary Lightsey, whose family has been raising cattle in the Northern Everglades for six generations. I am standing knee-deep in water fixing a camera trap when he calls me back. I set my phone on a log and his words reverberate through the speakerphone and echo through the swamp: "Carlton, the panther is going to have to help us save Florida." Then he explains that the panther is going to help people understand why we need to save the farms and ranches that make up the wildlife corridor.

In 2022, Lightsey's words are still ringing true. It's one year since the Florida Legislature passed the Florida Wildlife Corridor Act with a unanimous bipartisan vote. I am in a helicopter flying low over an 11-mile-long (18 km) cypress strand filming land that will soon be protected by new funding dedicated to the Florida Wildlife Corridor. Saving this land will provide connected habitat for panthers to safely move northward in the state. As the helicopter gains altitude, the wider landscape comes into view. My eyes follow a ribbon of green stretching from the Caloosahatchee far into the Everglades Headwaters National Conservation Area and beyond. Beneath the shade of the cypress trees, I imagine the forest floor where the next female panther may find a home, where her safe passage protects all in her path. ●

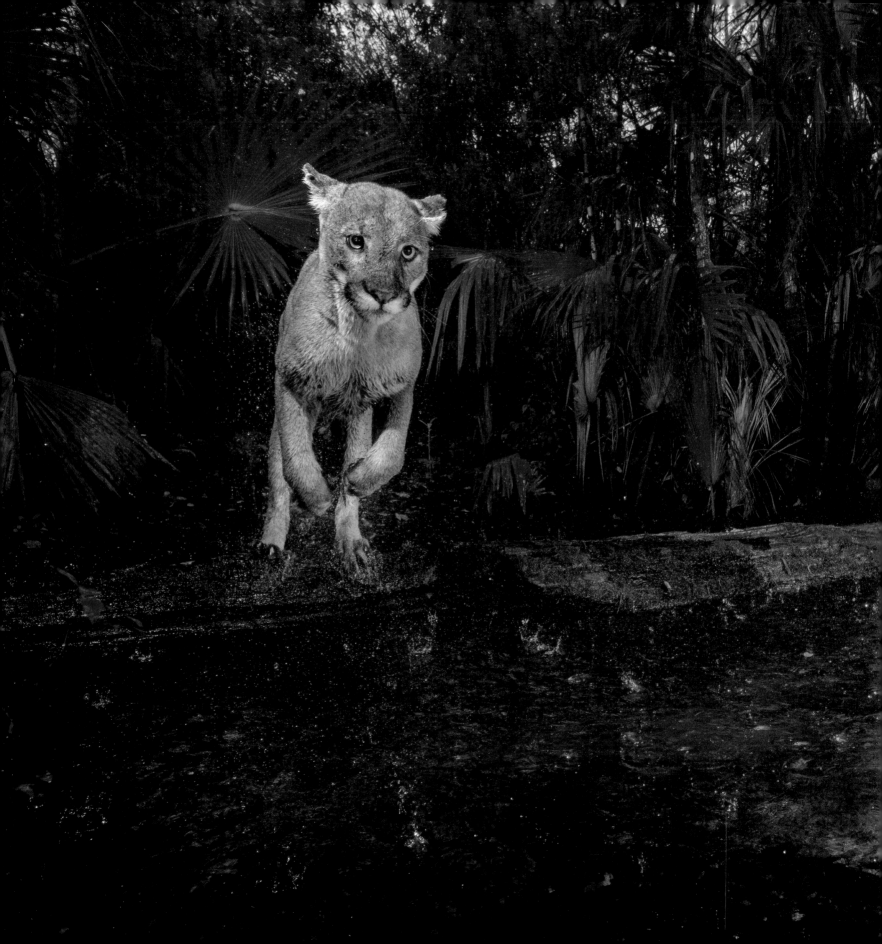

1

LORD
OF
THE
FOREST

"WELCOME TO panther country," Brian Kelly says when I meet him at a busy intersection in East Naples, Florida, a stone's throw from a gas station and an urgent care center. Kelly, a panther biologist with the Florida Fish and Wildlife Conservation Commission, points east toward the subdivision where he lives. A panther was caught on camera just a quarter mile away (400 m), he says, and another one made it across the six-lane road we're standing beside.

Yet another panther, an eight-year-old female named FP224, lives nearby. She's been hit by a car twice, breaking a leg each time. She was treated by veterinarians and released after both accidents. To look for signs of her, we drive to Kelly's house, next to a patch of forest where she recently denned and birthed at least three kittens. It's the wet season, when rain typically wipes out panther tracks, but we get lucky.

"There she is," Kelly says, pointing to large paw prints, about the size of my fist, in the soft sand. We follow the prints through tall pines and sabal palms festooned with air plants. Her tracks are thrilling to see—a reminder that Florida still has wilderness and large cats, some of them resilient enough to live unseen along the fringes of expanding suburbs.

Most Floridians will never see any signs of these predators, which weigh from 65 to 165 pounds (30 to 75 kg) as adults, depending on sex, and can leap more than 10 yards (9 m) in a single bound. But the panther—known to the Cherokee as "lord of the forest"—depends for survival on the millions of acres of swamps, forests, and fields in southwestern and central Florida, many of which are at imminent risk of development.

Classified as a subspecies of mountain lion, or cougar, panthers once ranged throughout most of the southeastern United States. But the animals were hunted aggressively, and by the 1970s they were only found in Florida and were within a whisker of going extinct. Their numbers had fallen to fewer than 20, making them highly vulnerable to inbreeding. On top of this, scientists had discovered a neurological condition called feline leukomyelopathy, which affects panthers and bobcats in Florida. Severe cases can lead to paralysis, starvation, and death.

Scientists hatched an unprecedented rescue plan: In the mid-1990s they hired Texan Roy McBride, arguably the world's best mountain lion tracker, to capture eight of the cats in Texas, all females, then release them into South Florida. Five of them bred, and this infusion of genetic diversity reversed the panther's downward spiral.

Populations grew slowly, and now about 200 individuals are mostly in a massive stretch of contiguous land south of the Caloosahatchee River, which cuts east from Fort Myers. But most remarkably, panthers are reclaiming some of their old territory. In 2016, for the first time since 1973, scientists spotted a female north of the Caloosahatchee River at Babcock Ranch Preserve. Unlike males, females don't travel far from their mother's home range, a major limiting factor in the animals' expansion. But now, Kelly estimates, a couple dozen panthers, including a few females, live north of the Caloosahatchee.

As panthers strike out north of the Caloosahatchee River, they'll encounter land dominated by large ranches and farms. Roads cut through many of these areas, and the region is dotted with small, often expanding towns. One of the better known cattle operations in south-central

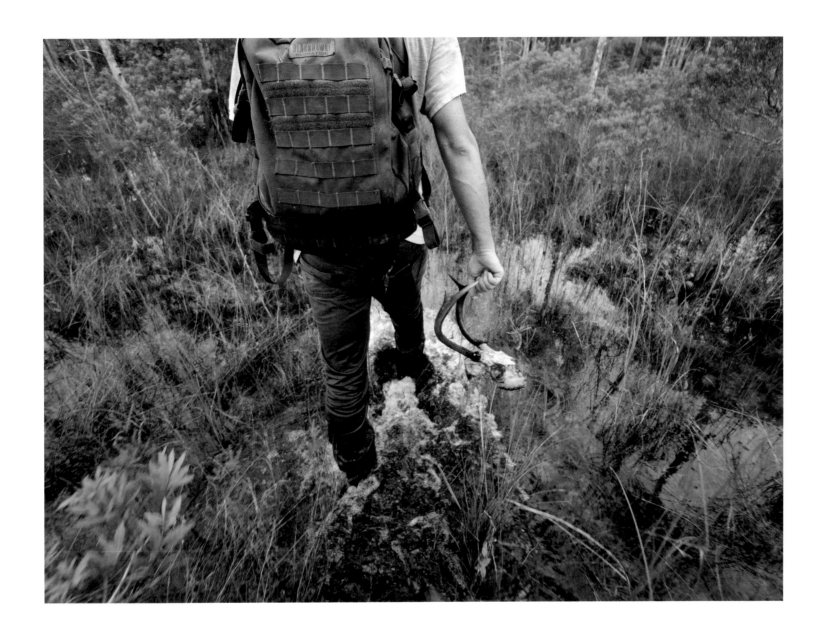

ABOVE: Biologist and tracker Brian Kelly carries a white-tailed deer skull from a Florida panther cache site in Big Cypress National Preserve to examine the predator-prey relationship between panthers and deer as part of the South Florida Deer Study with the University of Georgia and Florida Fish and Wildlife Conservation Commission. **PREVIOUS PAGES:** A male Florida panther leaps over a swamp creek in Florida Panther National Wildlife Refuge. This camera trap photo was taken right before Hurricane Irma, which drowned the camera system when it made landfall near Naples on September 10, 2017. Thankfully, the memory card survived.

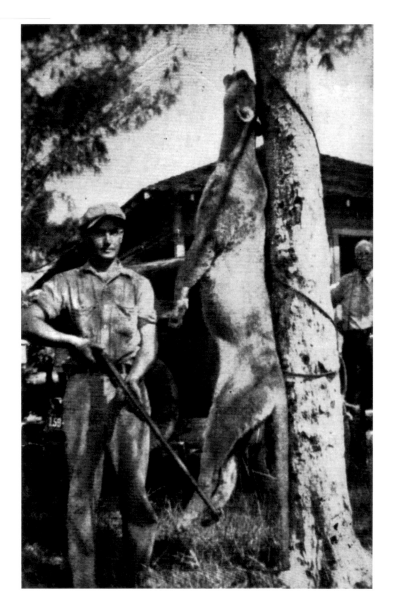

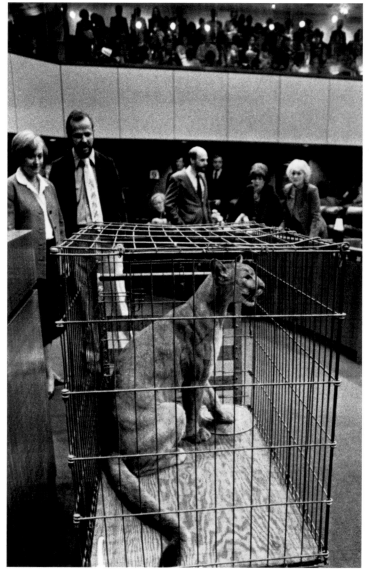

LEFT: Panthers were hunted to local extinction during the past century everywhere in the eastern United States except for South Florida. Often bounties encouraged their extermination. This panther was shot by Mitt McSwain in 1937 near Bonita Springs. RIGHT: This 14-month-old panther was displayed at the Florida House of Representatives on the day the legislative body passed a bill naming the Florida panther the state animal in 1982.

Florida is the 10,500-acre (4,250 ha) Buck Island Ranch, run by Gene Lollis, a sixth-generation Floridian.

On a March morning before sunrise, I head out on horseback with Lollis, who heads the Florida Cattlemen's Association. I ask Lollis how ranchers view the panther. "We're all pretty positive about them," he says. "They're part of the landscape." Many see the panthers' presence as a safeguard against land development because of the conservation measures protecting them. But especially to the south, where there are more panthers, ranchers are warier, says Alex Johns, a Seminole cattleman who notes his family has ranched since the 1500s, when his forebears poached cows from the Spanish. In the southern regions, panthers occasionally eat calves, and they are often blamed for kills carried out by coyotes, bears, and even buzzards.

David Shindle, the panther coordinator with the U.S. Fish and Wildlife Service, says incentivizing the presence of the animals on the land—which is mostly private north of the Caloosahatchee River—would go a long way toward easing tensions. One way to do that is to encourage public and private investment in conservation easements, which buy up development rights while allowing the owners to continue farming.

Though the threats facing the panther are all too real, Kelly believes panthers could make it all the way to northern Florida within decades and spread to other states, if the Florida Wildlife Corridor is protected.

In the meantime, Kelly and colleagues have placed around a hundred cameras at various spots north of the Caloosahatchee to learn more about how and where panthers move. That's where he recalls seeing a panther in the spring of 2021, at Babcock Ranch Preserve. "We just stared at each other for about 20 minutes," says Kelly, who quickly realized it was a female by her small size and because she was wailing, a sign of being in heat.

That was momentous—the first verified in-person sighting of a female panther north of the Caloosahatchee River since the cougar tracker Roy McBride found an old female at Fisheating Creek in 1973.

This newfound female was "my white whale," Kelly says.

Later Kelly and I take a swamp buggy through this area, 20 miles (32 km) to the north, crossing flooded fields and meandering through thickets of palmetto and cypress hammocks. Wildlife here is plentiful: On a good day you can see bears, otters, alligators, and bird species, including crested caracaras and swallow-tailed kites, all of which rely on the same wildlands as panthers.

Kelly stops to check a recently placed camera trap looped around an oak tree. He flips through the photos, and sandwiched within all the usual suspects—coyotes, wild pigs, raccoons, deer—is a photo of a panther, which passed by a few weeks earlier.

And not just any panther: a lanky female, never before spotted by biologists, striding along the northern side of the fence separating the creek from the adjoining ranch—and perhaps to a new life up north. ●

DOUGLAS MAIN is a senior writer and editor for National Geographic, focusing on natural history. He has covered Florida wildlife extensively and wrote a version of this story for the March 2021 issue of *National Geographic* magazine.

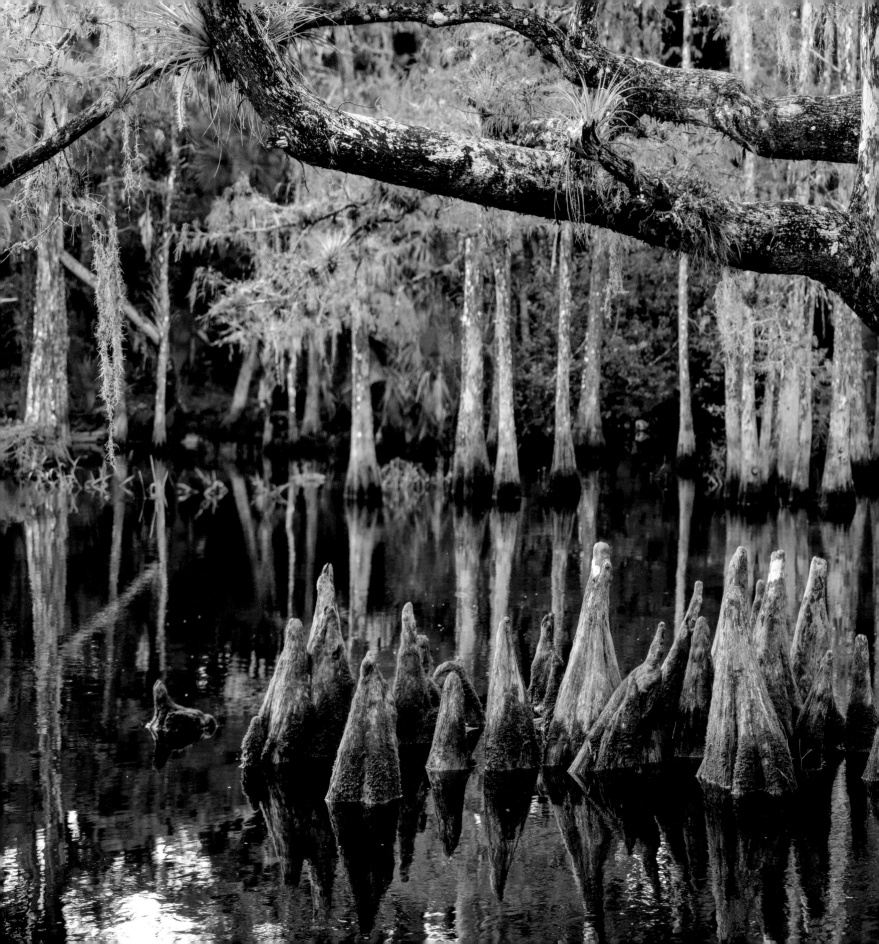

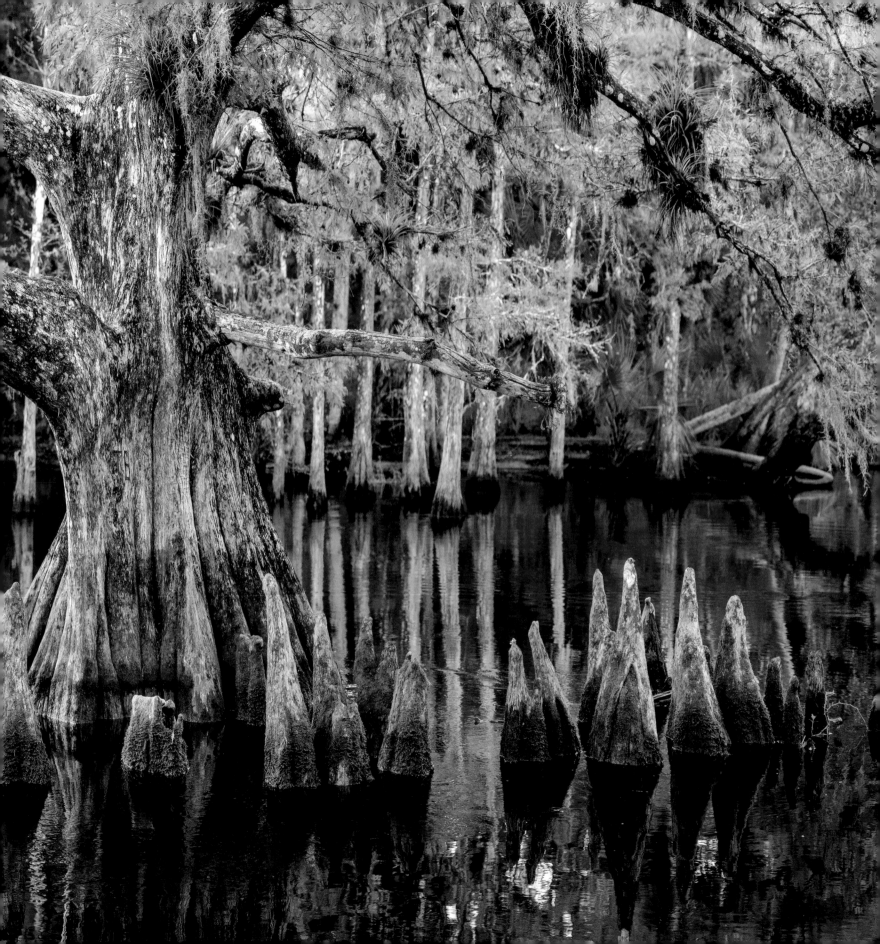

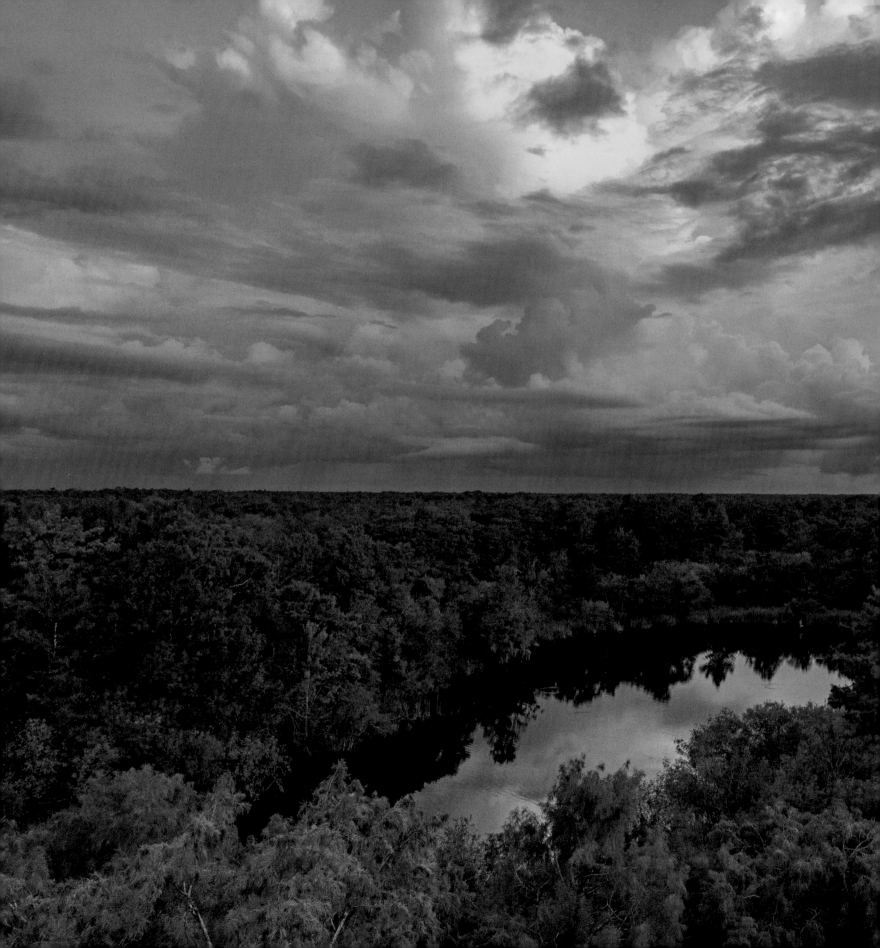

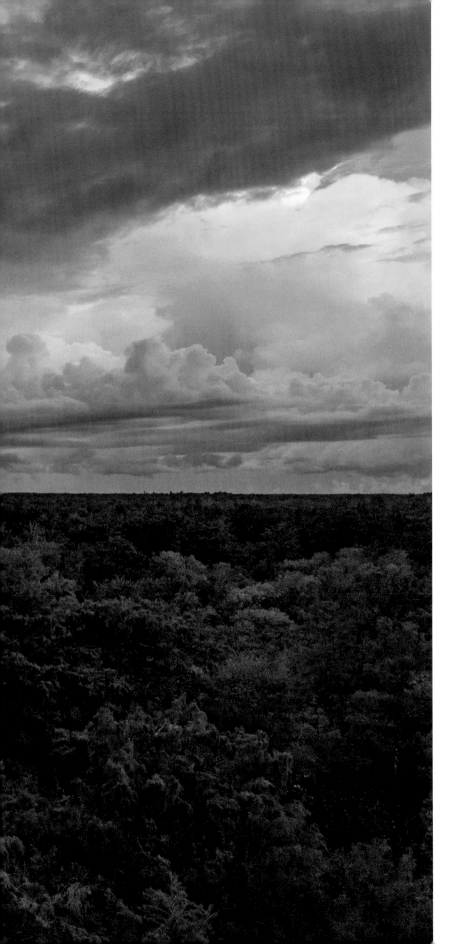

Afternoon storms build over Cochran Lake and the Fakahatchee Strand in Florida Panther National Wildlife Refuge. The remote swamps of the Southern Everglades have provided the last refuge for panthers in the east and the core landscape for recent decades of recovery.

PREVIOUS PAGES: Cypress trees stand in Fisheating Creek, a wild waterway feeding into Lake Okeechobee from the west. Scientists in 1973 captured a female panther near here, the last female documented in the Northern Everglades until state biologists documented another in 2016.

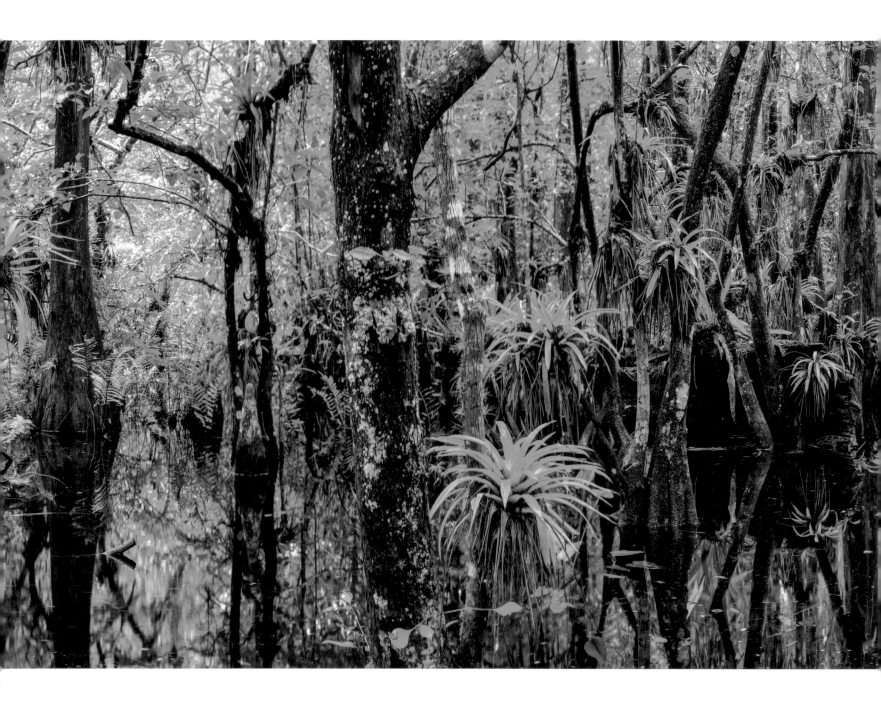

The seasonally flooded forests of the western Everglades, including what is now Fakahatchee Strand Preserve State Park, were among the last landscapes in the eastern United States to face pressure from encroachment and development. As a result, they were a natural shelter and sanctuary for panthers.

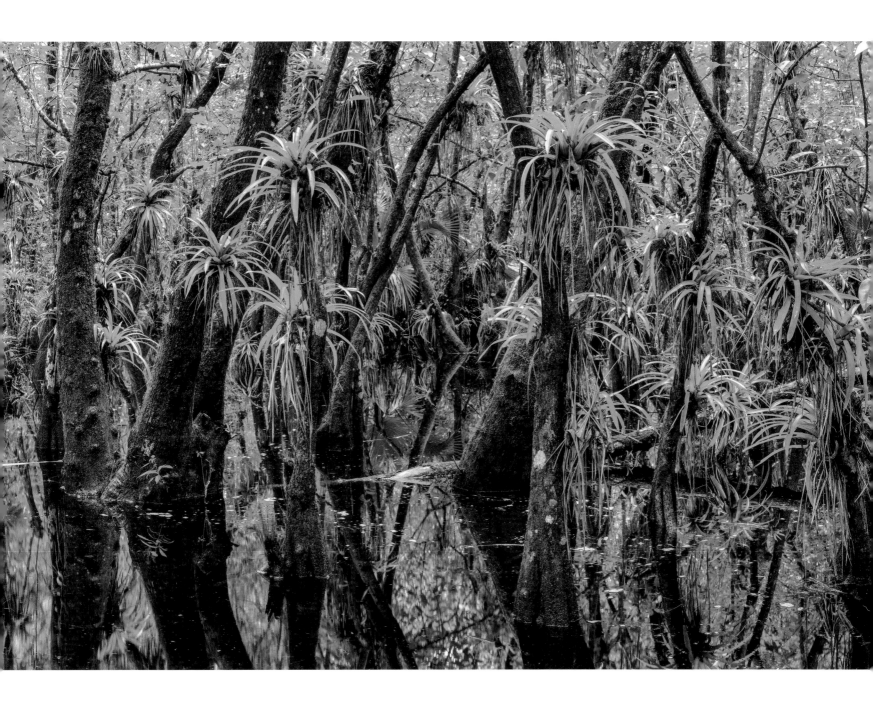

CTF021 | FAKAHATCHEE STRAND

It was a priority for the photography in this book to show panthers living in the iconic swamp habitats of the Southern Everglades that have been the key to their survival. Pictured here is the Fakahatchee Strand within Florida Panther National Wildlife Refuge, a particularly challenging landscape for camera trapping. Water covers trails for most of the year—at one point during the effort for 18 months straight. A benefit to the long time spent on the assignment was experiencing the seasons' diversity of life thriving on this single trail.

An American alligator squeezes past the camera, bumping a tripod on the way. South Florida is the last place in America shared by these two apex predators: panthers and alligators.

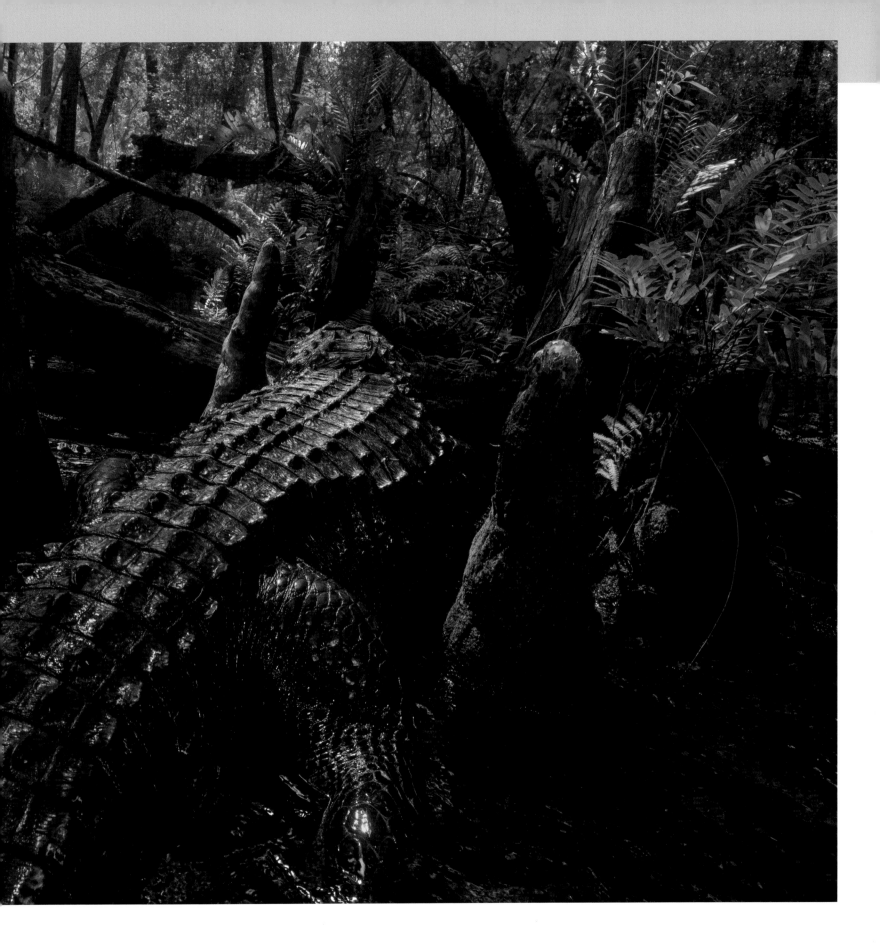

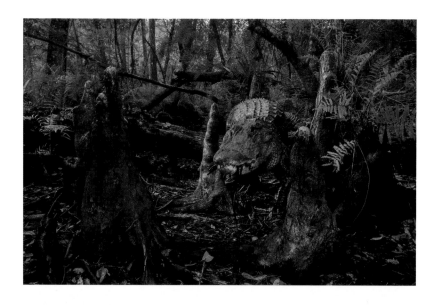

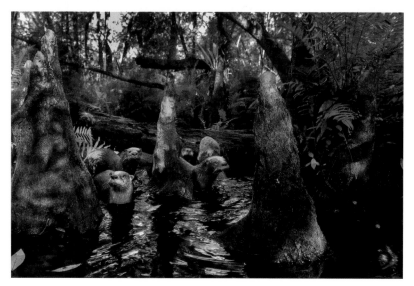

CLOCKWISE FROM BOTTOM LEFT: Otters hunt for fish and travel swamp trails; an alligator carrying a large salamander called an amphiuma navigates the cypress knees before the onset of the wet season; bobcats are the other species of wildcat that share trails with panthers; a raccoon seems to play hide-and-seek with the camera.

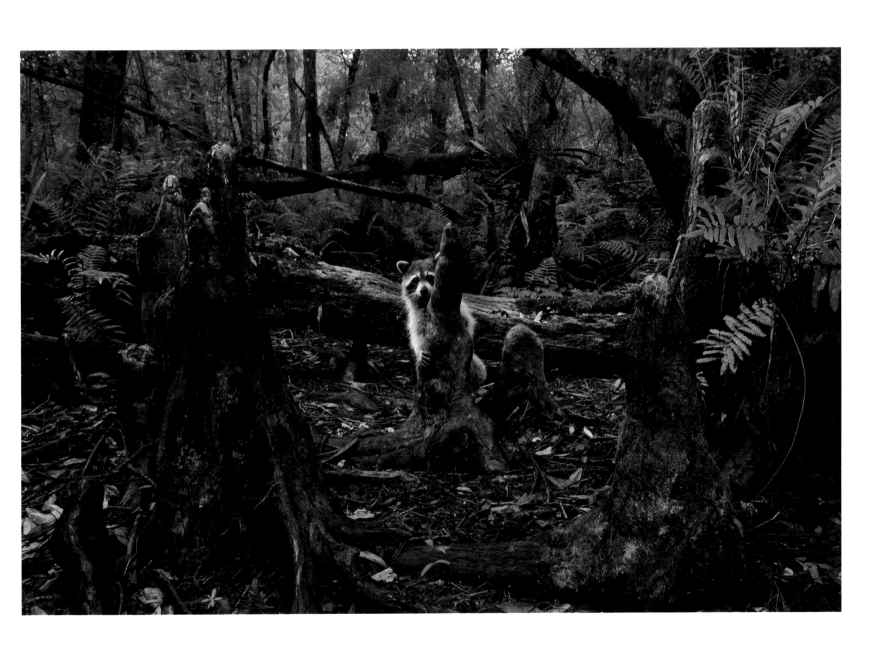

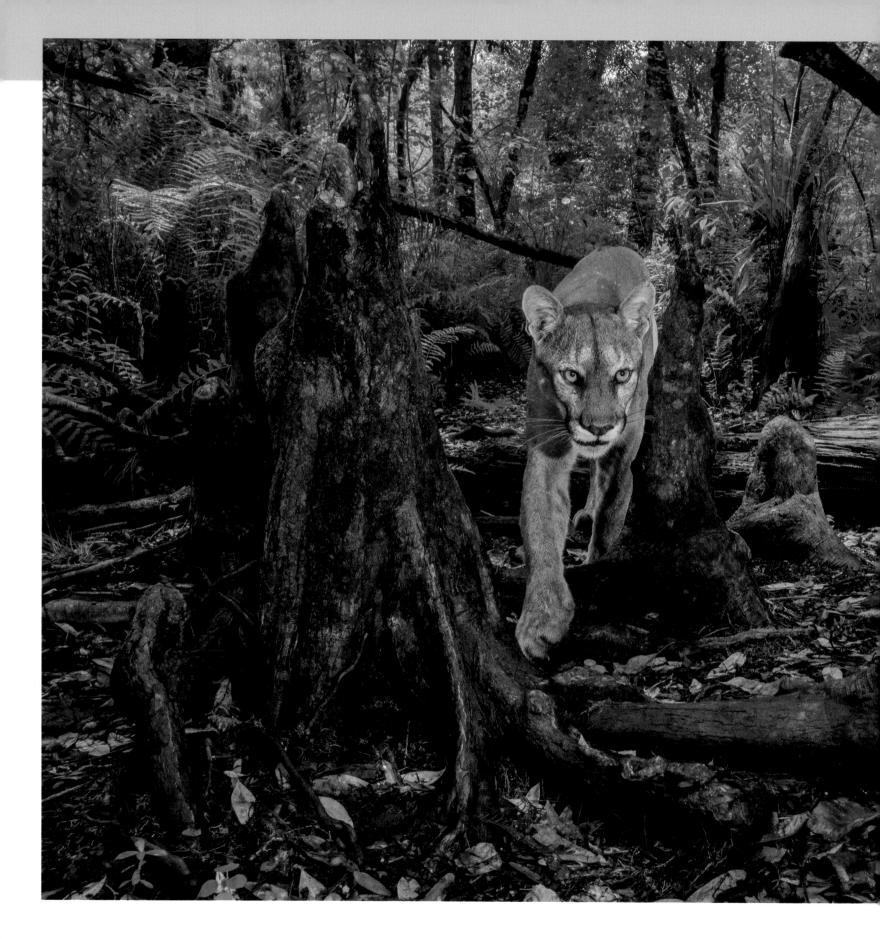

After five years of trying, during the last month of the project's special-use permit at Florida Panther National Wildlife Refuge, the team captured the moment they had been waiting for: a Florida panther walking toward the camera, surrounded by the remote swamp habitat that gave the subspecies a last refuge and saved it from extinction in the eastern United States.

A mother panther and three kittens walk a forest trail in Audubon's Corkscrew Swamp Sanctuary. This property east of Naples provides habitat for panthers throughout the year, but conservation is needed on surrounding properties to secure enough land for a panther's 200-square-mile (520 sq km) home range.

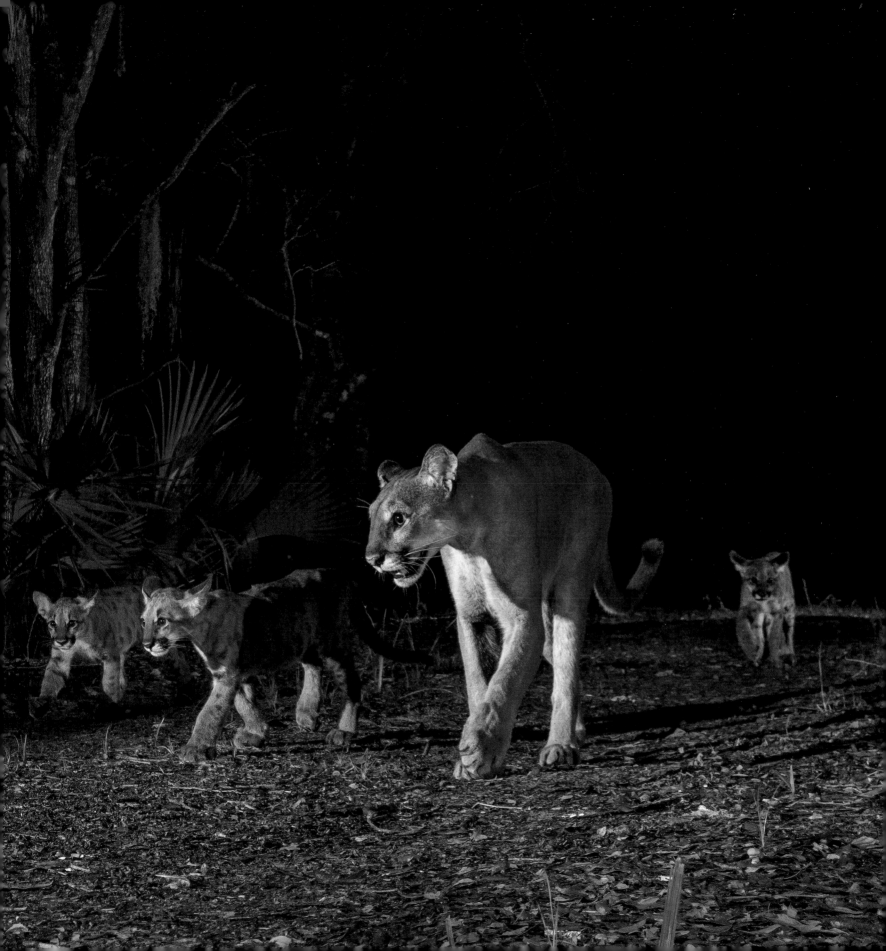

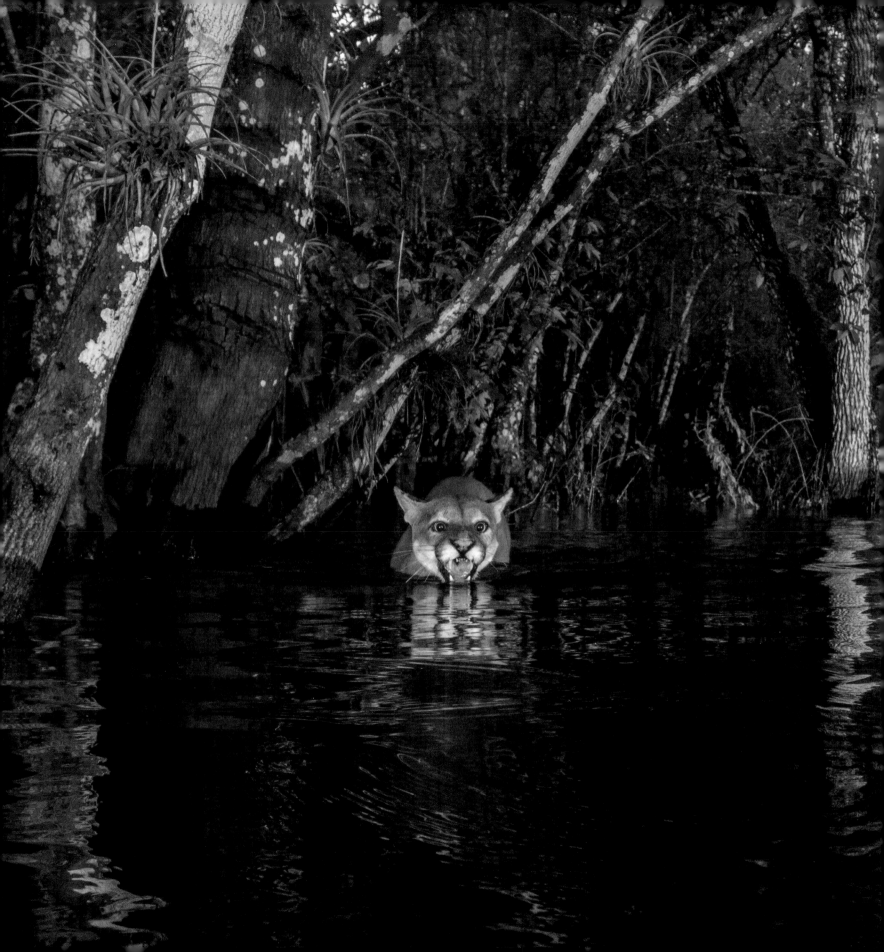

Chin-deep in water, a male Florida panther wades through a flooded section of a trail in the Fakahatchee Strand within Florida Panther National Wildlife Refuge. Cats may not like water, but the panther's ability to live in South Florida's subtropical swamps, far from conflict with people, allowed the species to survive during the past century.

TO THE RESCUE

DOUGLAS MAIN

ONCE RANGING THROUGHOUT the southeastern United States and Florida, panthers nearly went extinct from habitat loss and unregulated hunting. By the 1980s, 20 to 30 were left. Though the endangered cats have rebounded significantly in the last couple decades, with a total population around 200, their future remains tenuous.

That's why scientists are concerned about a newly discovered neurological disease in Florida panthers and bobcats that causes hind limb weakness and, in severe cases, partial paralysis. Affected animals often have trouble walking, which can lead to starvation and death. Known as feline leukomyelopathy (FLM), the disease has likely afflicted 35 panthers and 42 bobcats throughout the state since spring 2017.

What's causing the disease is unknown, but the prevailing theory points to the involvement of neurotoxins. Although a pathogen such as a virus might also be responsible, it's considered less likely. Ultimately, the illness could be due to a combination of factors, such as a nutritional deficiency combined with a neurotoxin. Since the disease is found in at least two feline species, it's not a genetic condition that's passed down from parent to offspring.

Dave Onorato, a panther biologist with the Florida Fish and Wildlife Conservation Commission, carries a panther kitten from where it had been trapped. A trail camera captured this kitten and its sibling having difficulty walking with their rear legs—a characteristic symptom of feline leukomyelopathy (FLM), a neurological disease.

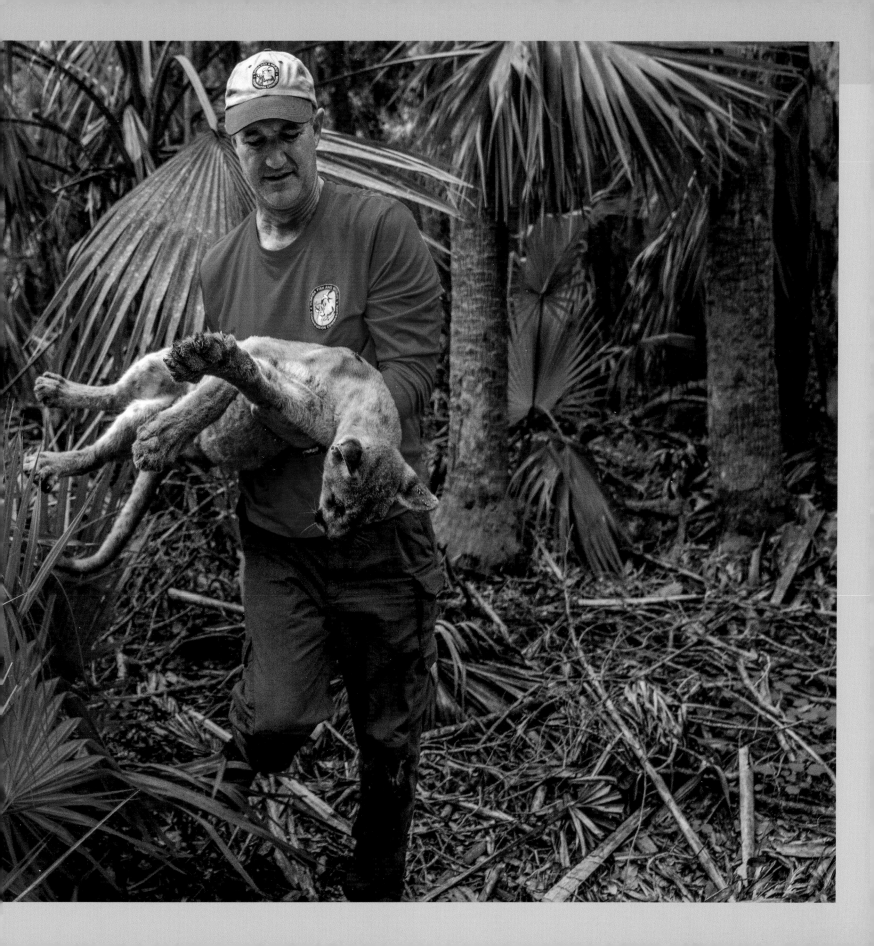

Researchers suspect the disease, characterized by damage to nerve cells, develops early in a panther's life and does not generally worsen—or improve—says Mark Cunningham, wildlife veterinarian for the Florida Fish and Wildlife Conservation Commission (FWC). In some areas, the disease affects a significant percentage of panther kittens.

The FWC has made studying the disease an urgent priority, Cunningham says. A band of organizations, research institutions, and private citizens, including photographers with camera traps, are working together to pinpoint the cause, he says.

"This is really an unprecedented event in wildlife, at least in felids," he adds.

In early 2018, photographers Ralph Arwood and Brian Hampton captured videos of a panther mom who'd just given birth to three kittens in the Corkscrew Swamp area, an expanse of old-growth cypress forest north of Naples. But in mid-May, it became apparent something was wrong. Two of the kittens, both male, had trouble walking, with obvious weakness in their hind legs. Arwood alerted the FWC.

A couple months later, photographer and National Geographic Explorer Carlton Ward Jr. encountered the panther mom while driving to a camera trap he'd placed nearby. It was a joyous moment—until he saw one of her cubs, dragging himself along the ground, while the mother waited for him. "It was crushing to witness," he says. "One of the saddest, most helpless things I've ever seen." One of the kittens was not seen again and was presumed to have died, while the other one was captured and fitted with a tracking collar, which fell off after a few

months. His final fate is unknown, Cunningham says. Several more probable cases of FLM have since appeared in panthers and bobcats in the Corkscrew Swamp area.

Of the four officially diagnosed cases in panthers, one cat is a female that gave birth to two kittens near Immokalee in summer 2019. She was seen on camera with severe weakness in her hind legs, and eventually state wildlife officials took in the three cats, because it appeared likely all three would probably not survive. Researchers with ZooTampa examined the kittens, and the mom was taken to the University of Florida College of Veterinary Medicine.

The female was given various tests, including an MRI, a neurological workup, and blood tests, but nothing stood out that could explain her condition. By this point she could barely walk, and a panel of veterinarians made the tough choice to euthanize her. The kittens recovered and are now healthy adults living at White Oak Conservation in northeastern Florida.

Necropsies of cats afflicted with FLM reveal they have severe damage to the spinal cord, which is typically riddled with holes where the axons, or nerve fibers, should be, says Nicole Nemeth, a veterinary pathologist with the Southeastern Cooperative Wildlife Disease Study, a collaborative research group. Nemeth is a member of a growing circle of researchers helping to analyze samples from affected animals.

A toxic substance is likely killing off the axons, says Ian Duncan, a neurologist at the University of Wisconsin who has collaborated with the FWC. Other possible culprits are neurotoxins produced by naturally occurring algae or some type of microbe in the cats' habitat.

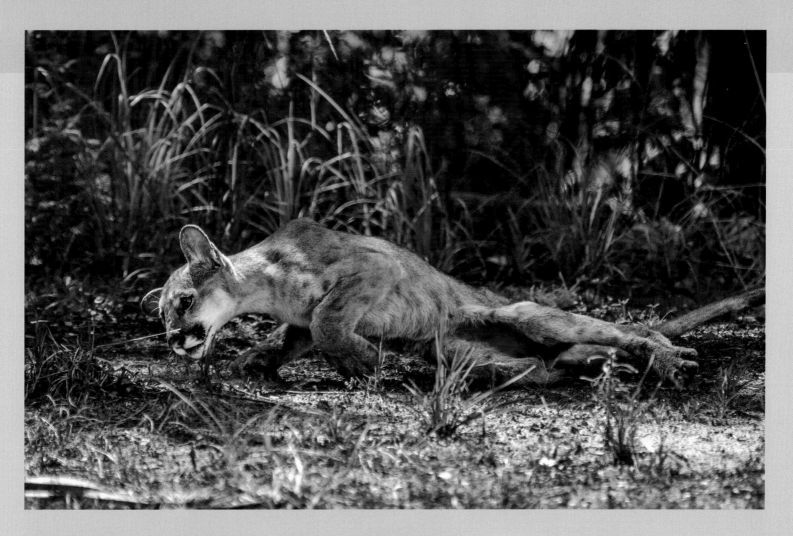

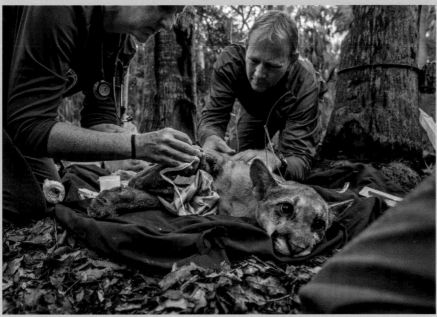

ABOVE: Photographer Carlton Ward Jr. observed this panther kitten struggling to keep up with its mother. It would take a few wobbly steps, and then lose coordination of its back legs and drag itself forward with its front legs until it could stand again. **LEFT:** Florida Fish and Wildlife Conservation Commission veterinarian Lara Cusack (left) and biologist Mark Lotz take blood samples before returning one of the affected kittens to its mother in the wild.

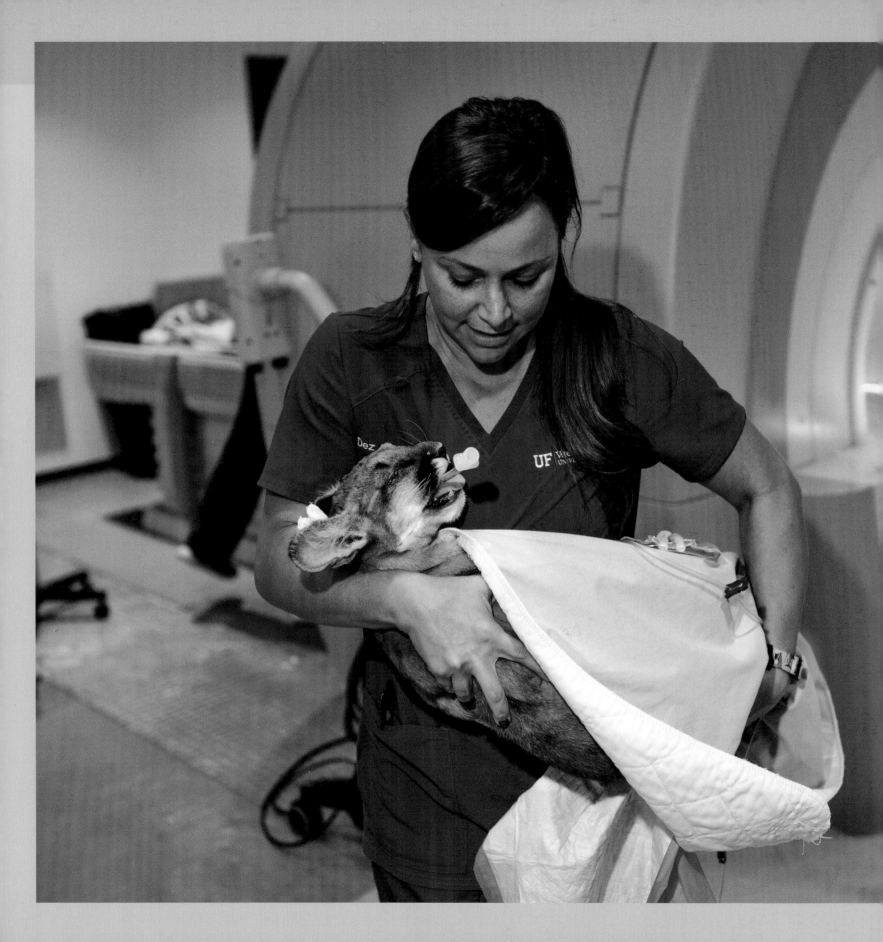

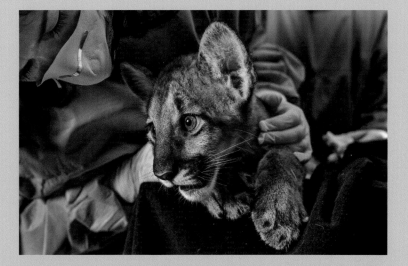

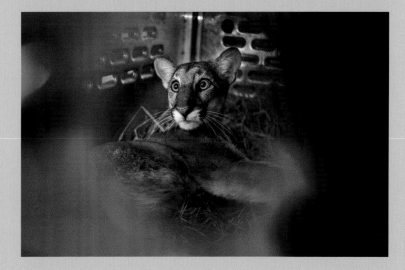

LEFT: Veterinary technician Des Muir carries a panther kitten after administering an MRI scan at the University of Florida Veterinary Hospital in Gainesville. These MRI scans focused on the spinal cords and brains of the panthers, where the neurological symptoms of FLM present. **TOP:** At ZooTampa, veterinarian Lauren Smith examines a panther kitten that showed initial signs of FLM but has now recovered. **BOTTOM:** The kittens' mother, FP250, was in such poor condition when her kittens were rescued that she had to be euthanized.

So far researchers have screened several dead panthers for scores of toxic substances, including rodenticides, pesticides, herbicides, and heavy metals, but nothing definitive has turned up.

Felines in general—such as domestic cats, cheetahs, and leopards—seem slightly more susceptible to neurological diseases than other mammals, Nemeth says.

"FLM is kind of a wild card at this point—we don't want to sound off the alarm bells too much, but [it] could impact our progress toward recovery," says Dave Onorato, FWC's lead panther biologist.

The disease's potential to disrupt the panther's precarious progress underscores the need for the animals to move into new territory to insulate them against new and growing threats, Onorato says. Panthers must expand their range to the north, which is only possible if wildlife corridors are expanded.

"The future of the panther is very much in question," says Deborah Jansen, a retired panther biologist with the National Park Service. "The panther is facing some really, really big obstacles, especially this neurological disorder." ●

Panther veterinarian Lara Cusack prepares her medical kit in the predawn light before approaching an affected panther kitten in a nearby trap. Current evidence suggests that FLM is caused by toxins in the environment, but the investigation is ongoing.

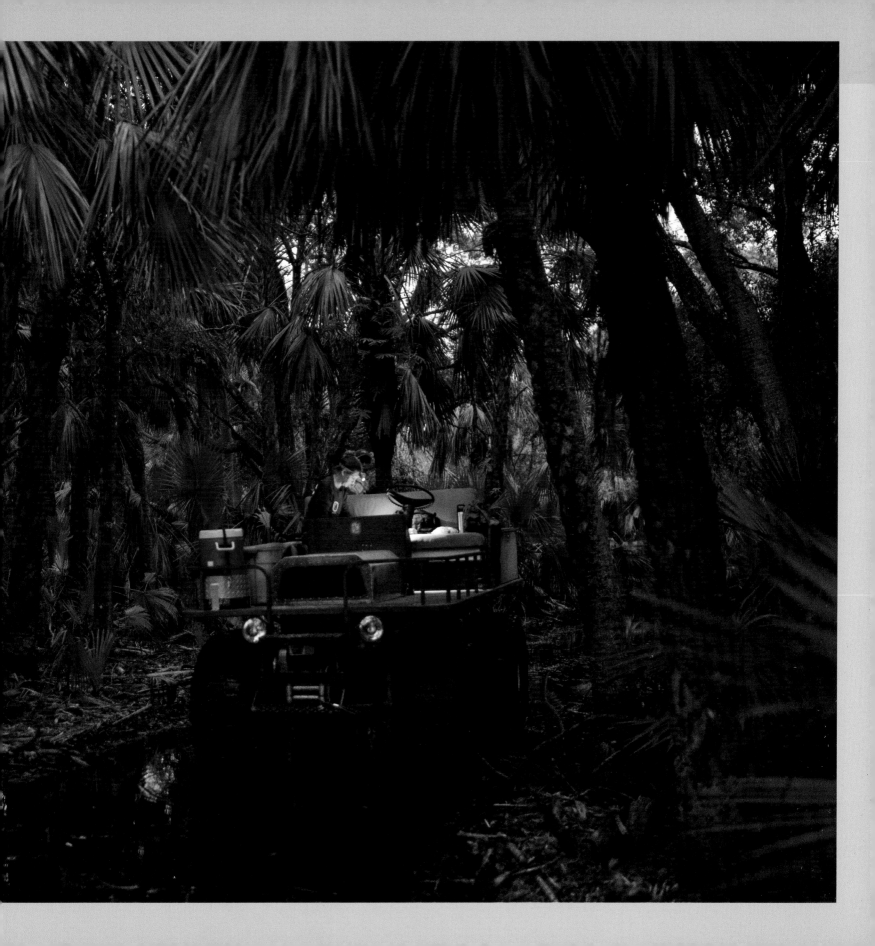

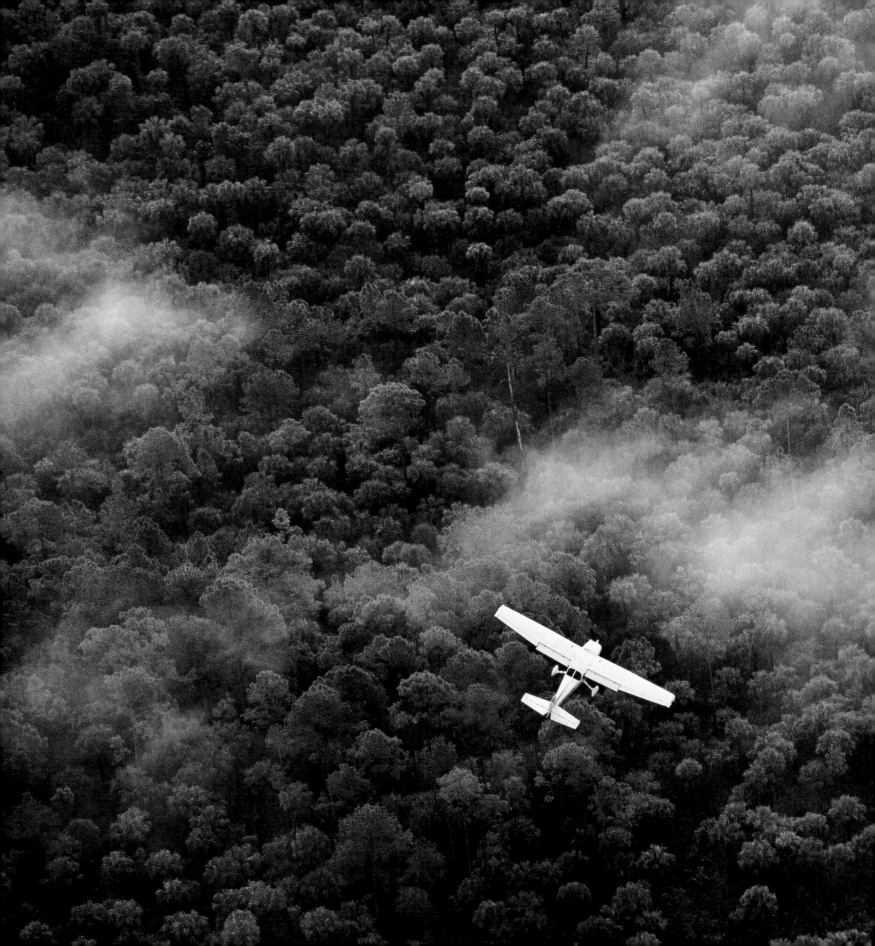

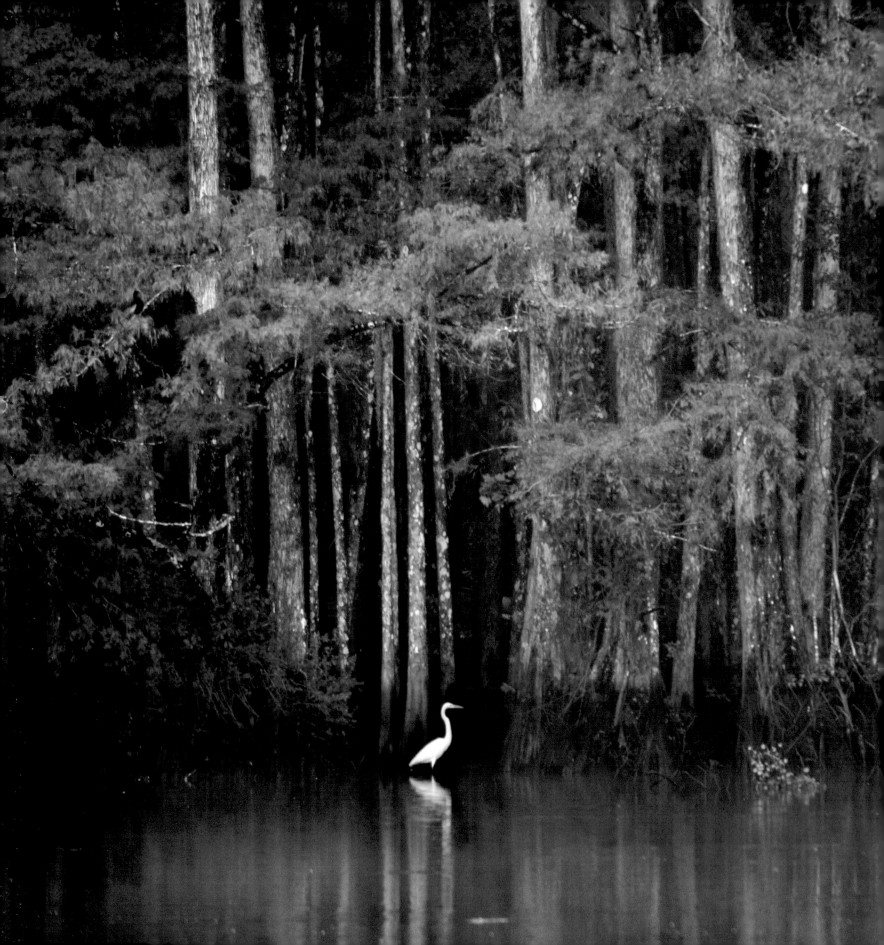

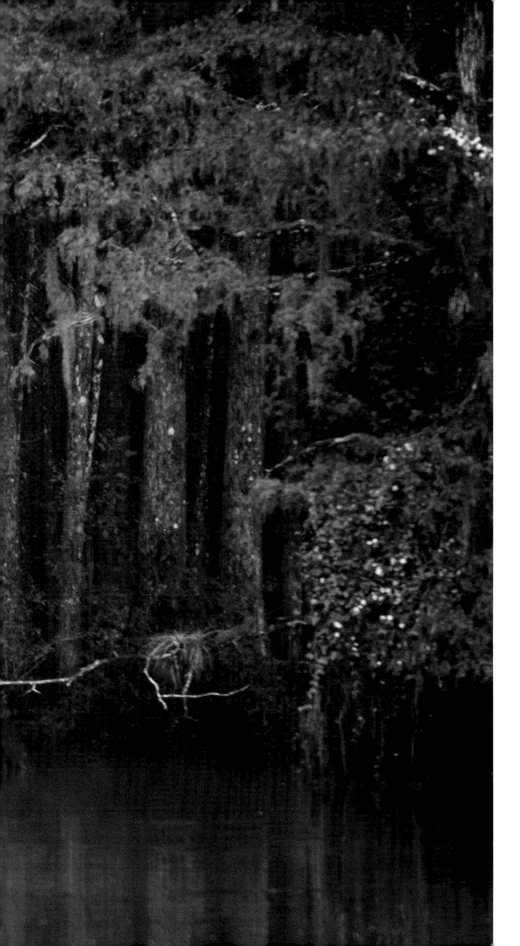

A white egret wades at the base of cypress trees in Telegraph Swamp at Babcock Ranch State Preserve, the location where the first female panther north of the Caloosahatchee River since 1973 was confirmed in 2016.

PREVIOUS PAGES: Biologists from the Florida Fish and Wildlife Conservation Commission fly low over South Florida panther habitat in an airplane outfitted with specialized radio antennas to locate panthers wearing VHF radio collars. Flights multiple times a week help scientists track the movements of as many as 10 collared panthers, providing vital information to understand panther biology and inform conservation planning.

NO. 023 | BABCOCK RANCH

Babcock Ranch is a hub of nearly 100,000 acres (40,470 ha) of land east of Fort Myers that was nearly lost to development in the early 2000s. But thanks to a hybrid approach adopted by real estate developer Syd Kitson, the land is today mostly in conservation designed around a contained high-density development. Eighty percent of the tract was sold at a discount to the state and county in exchange for the right to build a new town, called Babcock Ranch, closest to existing development. Nearly 90,000 acres (36,420 ha) of wildlife habitat are permanently protected, including the 68,000-acre (27,520 ha) Babcock Ranch State Preserve.

At the core of the preserve are 10,000 acres (4,050 ha) of cypress swamp that connects to the Caloosahatchee River. This camera trap site was selected on the east side of the cypress swamp, in hopes of capturing a photo of a female panther expanding the breeding territory north of the Caloosahatchee River.

Hunters trigger a camera trap while pursuing hogs in their hunting lease area on Babcock Ranch State Preserve. They were excited to learn that a female panther had returned to the area and eager to share tracks and sightings from their own cameras.

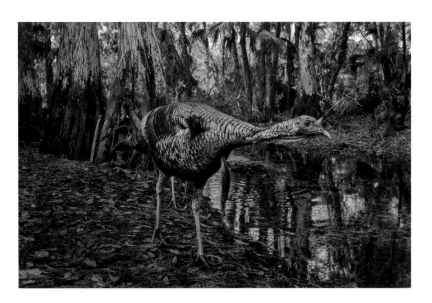

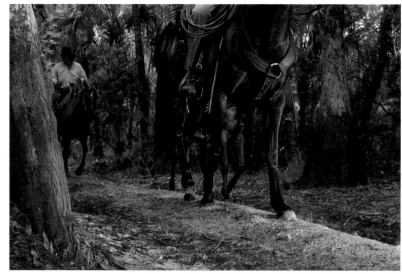

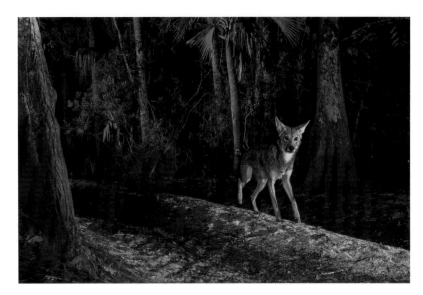

CLOCKWISE FROM BOTTOM LEFT: A coyote looks toward the camera. Coyotes didn't move into Florida until recent decades as they expanded from the west, taking advantage of cleared farmland and the absence of wolves and panthers; the Osceola variety of the American turkey thrives in Florida woodlands and swamps; cowboys on horseback follow the trail by day where panthers hunt by night; this panther is the pioneering female that scientists had first discovered a few months before.

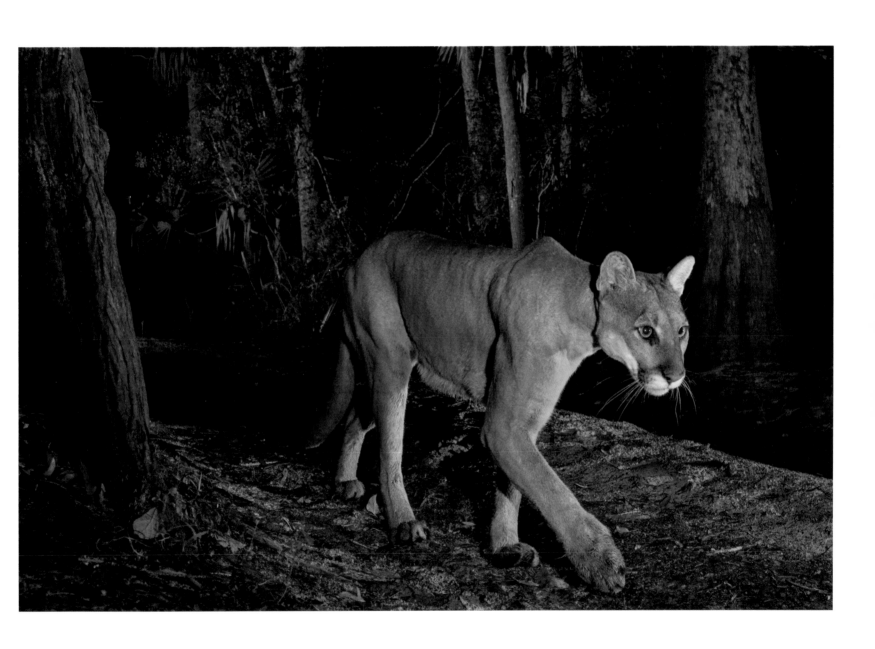

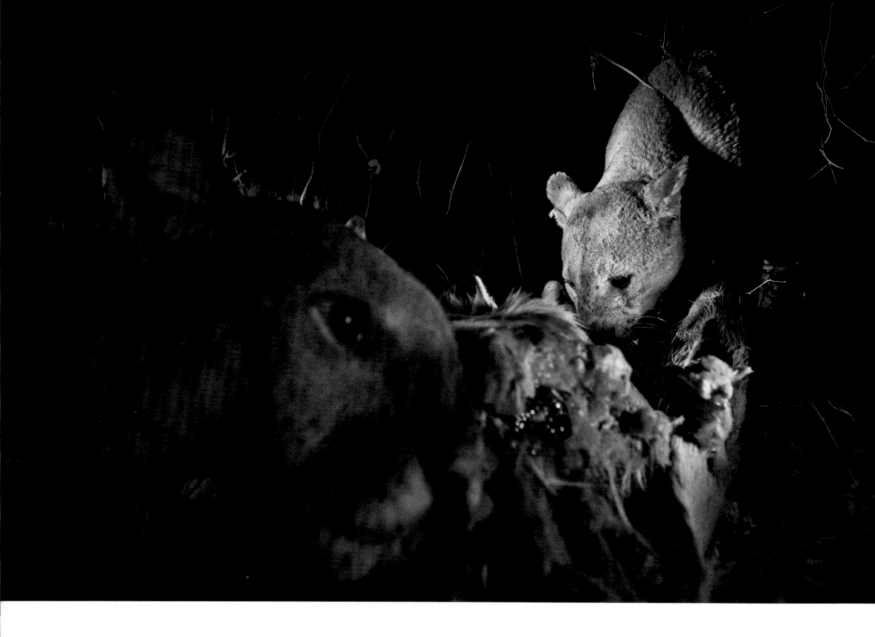

The South Florida Deer Study put GPS tracking collars on more than 100 white-tailed deer to better understand the sources of mortality. As suspected, panthers were proven to be the leading cause of death for deer in the region. A specialized silent camera system used invisible infrared light to produce black-and-white photos at a deer cache site.

ABOVE: The camera revealed a female and male panther foraging together, possibly the first time such behavior had been documented. Panthers remove the stomach and guts and bury them separately from the meat. Whenever they are not feeding, panthers also bury or "cache" meat under a layer of leaves and sticks to hide it from scavengers and other predators. **OPPOSITE:** A large male panther, clearly mature in age from his textured face and worn canine teeth, chews into the carcass in early morning light, one of the last photos captured after more than two nights of feeding.

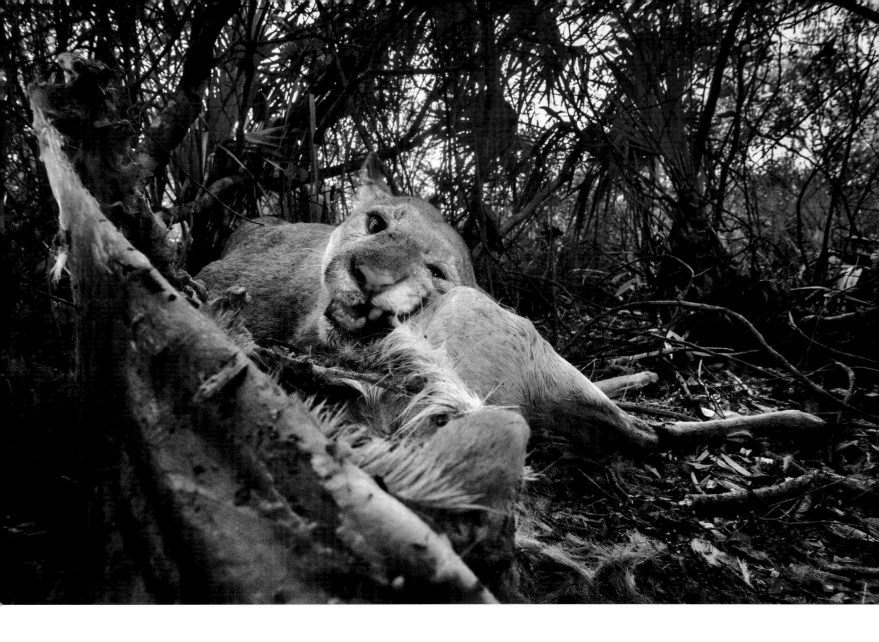

Flying midair over a swamp at Florida Panther National Wildlife Refuge, a panther jumps over the first infrared laser beam that was meant to trigger the camera sooner. Or it's possible the panther was just going too fast for the camera to keep up.

A mature male panther triggers a camera in early morning light at Babcock Ranch State Preserve. Distinguished by his square head and J-shaped tail, he was the only male documented by this camera in the territory where the first female had been seen.

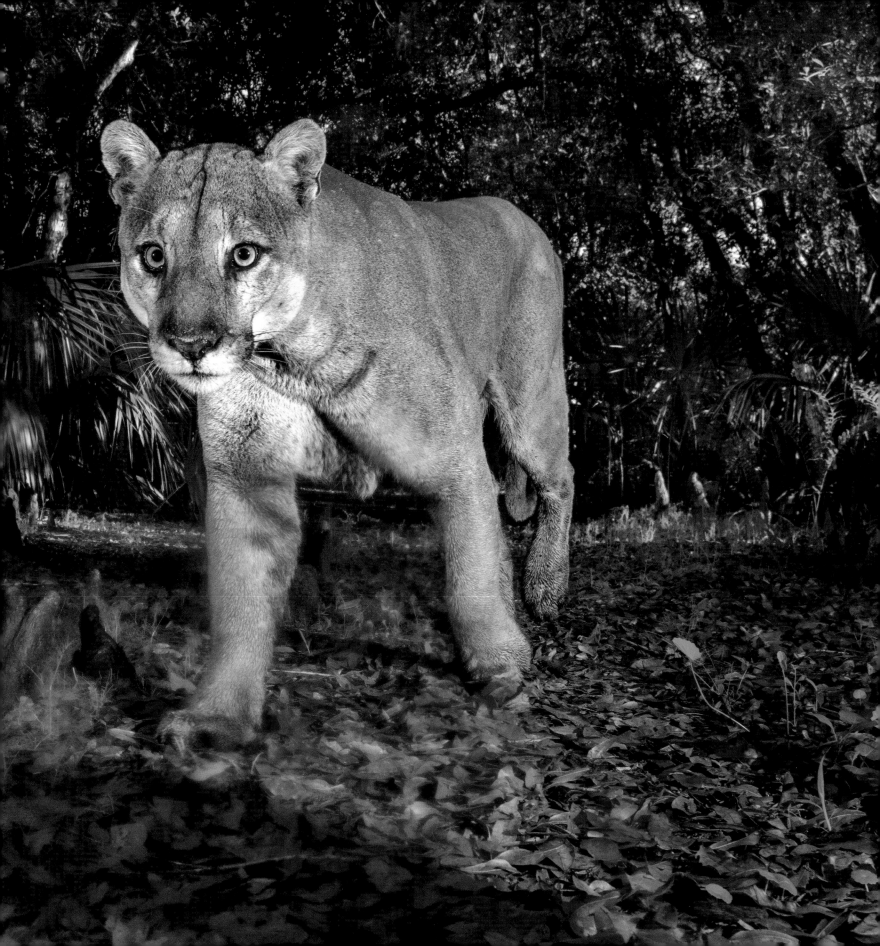

THE CAT THAT CROSSED THE RIVER

IN RECENT DECADES, a major barrier to the recovery of the panther has been the Caloosahatchee River, which has been the dividing line keeping the breeding population confined to the southern tip of Florida. Male panthers have been seen throughout Florida and as far north as Georgia, but a female panther had not been documented north of the Caloosahatchee River since 1973.

Hopes were raised in November 2016, when biologists from the Florida Fish and Wildlife Conservation Commission documented a female panther just north of the Caloosahatchee River at Babcock Ranch State Preserve. A couple months later, one of the Path of the Panther camera traps captured the photo at right—of the female who crossed the river. ●

Triggering a camera trap on Babcock Ranch State Preserve, this is the first female Florida panther documented north of the Caloosahatchee River since 1973. The ability to reestablish a breeding population farther north is vital to the recovery of the species.

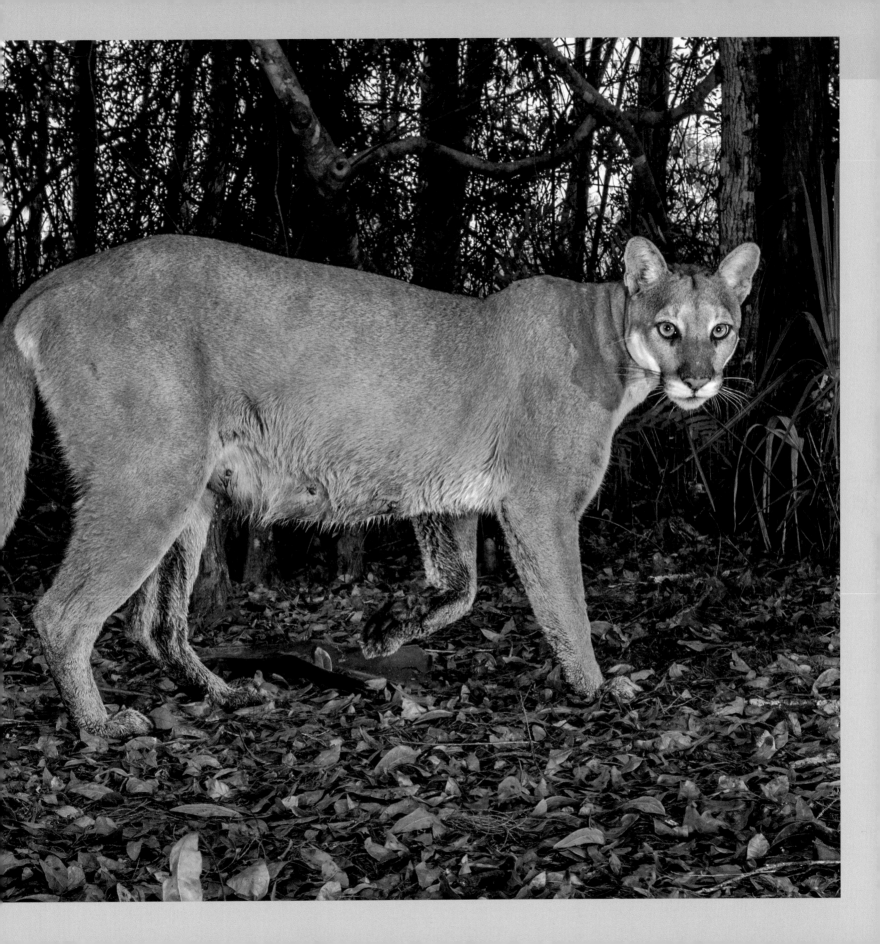

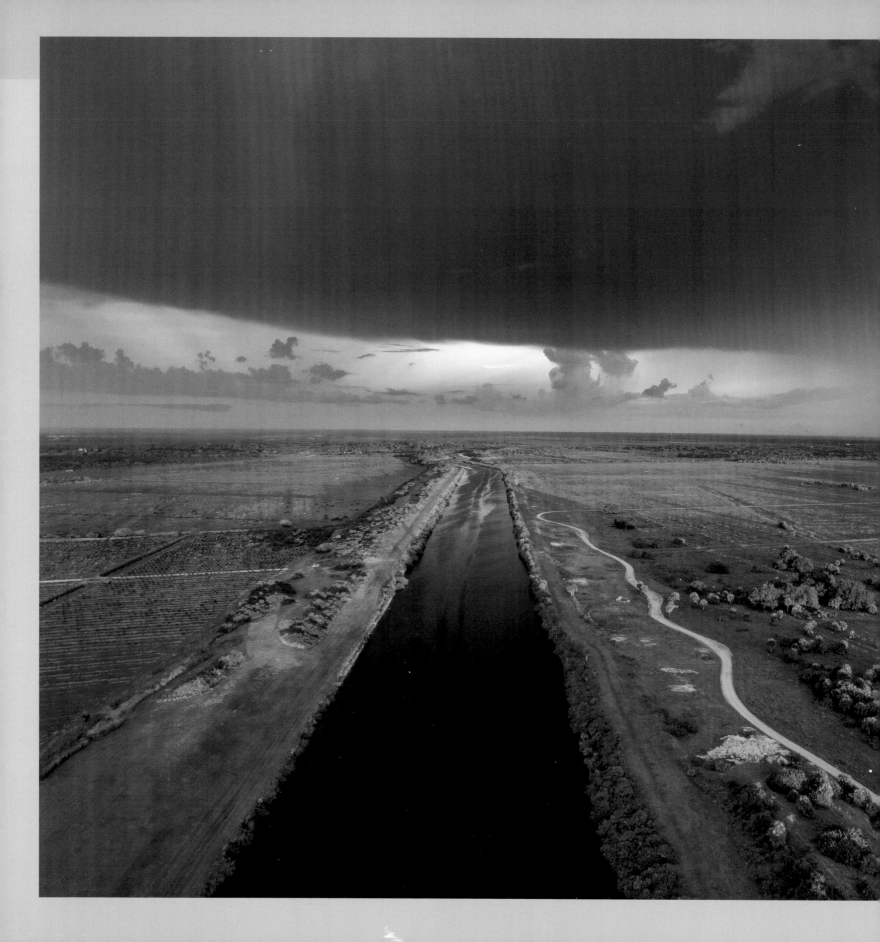

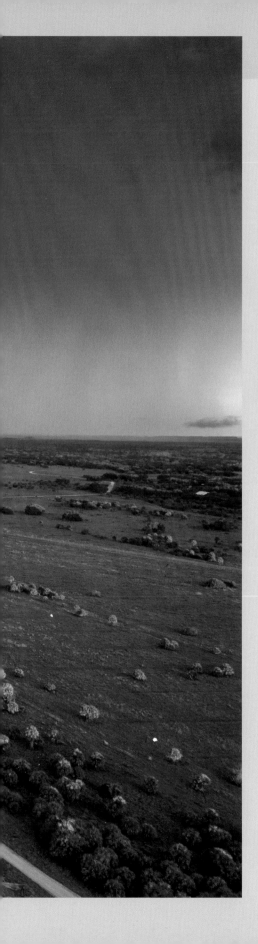

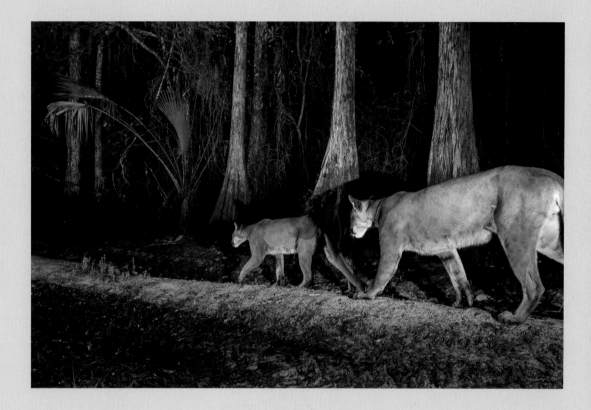

ABOVE: A male panther follows a female along a trail at Babcock Ranch State Preserve, raising expectations that a new generation of panthers may be born north of the Caloosahatchee River for the first time in nearly five decades. **LEFT:** The Caloosahatchee River is now a dredged canal that cuts from Lake Okeechobee west to Charlotte Harbor on the Gulf Coast near Fort Myers. Female panthers have recently been documented on the north side (at left in image) for the first time since 1973.

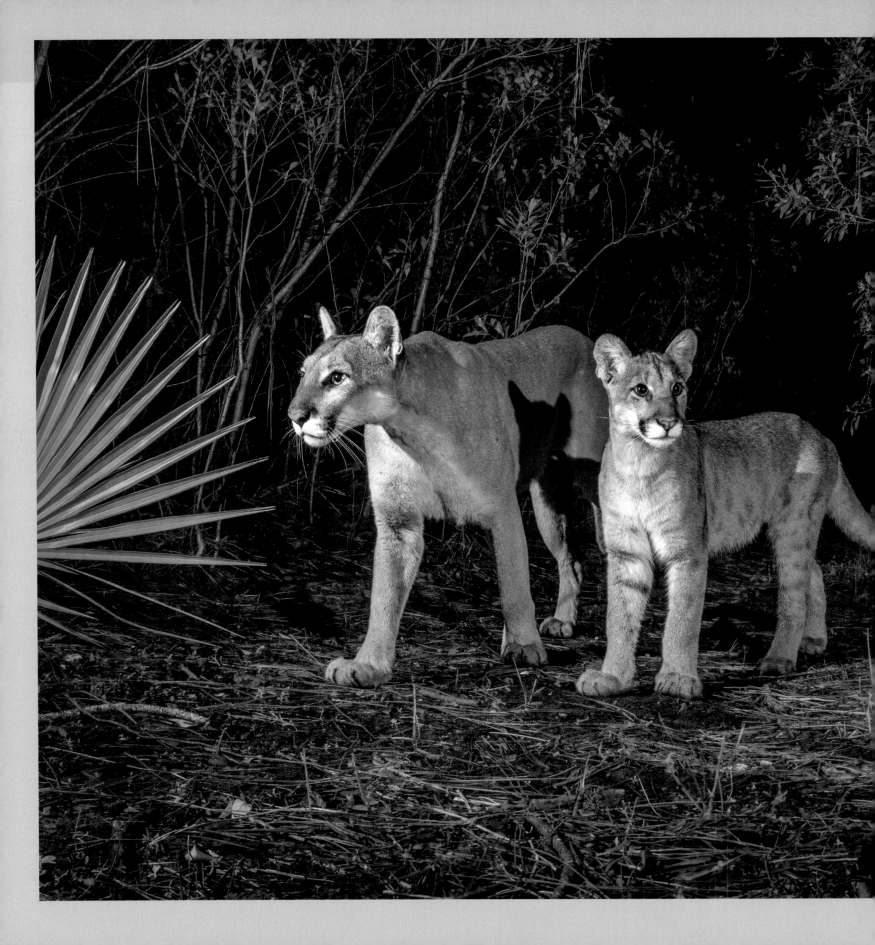

In February 2018, a Path of the Panther camera trap captured this photo at Babcock Ranch State Preserve, showing the first female, now a mother, standing next to one of her kittens, the hope of a new generation of panthers to be born north of the Caloosahatchee River for the first time in nearly 50 years.

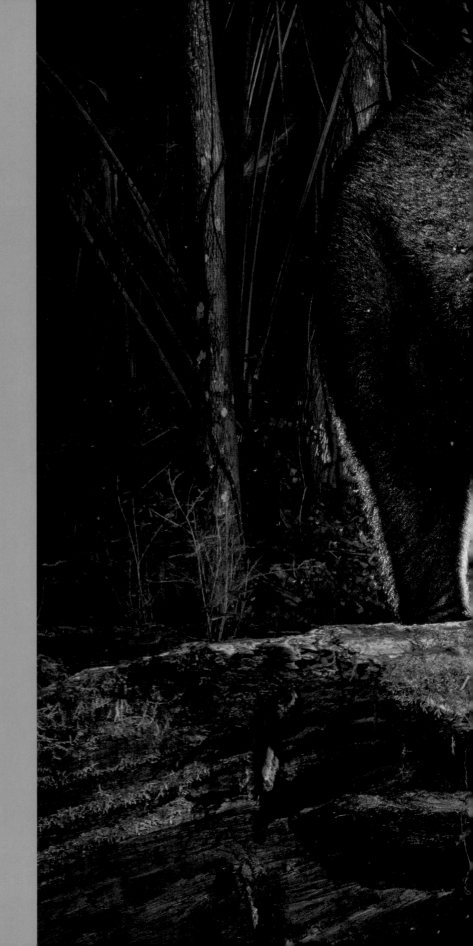

2

FLORIDA'S WILD HEART

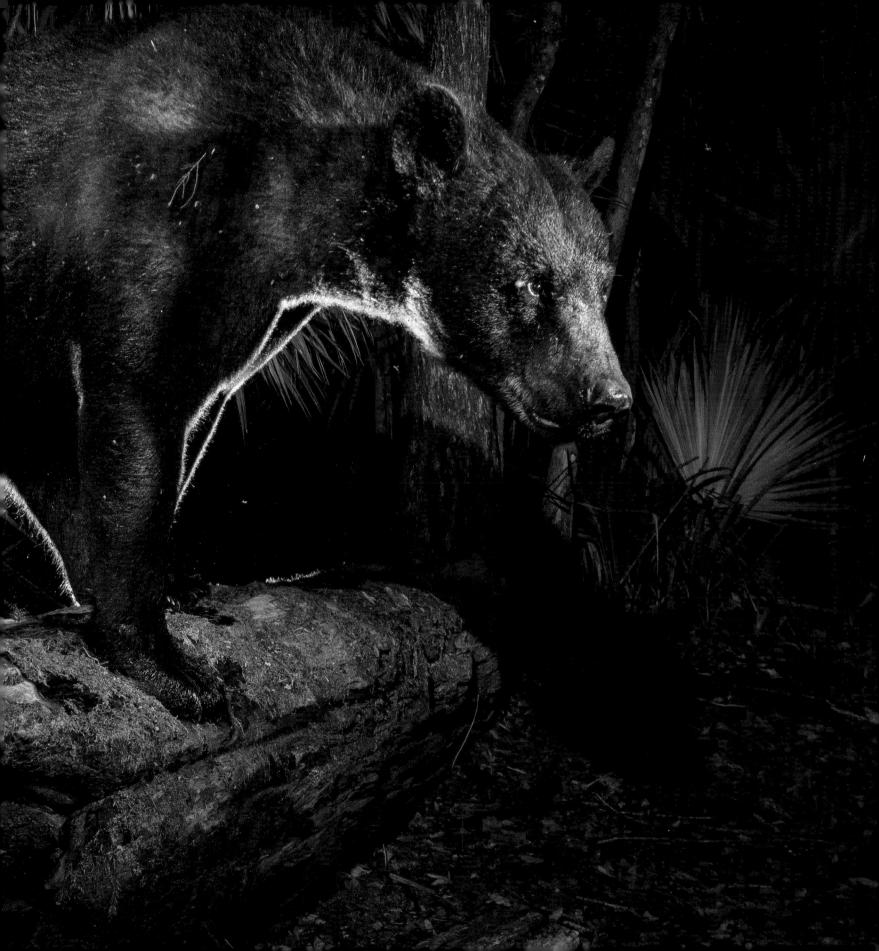

WHENEVER I HIKE in the woods in Florida, or wade through a swamp, or even steer my car down a pot-holed wilderness road, I dream of again seeing a Florida panther. More panthers are around than on my lucky day decades ago, but drink champagne if you spot one now.

About 150 are left in the world. Most remain in South Florida, but thanks to science, wildlife corridors, and determined panthers, their population is slowly spreading north. Back when I saw my panther, only a handful existed, brought to extinction's edge by modernity and persecution as a varmint or trophy.

I was young and immortal when I encountered my panther. Now my hair is white. I've had a stroke. I'm tentative about what I can physically do. An old man still dreams. Perhaps I will see another panther before it's time to leave the stage.

I grew up in Miami when only rich people had air-conditioning and color TVs. Poor or not, I was lucky to have the right parents, mentors, and Huck Finn–ish pals to lead me toward untamed Florida. My dad liked to fish. He liked to camp. When we snorkeled at Miami Beach, I'd hang onto his trunks as he breaststroked through massive schools of mullet.

My best friend was Domingo, a year older and wiser. We pedaled our rusty bikes down the block to the Biscayne Canal, leaned boldly over the bridge railing, and watched for the sweet potato–shaped manatees Domingo called sea cows.

The elderly neighbor who lived behind my house, Old Walter, taught me to identify mockingbirds, cardinals, and blue jays while I was still a chick. On Ever-

glades trips, he showed me how to bait a hook with a wriggling worm and catch a pan-size bream on a cane pole. He forbade me to kill snakes. About panthers, Old Walter said he had never seen one, but he knew a man who had. So don't give up. Keep looking.

There were a lot of kids like me. Wild Florida was our playground.

After college, I covered pro football for a newspaper. My friends thought I was batty when I traded that plum job to write about the outdoors. The thing is, I wanted to immerse myself in wild Florida. I had known so many gutsy old-timers growing up. I knew they had stories worth writing about.

They survived bites from rattlesnakes. They had heard lovelorn male alligators bellowing during mating season. They waded into swamps to see the rarest of Florida plants, the breathtaking ghost orchids.

One old-timer told me about the time he heard a panther scream at midnight in the Big Cypress section of the Everglades. I wasn't sure whether to believe him, since he also claimed he once had seen the enormous footprint made by a skunk ape, Florida's mythical version of Bigfoot. Tall tales were part of wild Florida, too.

ON A COLD WINTER morning in 1993, I rode with scientists in a four-wheel-drive pickup until even the gravel road vanished. Then we switched to a swamp buggy, something like a roofless tank that crept through the mud and wet until the water was waist-high. Now we waded, all the while watching for cottonmouth snakes.

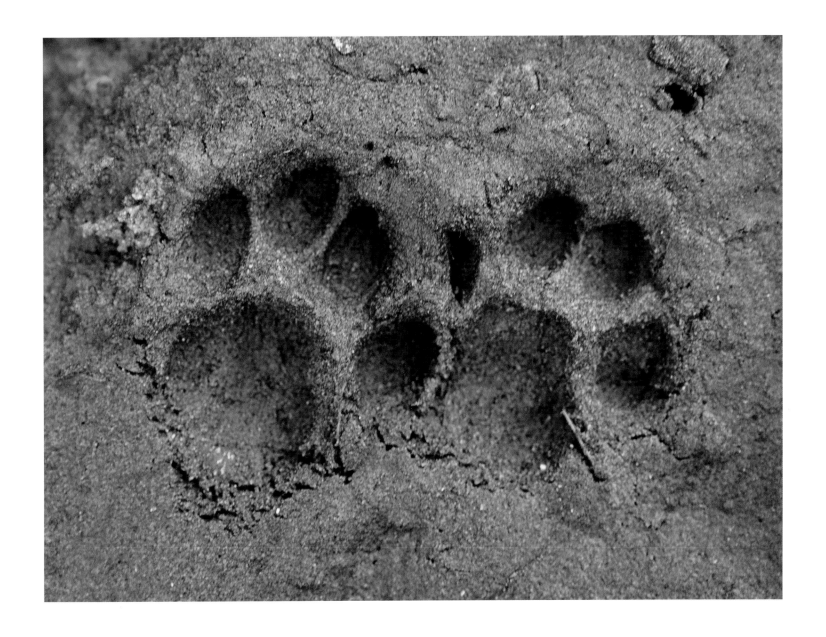

ABOVE: Panther tracks are easy to recognize when imprinted in sand or mud. The prints are as large as you might expect from a 100-pound (45 kg) dog. But because panther claws are retractable, their tracks lack the distinctive nail marks characteristic of those belonging to bears and dogs. **PREVIOUS PAGES:** A large male Florida black bear crosses a swamp in the dry season at Florida Panther National Wildlife Refuge. Remnant bear populations still exist in forests throughout Florida, from Naples to Pensacola. Like panthers, bears need a lot of room to roam and more land conservation so that distant populations can reconnect.

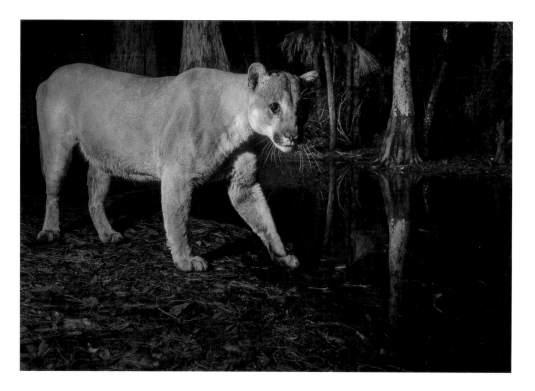

A male panther triggers a camera trap along a flooded trail at Babcock Ranch State Preserve east of Fort Myers.

We were trying to catch a wild panther on wild land known ominously—and thrillingly—as the Devil's Garden.

I had been invited on the expedition by Florida's foremost panther expert, an athletic and decisive scientist named Dave Maehr. His team included two veterinarians, other wildlife scientists, and a few starry-eyed volunteers like me.

Ahead we heard dogs baying on the trail of a Florida panther. They were guided by Roy McBride, who over the decades had toiled for wildlife researchers all over the world. He was a taciturn Texan who looked

WHEN THE PANTHER FELL INTO THE CRASH BAG, IT WAS SUPPOSED TO BE ASLEEP. INSTEAD, IT SPRUNG TO LIFE. **IT HISSED. IT GROWLED. IT THRASHED.** IT LEAPED OFF THE CRASH BAG AND FLED FOR THE NEAREST CLUMP OF PALMETTOS.

completely at home in a Florida swamp. Years before, he had captured a snow leopard in Mongolia.

"I think we have him." McBride's drawl crackled over the radio. "Come on in." We did as told.

A year before, the crew had caught the same panther on a Seminole Indian Reservation in the Big Cypress. A young male, it weighed 65 pounds (29.5 kg). Around its neck, Maehr had attached a collar that transmitted a signal to scientists who studied how panthers moved through the wilderness. Now Maehr planned to recatch the panther and install fresh batteries in the collar.

We climbed out of the water onto an island of oaks and pines, palmettos and tall grass. McBride's hounds barked below the tallest oak. At the very top, gazing down, looking more curious than alarmed, was the panther.

We had brought a crash bag along. It was something like what firefighters might place below a burning building to catch someone who needed to escape. McBride, using a special gun, fired a tranquilizer dart into the panther. Below, we gripped the crash bag and got ready.

When the panther fell into the crash bag, it was supposed to be asleep. Instead, it sprung to life. It hissed. It growled. It thrashed. It leaped off the crash bag and fled for the nearest clump of palmettos. Maehr grabbed the undermedicated panther by the tail and was dragged on his belly. Now the panther bounded in my direction. My chance to be a hero slipped away as I retreated, holding my journalist's notebook in front of me like a shield.

I was saved from harm by the brave veterinarian who slid on his knees to the panther's backside and administered a second tranquilizer. This time the panther went down, asleep at last. I was too excited to join the cheers.

McBride and the vets had underestimated the panther's weight. Living among deer and feral hogs in the Florida wilderness, the cat had doubled its weight—now 130 pounds (59 kg) according to our scale.

Everyone seemed to have a job but me. Maehr changed the battery on the radio collar. The veterinarians took fur samples to test for mercury in the food chain. They took fecal samples to look for worms. They vaccinated it for feline leukemia.

I made a mental photograph of what I thought would be a once-in-a-lifetime scene. The slumbering panther was tawny brown and muscular. His legs were thick and powerful. His chest rose and fell with every slow breath. His paws were gigantic.

I knelt. I plunged my face into its heavy fur and breathed the panther odor deep into my lungs. He smelled utterly wild, a giant tomcat magnified by 10.

I found it pleasant. Lying on the ground before me was a Florida boy's holy grail. ●

JEFF KLINKENBERG worked for more than 30 years as a newspaper reporter covering Florida culture, and he's written several books on Florida, including the memoir *Son of Real Florida*. In 2018, he won the Florida Humanities Council's Florida Lifetime Achievement Award for Writing, joining previous recipients, including novelists Carl Hiaasen and Patrick Smith.

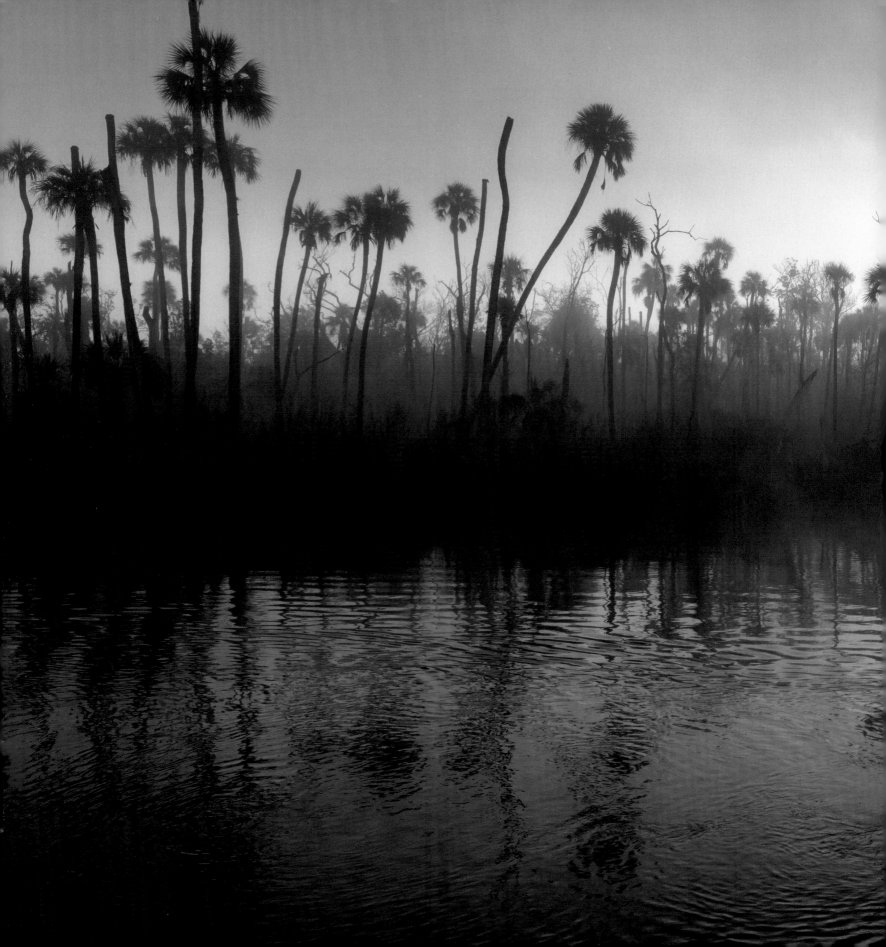

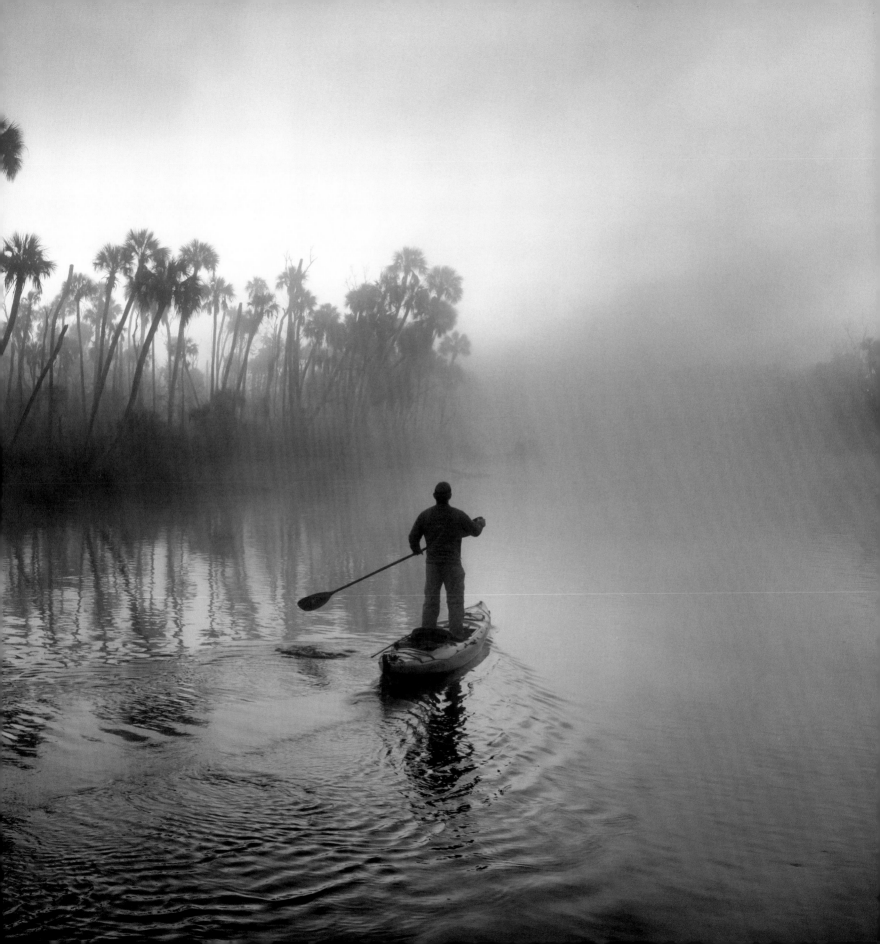

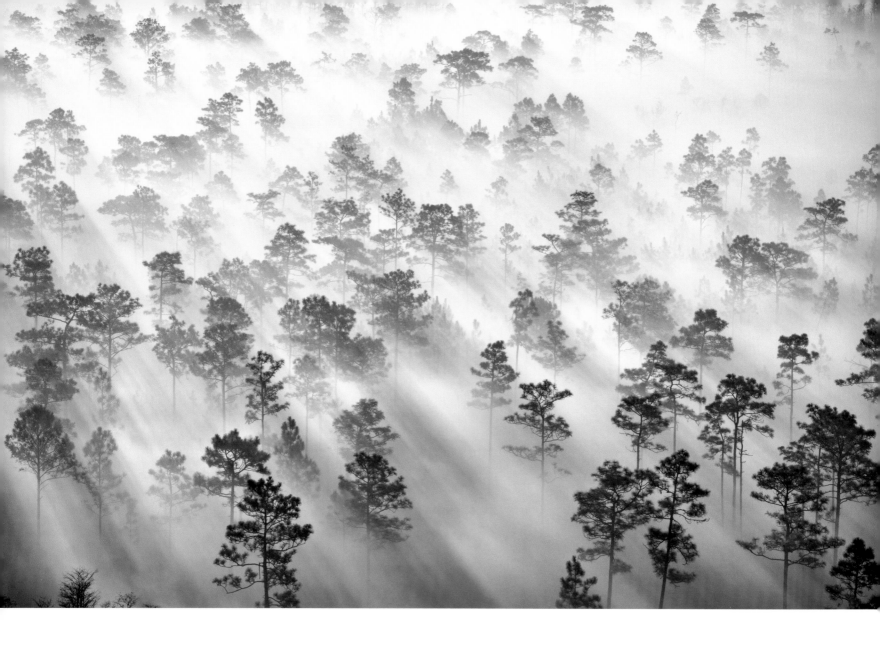

ABOVE: Early morning sun lights a blanket of fog among restored longleaf pines at the Nature Conservancy's Disney Wilderness Preserve in the Everglades Headwaters near Orlando. **OPPOSITE:** Longleaf pines stand over an understory of wire grass and palmettos in Ocala National Forest. Longleaf habitat once covered 90 million acres (36.4 million ha) of the southeastern United States, but logging reduced its original range by 97 percent. Longleaf pine restoration projects throughout Florida and the Southeast are bringing back biodiversity while also building habitat where the panther could soon return. **PREVIOUS PAGES:** From the palm-lined Chassahowitzka National Wildlife Refuge north of Tampa (pictured) around the Gulf Coast past Tallahassee, vast areas are protected in places once home to panthers. With the establishment of the Florida Wildlife Corridor, panthers could have a path to return to the Nature Coast again, hunting beneath coastal palms.

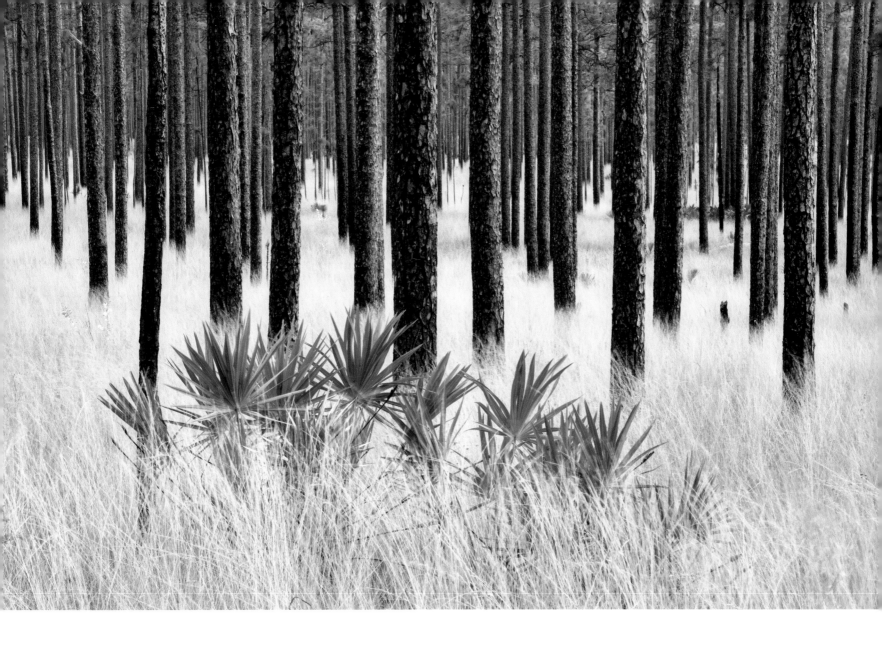

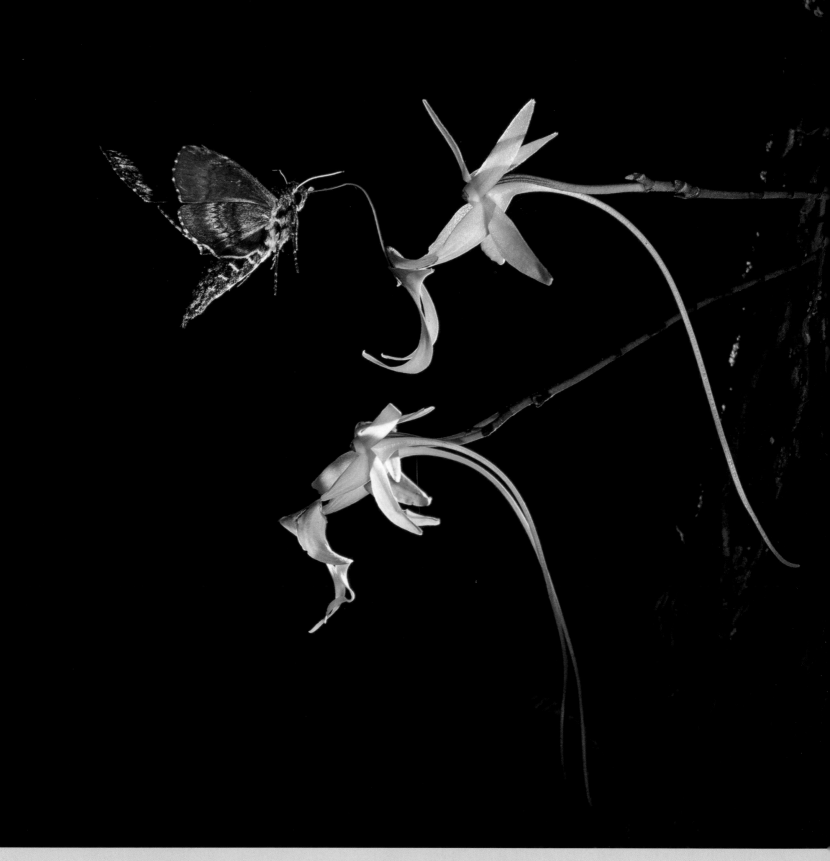

GHOSTS OF THE EVERGLADES

DOUGLAS MAIN

THE GHOST ORCHID is an unusual and unusually beautiful flower found only in Cuba and the flooded forests of South Florida, where about 2,000 remain. A leafless green plant that clings to its host tree like bits of linguine, the ghost orchid is mostly unremarkable.

But when it blooms, it stuns. The flower is a bright white, standing out against the shaded green swamps it calls home. An umbrella species, *Dendrophylax lindenii* survives only in intact forests with high levels of humidity, which protect it from winter freezes, drought, and wildfire.

Only one in 10 ghost orchids produce a flower each year. These rare orchids were long thought to be pollinated by a single insect: the giant sphinx moth. But camera trap photographs by Carlton Ward Jr. and fellow National Geographic Explorer Mac Stone have upended what scientists thought they knew about this iconic flower, and how it reproduces.

On a summer day in 2019 at Florida Panther National Wildlife Refuge—home to a quarter of the state's ghosts—I spent many hours searching for one in bloom with Ward and refuge biologist Mark Danaher. We hiked through knee-deep water the color of sweet tea from early morning until afternoon, marveling at

This photo of a pawpaw sphinx moth is the first ever showing it probing and likely pollinating a ghost orchid bloom (ghost orchid pollen on its head). It was previously thought only one species, the giant sphinx moth, pollinated these flowers.

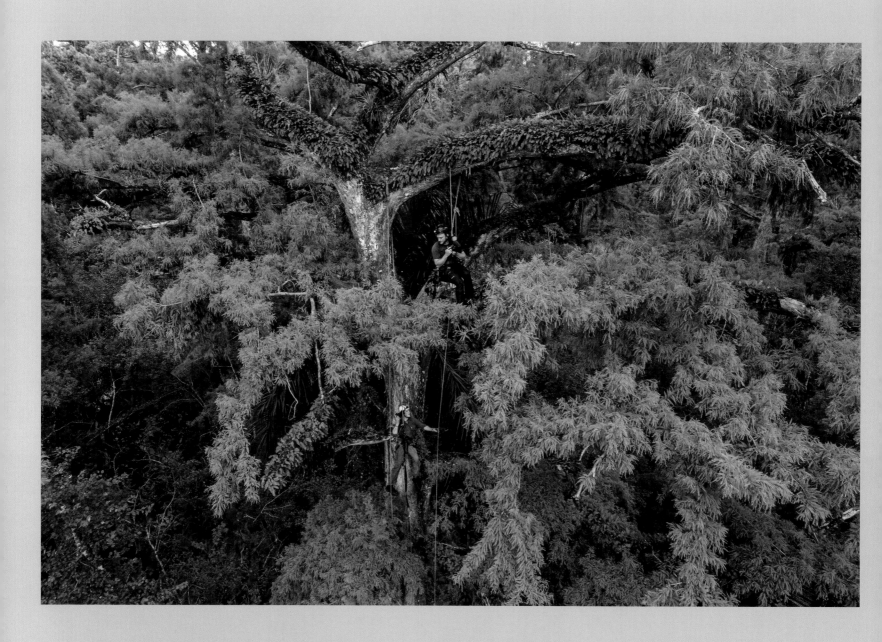

Photographer Mac Stone and ecologist Peter Houlihan (top) search for orchids in the canopy of remnant old-growth cypress trees in Audubon's Corkscrew Swamp Sanctuary. Through a camera trap positioned at similar height in a nearby tree, they developed a new theory that the giant sphinx moth, once thought to be the sole pollinator of the ghost orchid, may actually be a nectar robber without pollinating the flower.

the diversity of air plants and orchids. When we finally found a ghost, it was really magic.

The delicate flower seems to hover in air, its modified petals with two long, delicate tails that flutter in the breeze. In the center of the flower is the entrance to a tube called a nectar spur, which contains sweet secretions. Ideally, the nectar will attract a moth, which will elongate its tonguelike proboscis and stick its head into the tube. If all goes well, the moth will contact the plant's bundle of pollen, called a pollinium, which will stick to its head and be carried on to fertilize another ghost.

These orchids have long nectar spurs, stretching five inches (13 cm) or more in length, though this varies. Given the size of the tube, it has long been thought that only the giant sphinx moths would be capable of reaching the nectar.

But when Ward set up several remote camera traps in this wildlife refuge, he documented five species of moths visiting these ghost orchids. Two of these species, fig sphinx *(Pachylia ficus)* and pawpaw sphinx moths *(Dolba hyloeus),* had ghost orchid pollinia on their heads.

Stone and ecologist Peter Houlihan worked out of Corkscrew Swamp Sanctuary, one of the world's largest old-growth cypress forests. The sanctuary, owned and operated by the National Audubon Society, has set up a scope for visitors to see a massive ghost orchid, known as the "super ghost." This flower sits 50 feet (15 m) up on a cypress, and it is the only ghost that is relatively easy to see. In mid-July, the orchid had eight flowers, "which is just insane,"

Stone says—most plants put out only one flower at a time.

The two photographers had their cameras trained on the flowers for a total of 7,000 hours, but the work paid off. Stone captured photos of a fig sphinx visiting the flower with ghost orchid pollinia on its head, complementing Ward's pictures of the same in the panther refuge. Both photographers also captured giant sphinxes visiting the ghosts—but the insects weren't carrying any pollinia. In one shot by Stone, the moth can clearly be seen drinking nectar, but its head is not nearly close enough to the flower to pick up the pollinium.

This led to a wild hypothesis: Perhaps the giant sphinxes steal nectar from the ghost orchids without pollinating them, Houlihan says. His research also turned up a dozen local hawk moth species (including the two species Ward photographed pollinating orchids) with tongues long enough to theoretically sup the orchids' sugar. "There are probably lots of moths that can pollinate these flowers," he says.

In the Fakahatchee and Big Cypress National Preserve, where most ghost orchids remain, the flowers are primarily found in pop ash trees, followed by pond apples. These trees are much shorter than cypresses, and many of the ghost orchids there are only a few feet off the ground. "The ghost orchid motivated me to explore these swamps," Ward says. "And I hope its story can inspire others to protect the places where it lives." ●

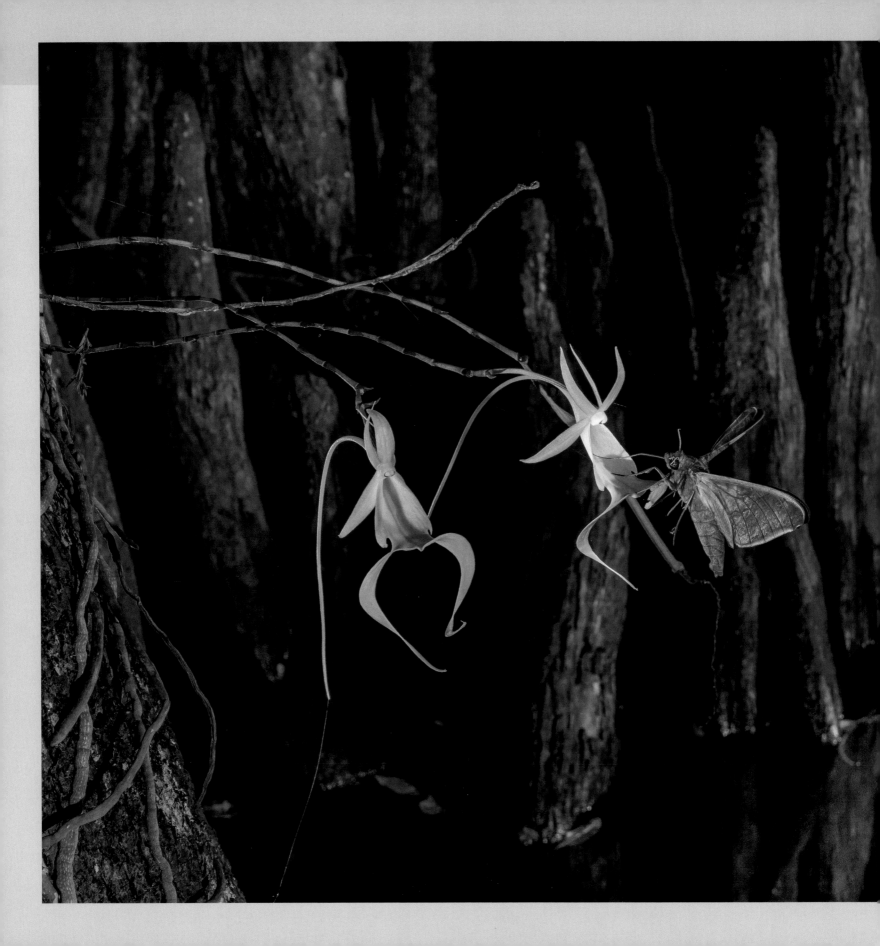

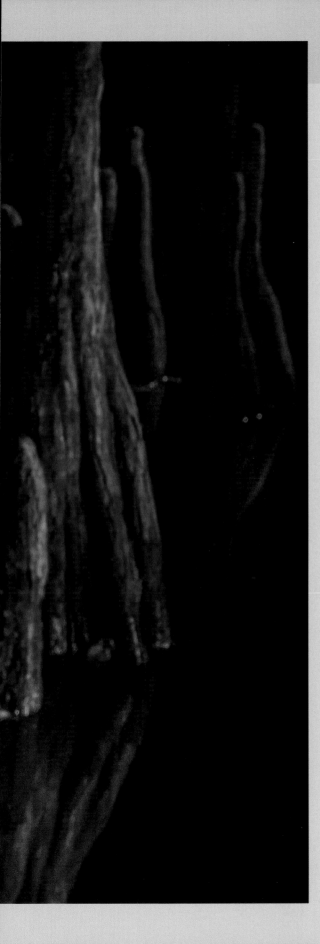

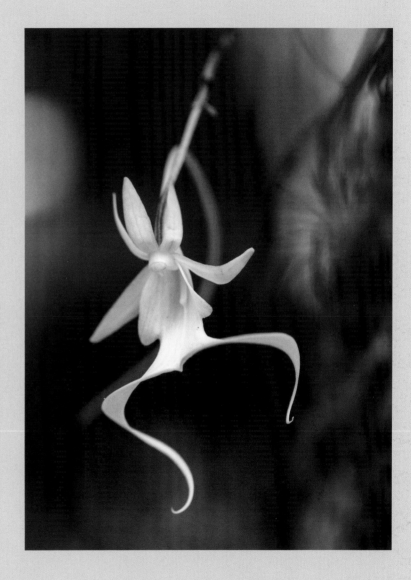

ABOVE: Ghost orchids live in cypress, pond apple, and pop ash swamps in South Florida, where an estimated 2,000 plants remain. During the summer months, one in 10 orchids will produce an ephemeral flower, of which one in 10 will successfully attract a pollinator. **LEFT:** This photo in the Fakahatchee Strand within Florida Panther National Wildlife Refuge is the first ever record of a streaked sphinx moth probing and potentially pollinating a ghost orchid flower. Pollination happens fast; the moth was in contact with the flower for less than a second.

A bobcat triggers a camera trap in sandy scrub habitat at Archbold Biological Station in the Everglades Headwaters, the region that is the current frontier in the northward expansion of the panther range. As much smaller cousins of the panther not needing as much land, bobcats are distributed more widely throughout Florida. With the land protection offered in the Florida Wildlife Corridor, panthers and bobcats may share territory statewide once again.

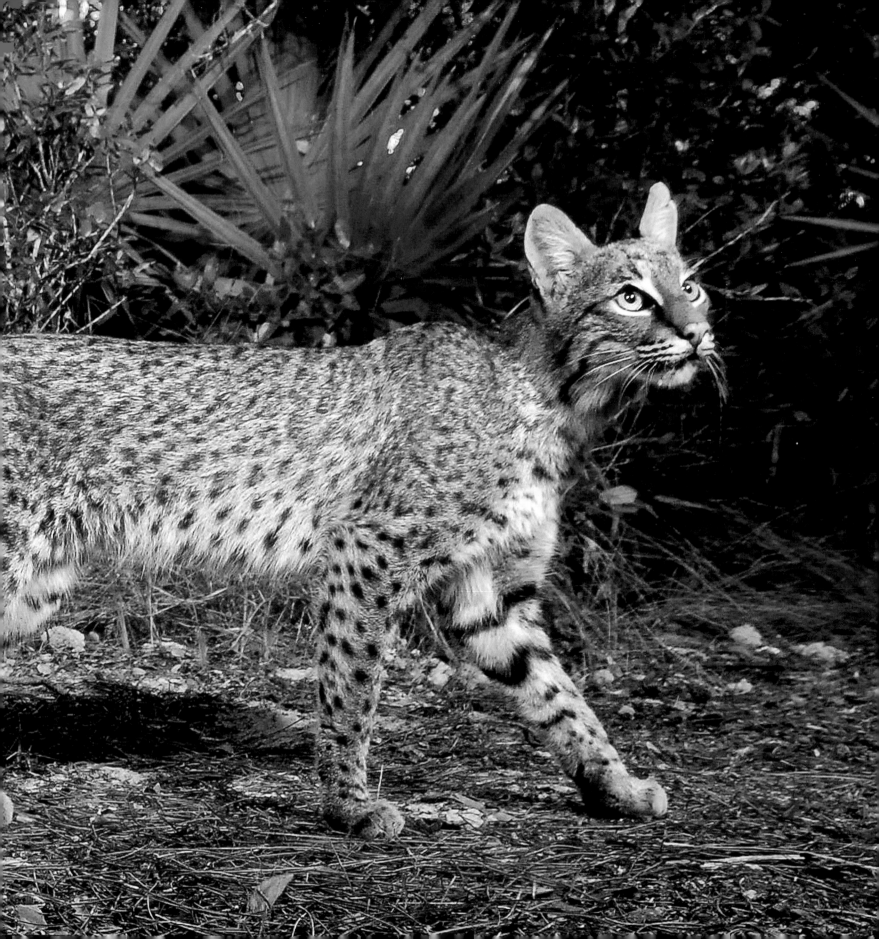

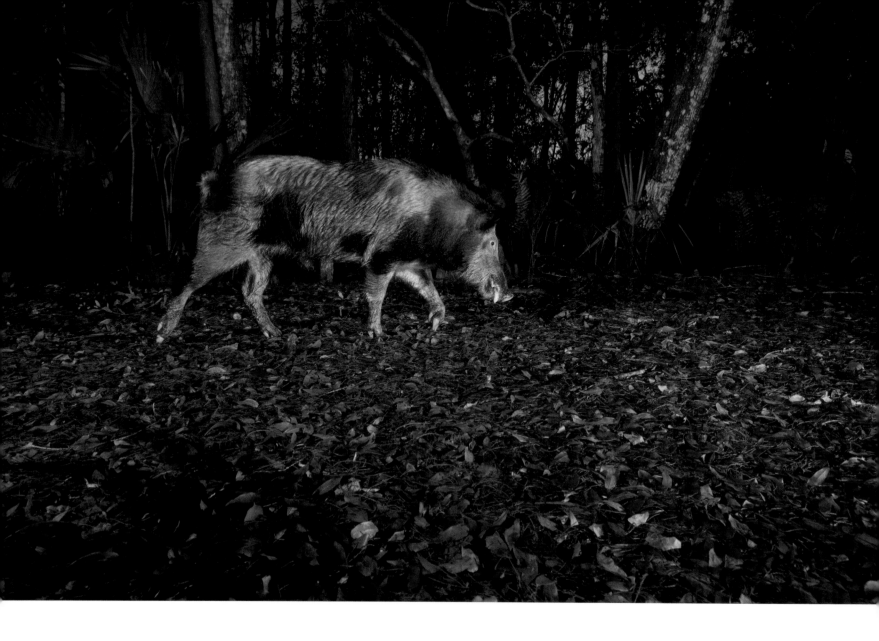

ABOVE: The wild hog is an invasive species introduced to America by the Spanish during their Florida expeditions starting in the 1500s. Hogs are destructive to native landscapes and ranchlands. They have also become a helpful food source for panthers, with evidence that far fewer hogs are in areas where panthers are present. **OPPOSITE:** The coyote is also considered an invasive species, though it migrated to Florida on its own from the western United States, aided in its eastern expansion by the clearing of forests to more open farmlands and by the regional extinction of its historic competitors, the wolf and puma. Because panthers eat both coyotes and hogs, one advantage to the panther population recovering statewide would be their role in keeping invasive species numbers in check.

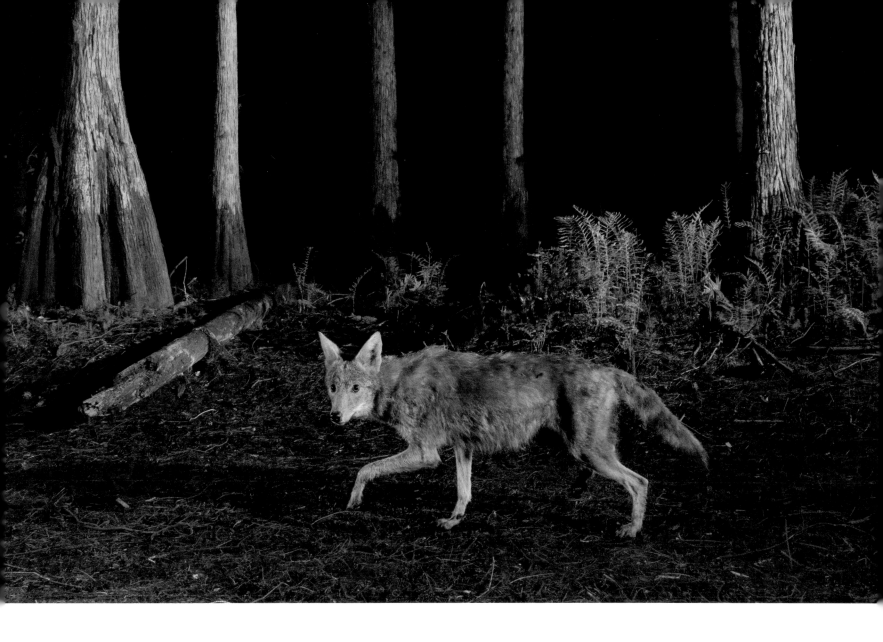

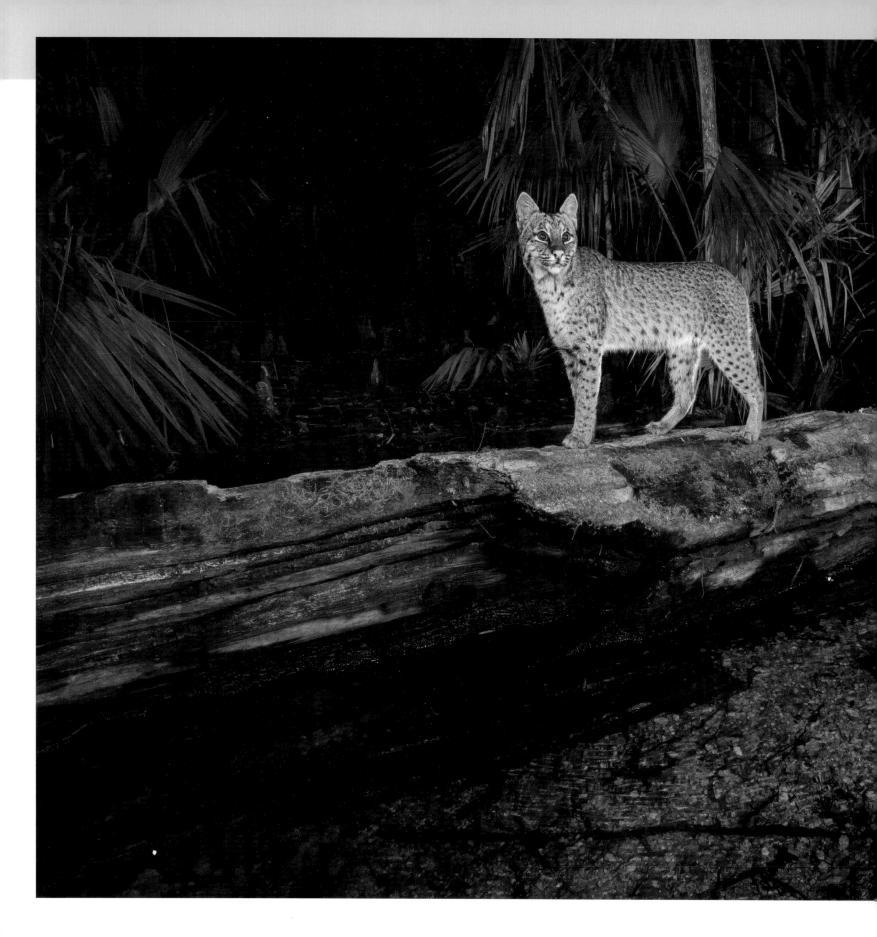

NO. 018 | PANTHER REFUGE

When Carlton Ward Jr. found this location at Florida Panther National Wildlife Refuge, where an old logging trail was washed out by a creek in the swamp, he could see the possibilities. The goal was to show panthers and other wildlife navigating the water, which transforms their habitat for at least half of the year. A panther came through nearly once a month, but only once or twice a year during daylight and while facing the direction of the camera. It was challenging to get cameras, electronic triggers, and flashes to all work together in the instant an animal broke the beam. Then Hurricane Irma made landfall a few miles away as a Category 4 storm, knocked down trees and branches, and drowned the cameras. But looking back over multiple years of photographs, the effort was worth it, including producing the photo on the cover of this book.

A bobcat pauses on a log while crossing the swamp. In the dry season, typically from January through June, animals can walk practically anywhere they want in the forest. In the wet season, when swamp waters rise, wildlife tend to travel on higher ground— when they can find it.

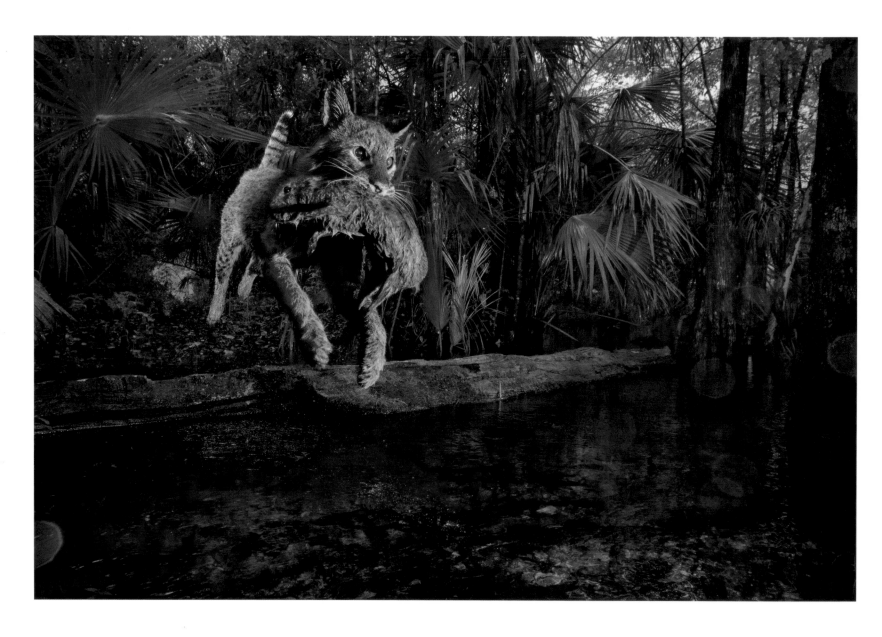

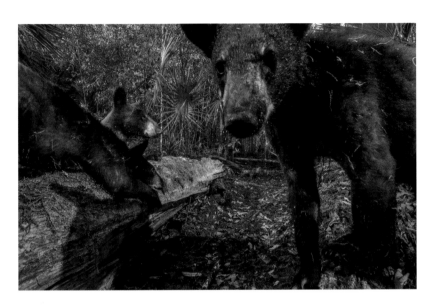

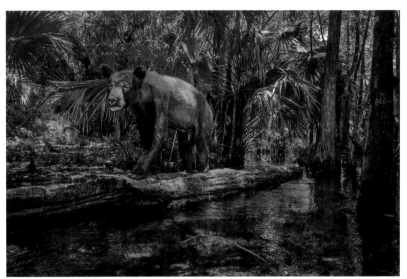

CLOCKWISE FROM OPPOSITE: In the height of wet season, a bobcat flies over a swamped log with its freshly caught dinner: a marsh rabbit; a family of black bears scratches on the log in the dry season; a mother bear walks the log in the wet season; a barred owl perches on the log in the middle of the night.

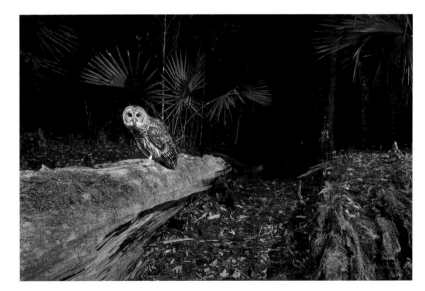

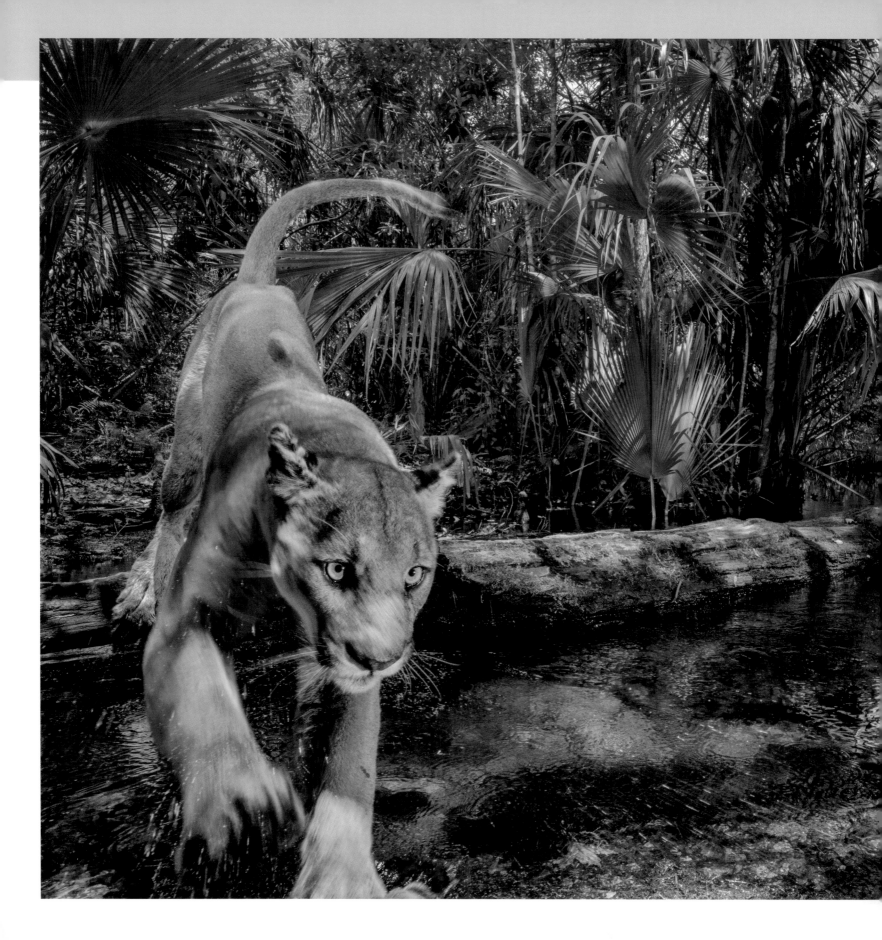

A male Florida panther leaps over swamp water as he patrols his territory in Florida Panther National Wildlife Refuge and adjacent state, federal, and private lands. The cowlick on his back is a vestige from recent history when the panther population was fewer than 20 and suffering from inbreeding. His strength and robust condition reflect the success of genetic rescue and other conservation measures designed to bring the species back from near extinction to a stable if still preliminary recovery.

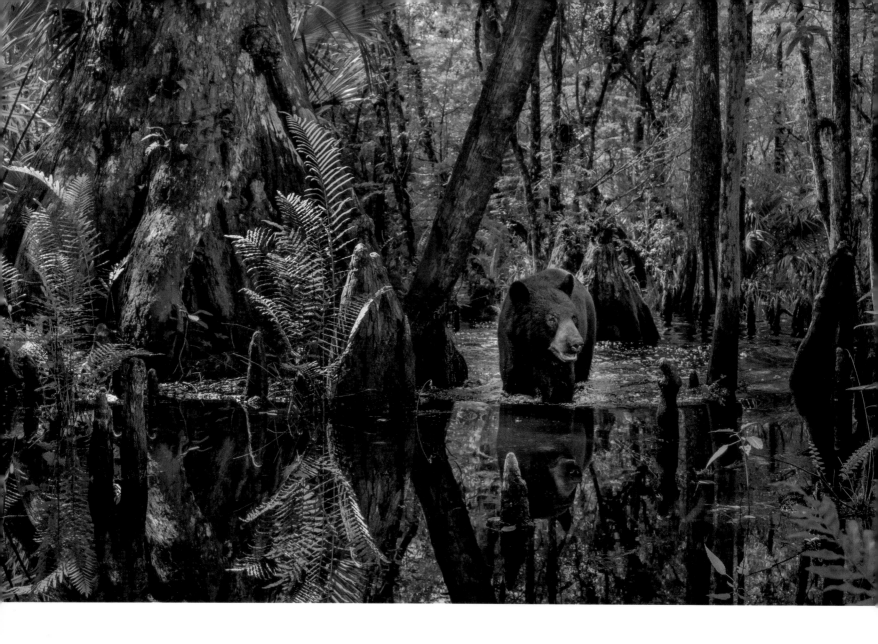

A camera trap on Green Glades West Ranch, adjacent to Big Cypress National Preserve, shows the transition from wet season to dry season at the base of a 500-year-old cypress tree. Like panthers, Florida black bears have vast home ranges and depend on a network of connected habitats to survive.

FOLLOWING PAGES: During the late spring and summer breeding seasons, Florida black bears actively scratch their backs on trees to mark their territories and to advertise their presence to other bears. A mature male bear scratches on a large pine tree at Green Glades West Ranch, while a much smaller bear joins the action on a nearby pine.

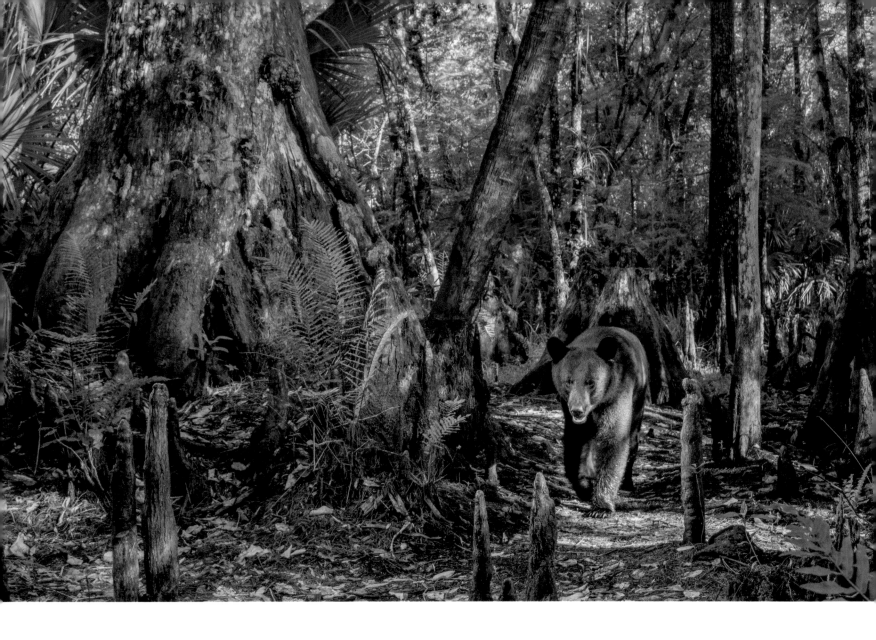

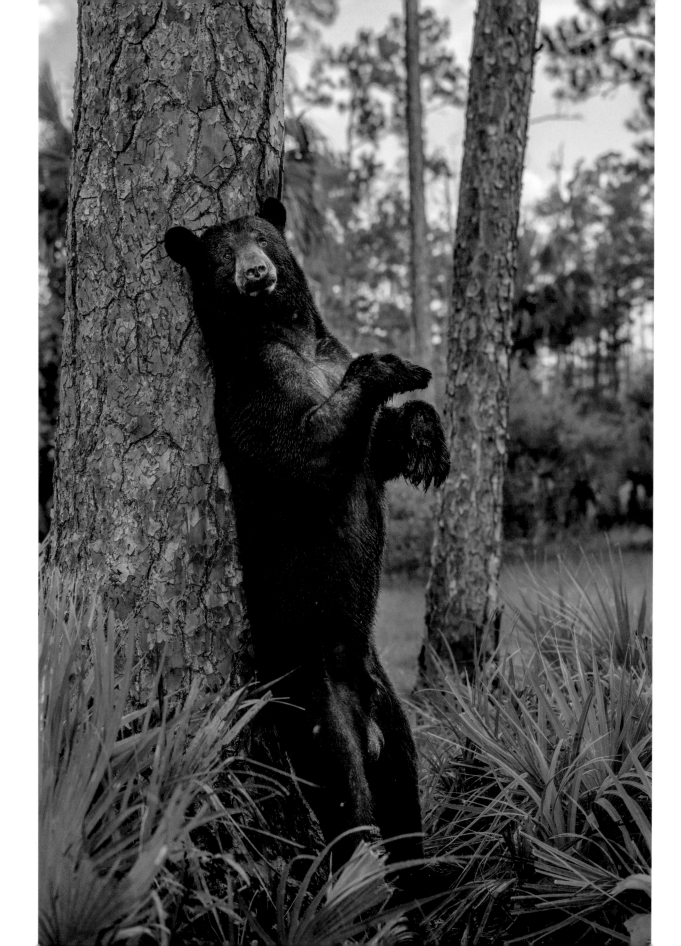

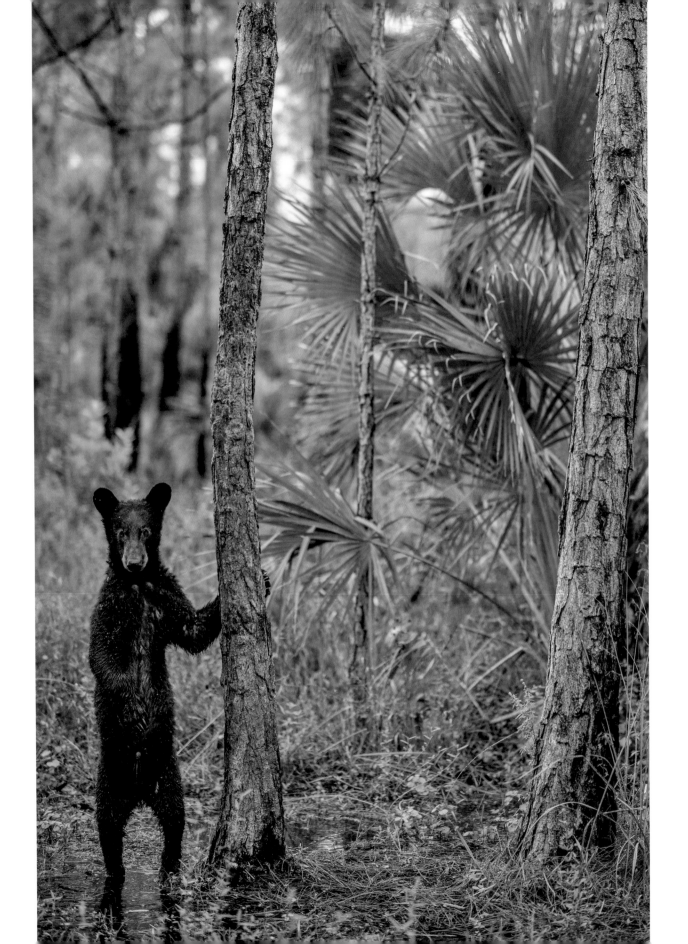

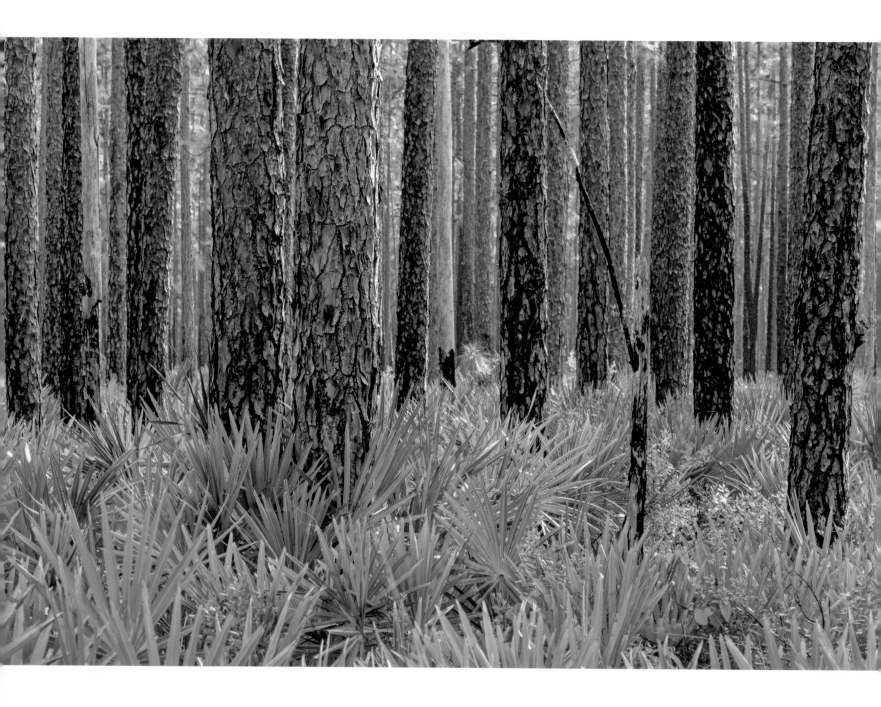

Longleaf pine forests and savannas provide important stepping-stone habitats throughout the Florida Wildlife Corridor. Conserving and restoring these native pinelands is one of the best ways to help keep the corridor connected. Pictured here is a longleaf pine restoration site at Camp Blanding Joint Training Center, a vital linkage helping connect Ocala National Forest with Osceola National Forest in North Florida and the Okefenokee Swamp in Georgia.

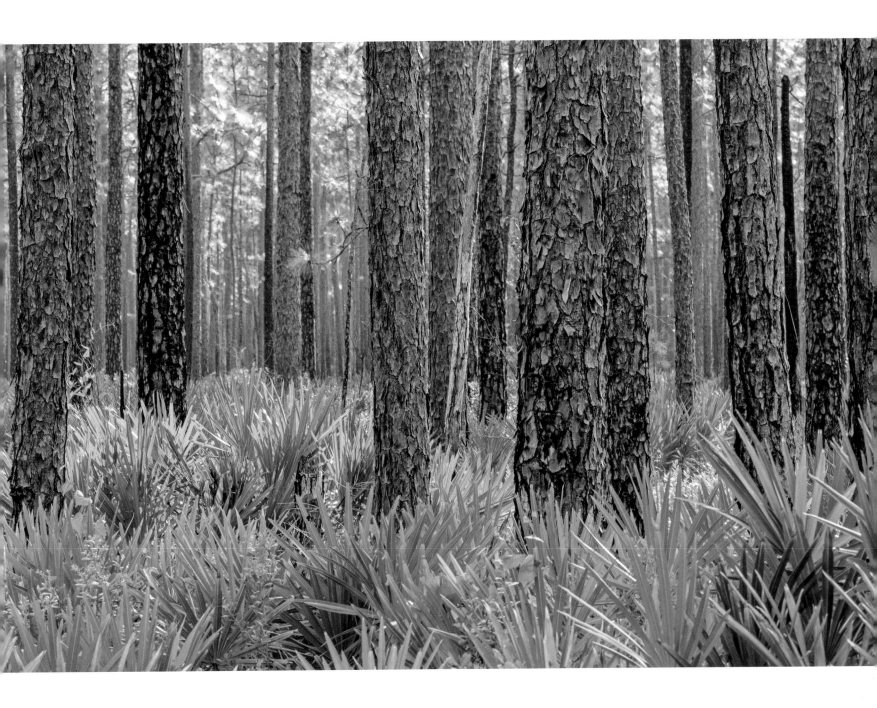

FOLLOWING PAGES: Among the biggest beneficiaries of pine forest conservation and restoration are Florida's waterways. The fabled Suwannee River flows unimpeded for 240 miles (390 km) from its headwaters in Georgia's Okefenokee Swamp to Lower Suwannee National Wildlife Refuge on Florida's northern Gulf Coast, where abundant clean water makes ideal conditions for a nationally significant clam and oyster fishery. If the pine forests upstream are lost to development, the entire region will suffer. The large, connected landscapes of this region are well suited for panthers—if the cats can make it back to this former territory along the Gulf.

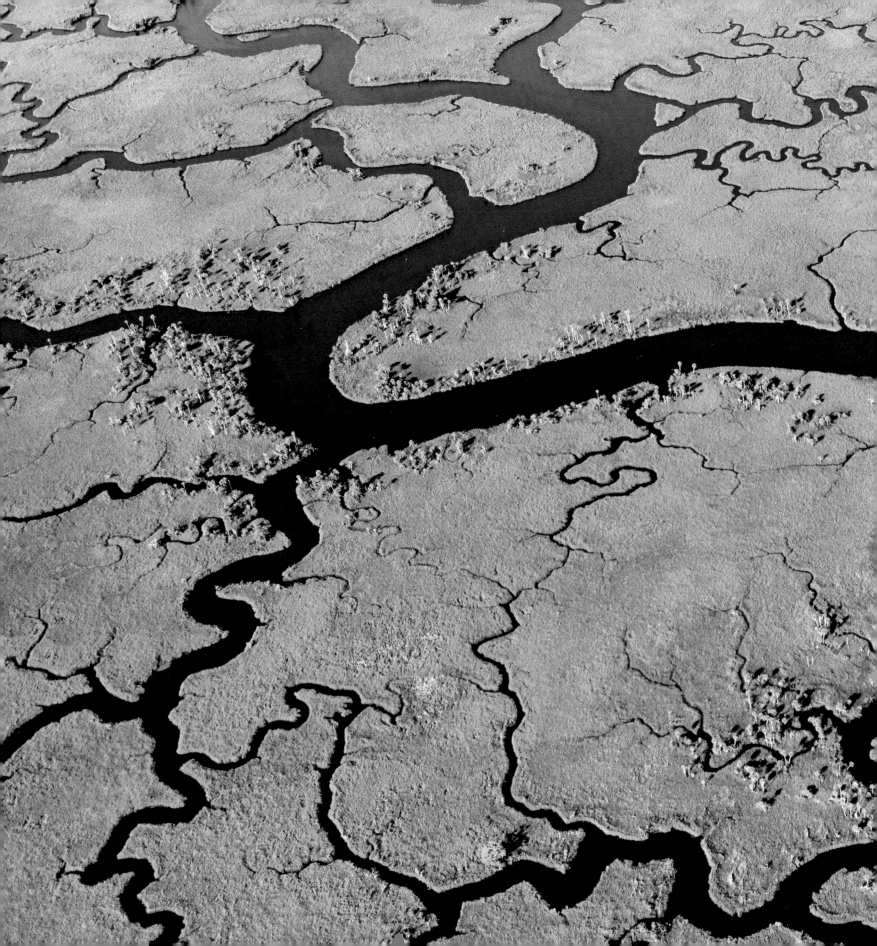

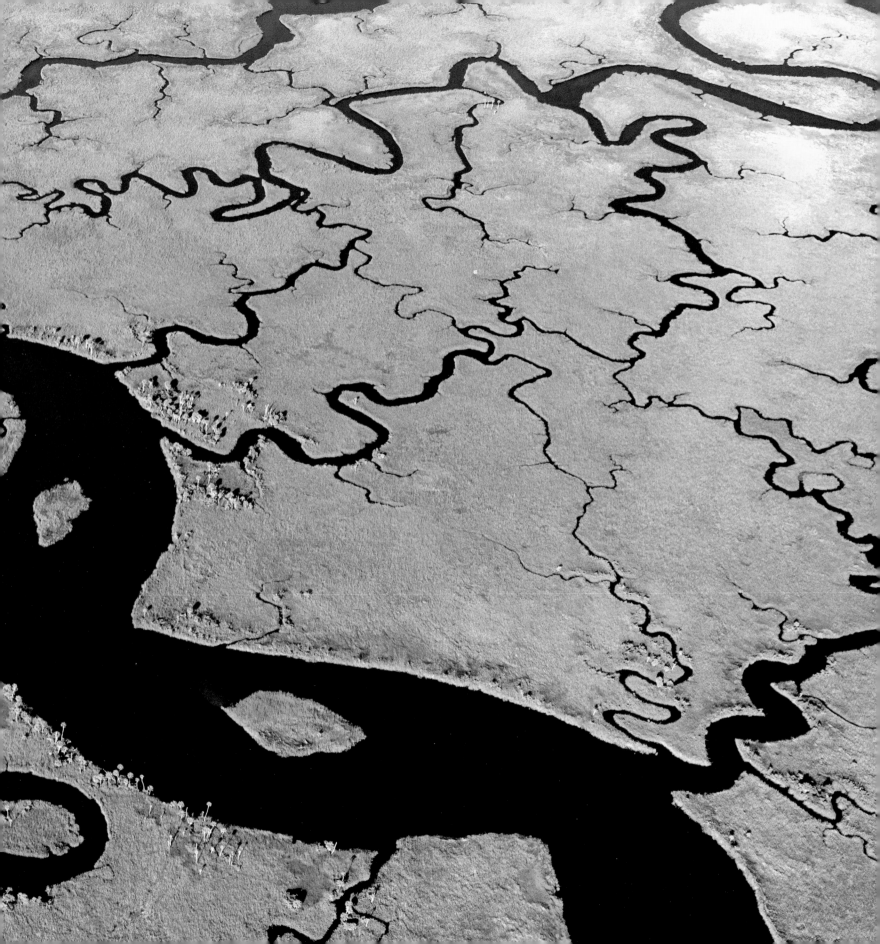

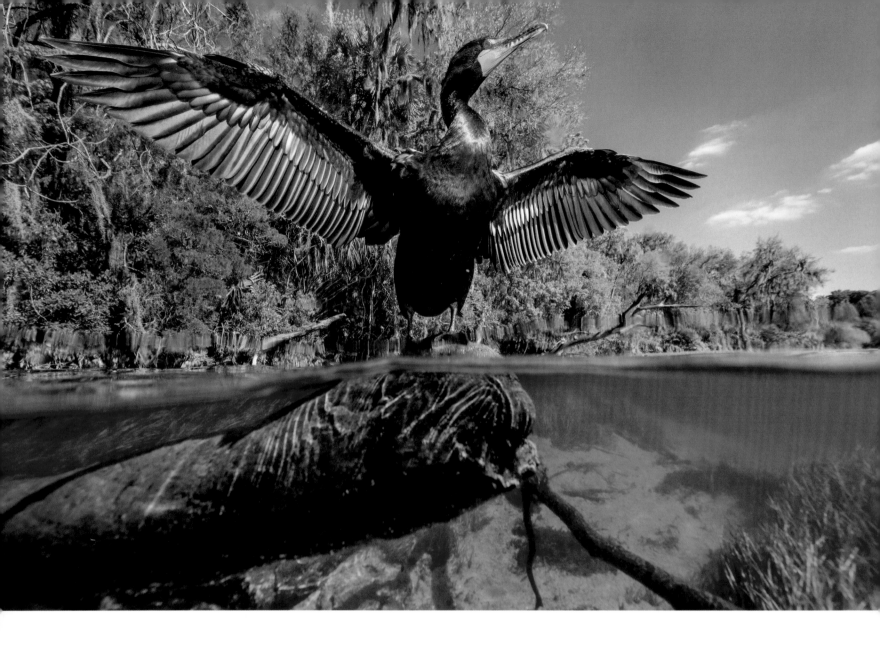

North Florida boasts the highest concentration of freshwater springs in the world. Many of Florida's springs are imperiled by overpumping groundwater from the subterranean aquifer and polluted runoff from development and intensive agriculture. Springs are one place where the connection between land conservation and water quality is clear.

ABOVE: The spring-fed Rainbow River, where a double-crested cormorant dries its wings from a submerged palm, flows relatively healthy and clear thanks to the headspring and long stretches of its banks being protected as a state park.
OPPOSITE: Because the flows are at nearly 72°F (22°C) year-round, Florida's springs provide important winter refuges for manatees, such as this mother and calf in Crystal River National Wildlife Refuge, who seek relief from the much colder Gulf.

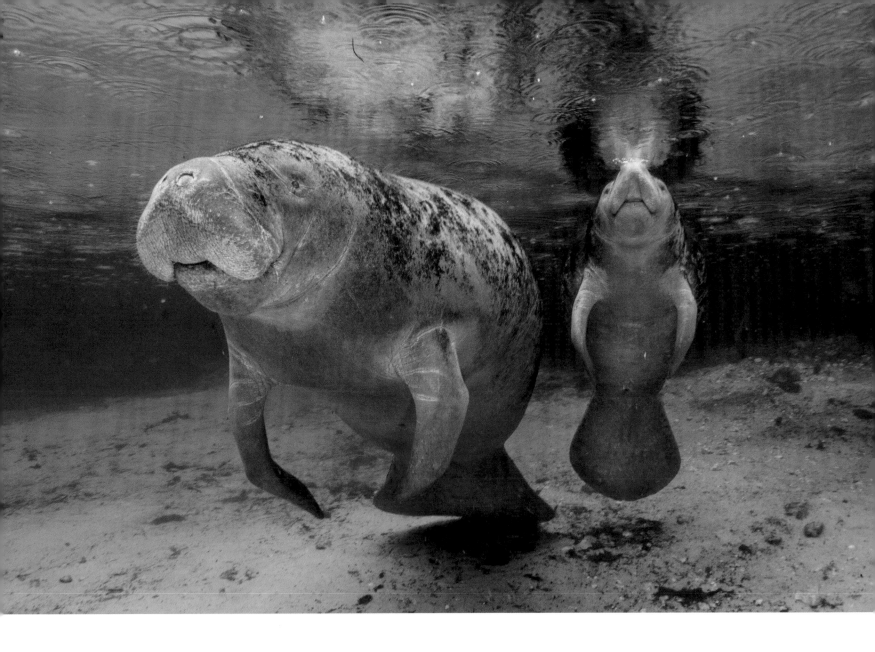

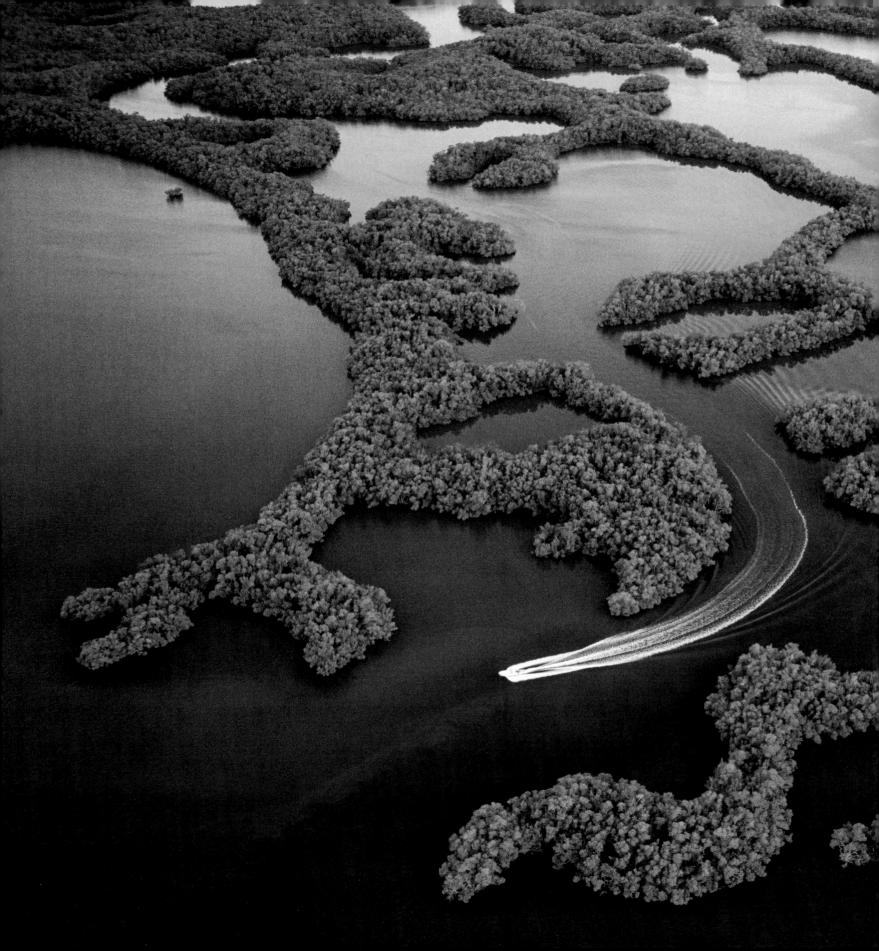

A boat navigates mangrove islands at the southern tip
of Florida in Everglades National Park, a beneficiary of
protecting the Florida Wildlife Corridor upstream.
Much of the Everglades watershed, from Orlando
south, is in the corridor, and protecting and restoring
the land is one of the best ways to ensure the
abundance and quality of water the Everglades needs.

An American alligator glides through a pond reflecting winter cypress trees above in Everglades National Park. Alligators were commercially hunted in the early 1900s to supply markets for their skins and further reduced in numbers by draining wetlands during the same period. By the 1960s, alligators were considered imperiled and, like panthers, were one of the first animals on the U.S. Endangered Species List in 1973. Since then, alligators have rebounded and are no longer endangered. Panther recovery has been slower and less secure.

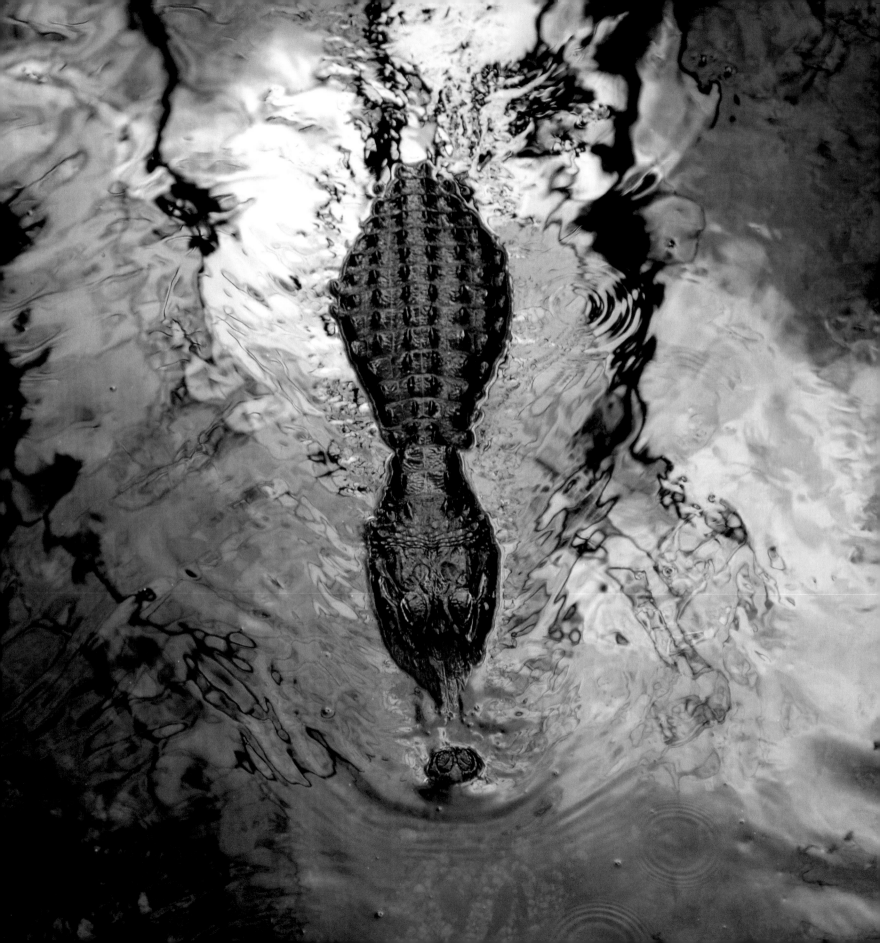

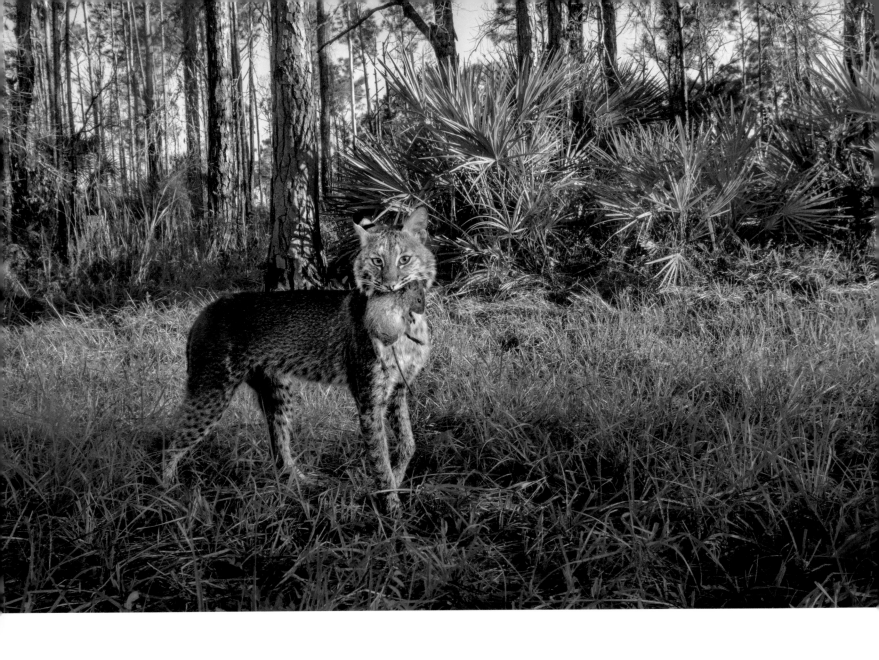

ABOVE: Hunting a public trail at the Corkscrew Regional Ecosystem Watershed, a bobcat carries a cotton rat, probably its breakfast. This forested landscape east of Naples is an important western frontier of the panther's range in South Florida.
OPPOSITE: From a fence post on the Camp Lonesome Conservation Area in the Everglades Headwaters, a burrowing owl holds on to a mole cricket that appears to be its next meal. Well-managed ranches in the Florida Wildlife Corridor support a diversity of wildlife on par with adjacent state and national parklands.

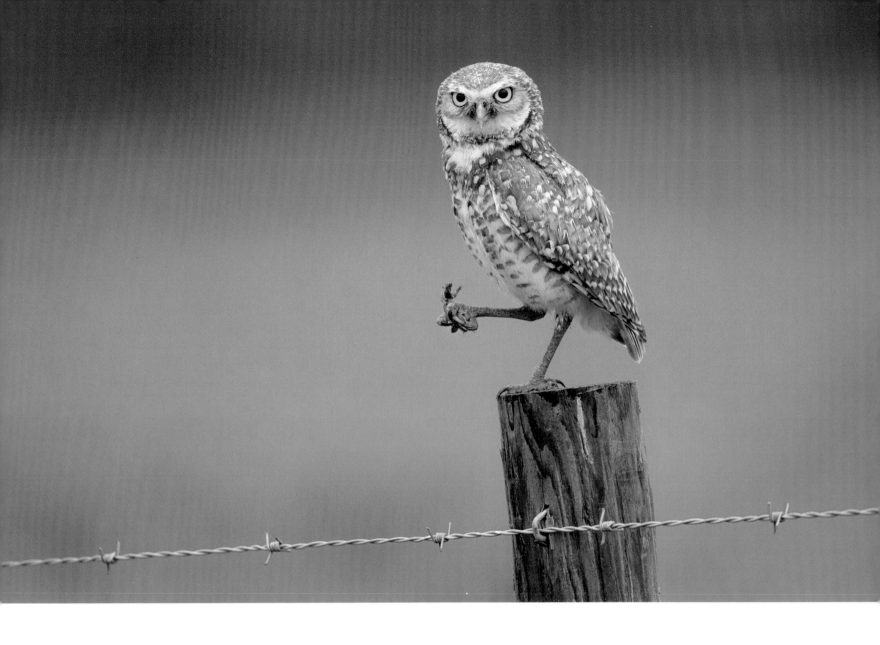

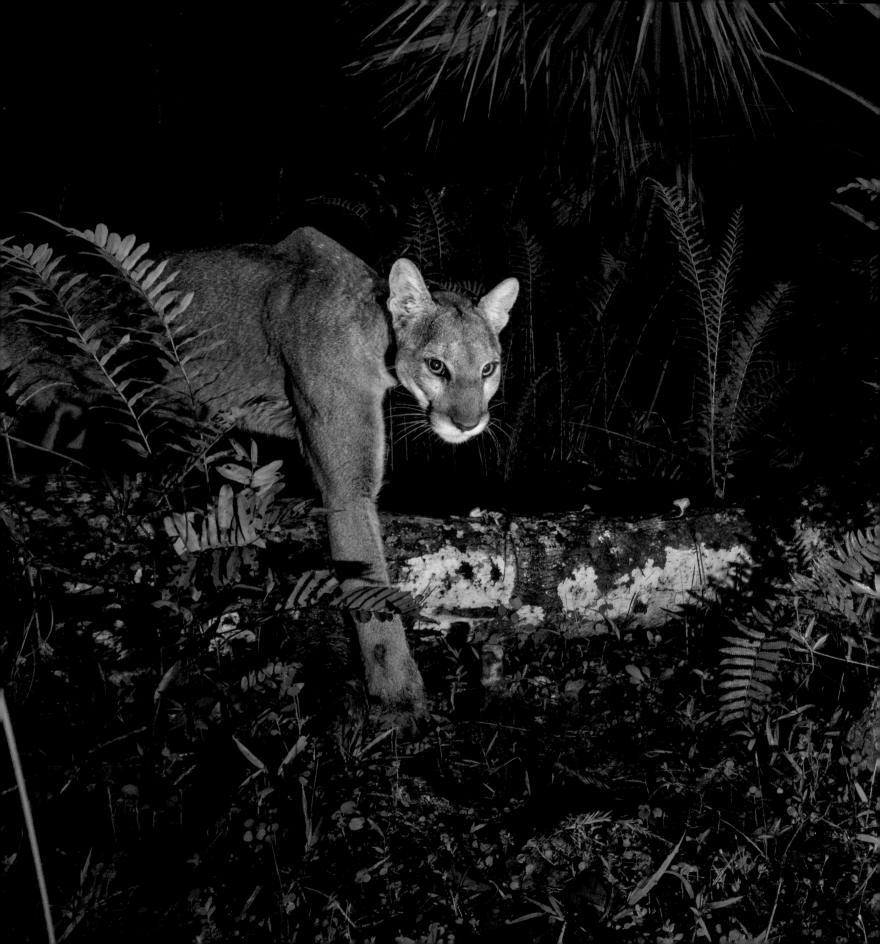

A female panther steps over a downed tree in Florida
Panther National Wildlife Refuge, which shares
borders with Fakahatchee Strand Preserve State
Park, Picayune Strand State Forest, and Big Cypress
National Preserve, which is contiguous with Everglades
National Park and tribal lands belonging to the
Seminole Tribe of Florida and Miccosukee Tribe of
Indians of Florida.

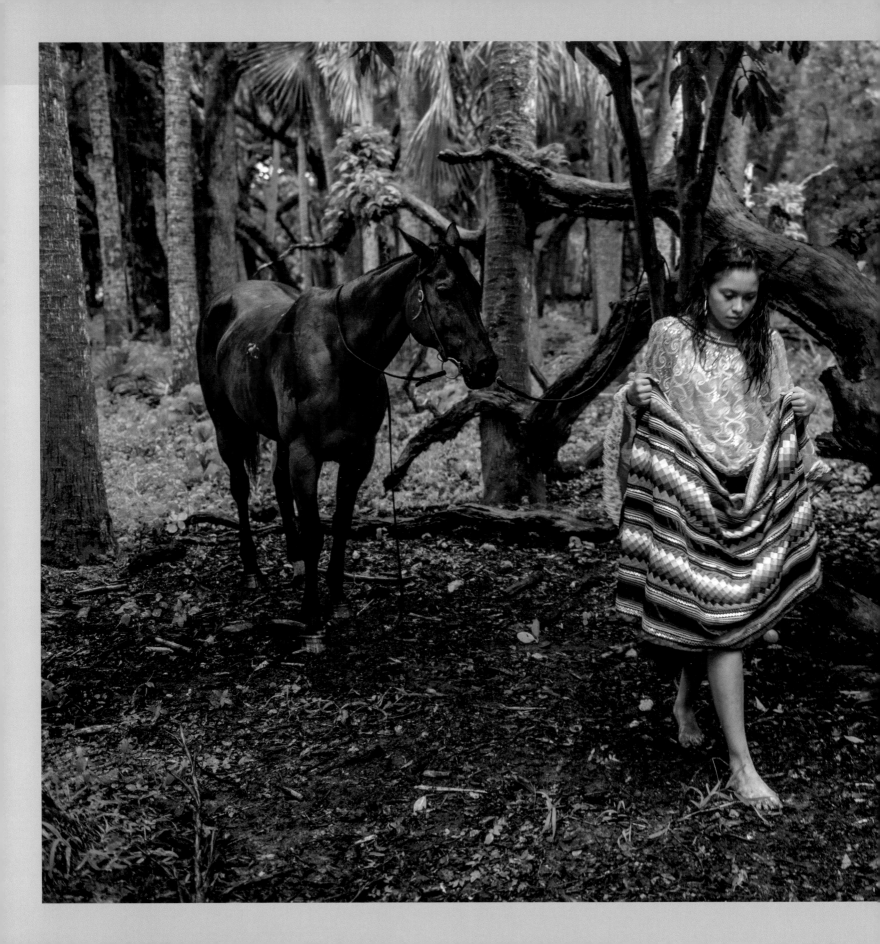

KINSHIP WITH THE PANTHER

BETTY OSCEOLA

THE FATE OF the Florida panther feels personal to me. As an elder of the Panther clan, my people and I have an especially close bond to this magnificent creature. Panthers are like our brothers or sisters. Their well-being is our well-being. For my tribe, the Miccosukee, the panther's survival is vital to maintaining the balance in nature essential to the survival of all beings.

The Panther clan is considered the warrior clan of the Miccosukee. Being of the Panther clan carries a responsibility to protect the animal kingdom as well as to be at one with Mother Earth.

I was taught that being of the Panther clan shapes our character, and its personality traits reflect our own. We are reserved until provoked, just as the panther keeps to itself unless protecting its offspring or reacting to an otherwise threatening situation. Faced with distress, a panther can be fierce. It's hard to say whether my clan's affinity to the panther is mostly innate or learned. No doubt it's a mixture of the two. But I can clearly see panther attributes already emerging in my young grandchildren.

The last time I saw a panther was more than 20 years ago. I was outside with my late mother and aunts. My mother told us to stand quietly without speaking and let

Morgan Yates, a member of the Panther clan of the Seminole Tribe of Florida, walks beneath her favorite wild grapefruit tree near her home at the Brighton Reservation. She is wearing a traditional Seminole dress that she and her mother made for a planned portrait shoot that an afternoon rain turned into a horseback adventure.

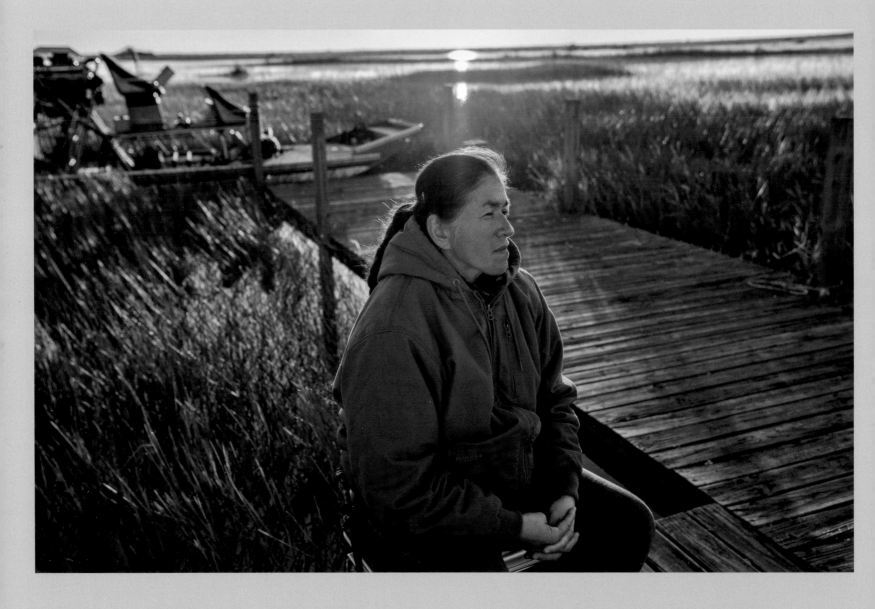

Betty Osceola, a member of the Miccosukee Tribe of Indians of Florida, sits on an ancestral tree island in the Everglades during an interview. Tree islands once provided substantial habitat for terrestrial wildlife, including panthers, as well as dwellings and ceremonial grounds for Osceola's people. But since the construction of the Tamiami Trail across the Everglades in the 1940s stopped the flow of water, the tree islands' area has been reduced by 70 percent, something that Everglades restoration is working to help change.

the animal walk by undisturbed. My son, who was nine years old, and my daughter, who was eight, were off in the distance playing. Fortunately, the female panther didn't go near them. Indigenous people are taught to treat animals with respect. Whether a bear, an alligator, or a panther, we recognize an animal's intention to peacefully coexist with us. It comes down to common sense: At times a wild animal may cross near homes or onto trails humans use. If you pay attention to the seasons and to weather conditions, you won't be caught unawares when an animal wanders onto your yard.

WHEN I WAS A CHILD, stewardship of the land followed a clear path. I grew up amid wildlife in a chickee hut—palmetto thatch over a bald cypress log frame—in the Everglades near the Tamiami Trail of southern Florida. My family and our Indigenous neighbors lived off the land, eating food that we hunted, fished, or grew ourselves. Fish like bream, bass, garfish, and mudfish were plentiful. We also caught snook and tarpon when they came seasonally to spawn in the area.

Today, I still live in the Everglades, but it's impossible to live the hunter-gatherer lifestyle. Local varieties of fish contain toxins, so I watch how often I eat them. I plant corn and pumpkin, but these crops don't thrive like they used to. The land often floods. Of course, some of that is a natural occurrence during the wet season. But long-standing water management practices for densely populated South Florida cause floods in the Everglades for many too many months at a time. This leads to degradation of the soil on the tree islands, ancestral grounds to my people. Pollution largely gen-erated by agricultural production and human waste leads to algae blooms and other environmental hazards. Everyone in South Florida depends on the Everglades aquifer, and we need it to be clean.

I am sometimes sad that my children and grand-children can't live the way I lived. But the old ways haven't been entirely lost. I have observed that many in the younger generation of Miccosukee and Seminole Indians are keen to keep traditions alive and have taken pains to learn how to build canoes and construct chickee huts.

From an early age, my children were exposed to the traditional ways. They helped gather the natural materials for the chickee hut where we lived, and they learned how to handle the tacking, the technique of pre-nailing palmetto leaves before attaching them to the thatched roof. I taught my daughter how to cook over an open fire. One grandson was lucky enough to grow up in an Indian village. And most of my grand-children speak or understand our Native language and know the history of the tribe.

It's a horrible history, and it's hard not to feel bitter about the senseless suffering. My people faced brutal reprisals during three wars in the 19th century that were intended to destroy our Indian nation. I think about the babies and children who were submerged underwater to hide from the cavalry and ended up drowning. It makes me want to cry even now. I am proud that my tribe persevered and remained unconquered, but in all honesty, the powers that be are still trying to divest us of our lands. Not at the point of a gun but by telling us how our lands should be managed.

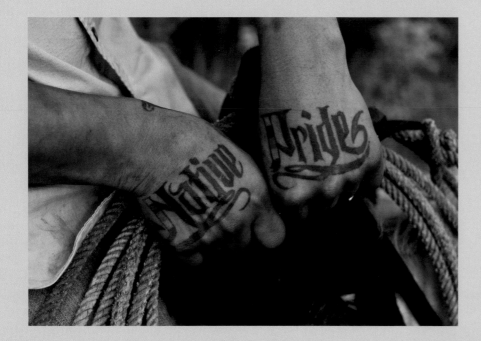

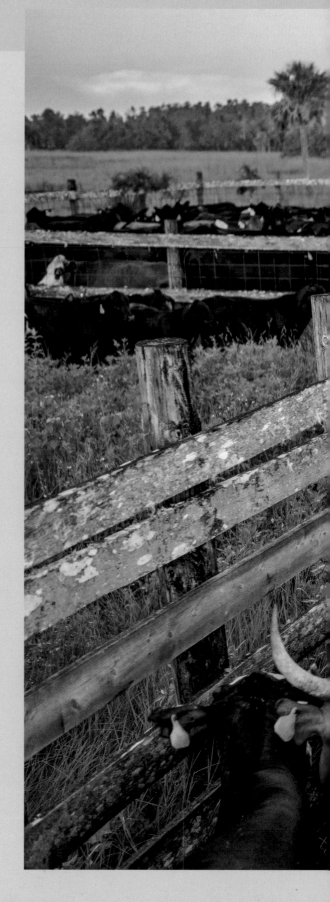

Ranching has been an important livelihood for the Seminole Tribe of Florida and other Native Americans since acquiring Spanish cattle more than five centuries ago. Today, the tribe is one of the leading producers of beef cattle in America.

ABOVE: From his saddle at the Big Cypress Reservation, Cane Jumper's hands display "Native Pride." **RIGHT:** Andre Jumper, a ranch foreman with the Seminole Tribe of Florida, steers cattle through wooden sorting pens at the Big Cypress Reservation, with Bobby Yates manning the parting gate in the background.

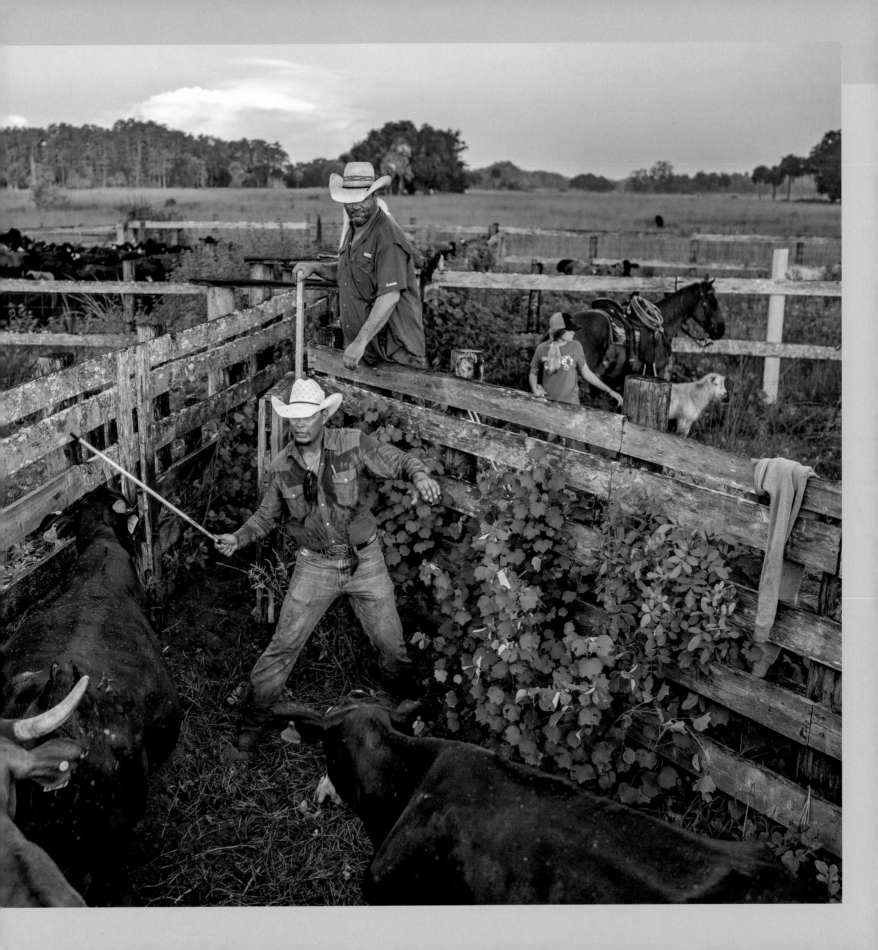

My mother taught me that I should remember this history but get on with life. I have taken the path of environmental activism and have raised my voice in support of anti-fracking legislation and many clean water campaigns in the state. I earn my living right in the Everglades, taking tourists out in my airboat. This too is a form of environmentalism. That boat is a way of teaching about nature and imparting the values of Native Americans.

High among those teachings is stewardship of the land. One of the reasons the Miccosukee are so adamant about protecting tribal lands is for the sake of the natural world. Many tree islands on the River of Grass at times are submerged for prolonged periods of time in water, and as a result, wildlife has lost its habitat. The Everglades have 70 percent tree-island loss. Our tribe would like to bring back the deer hunt, but how are we going to take that step, given the flooding and habitat loss? The deer will drown.

How can panthers exist here? They need a wide home range. If you keep diminishing where they can live, you are going to create conflict that's not the panthers' fault. Filling in the missing links, the Florida Wildlife Corridor will provide the connected land for panthers and other animals to be healthy and strong. ●

Born and raised in the Everglades, **BETTY OSCEOLA** is a member of the Miccosukee Tribe of Indians of Florida.

As dawn paints the eastern sky, Betty Osceola readies her airboat for a media tour of the River of Grass, a name for the Everglades that was made popular by writer Marjory Stoneman Douglas. At the heart of the Everglades is a slow-moving river about 60 miles (100 km) wide and more than 100 miles (160 km) long.

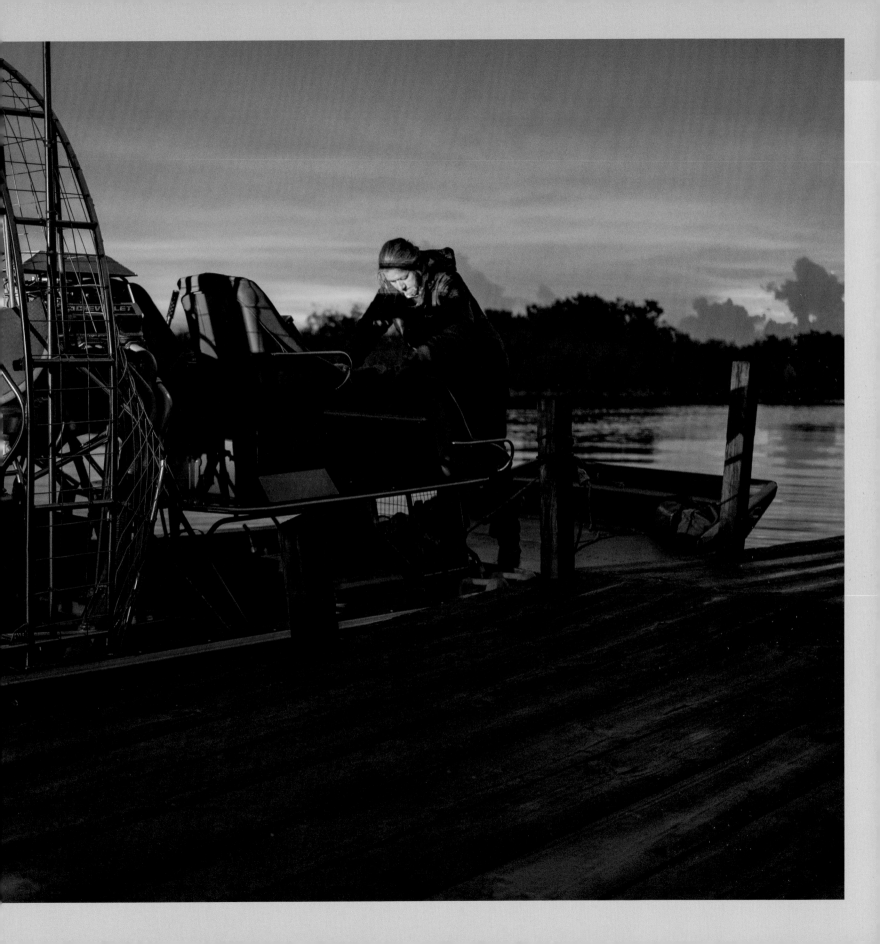

3

WHERE
WORLDS
COLLIDE

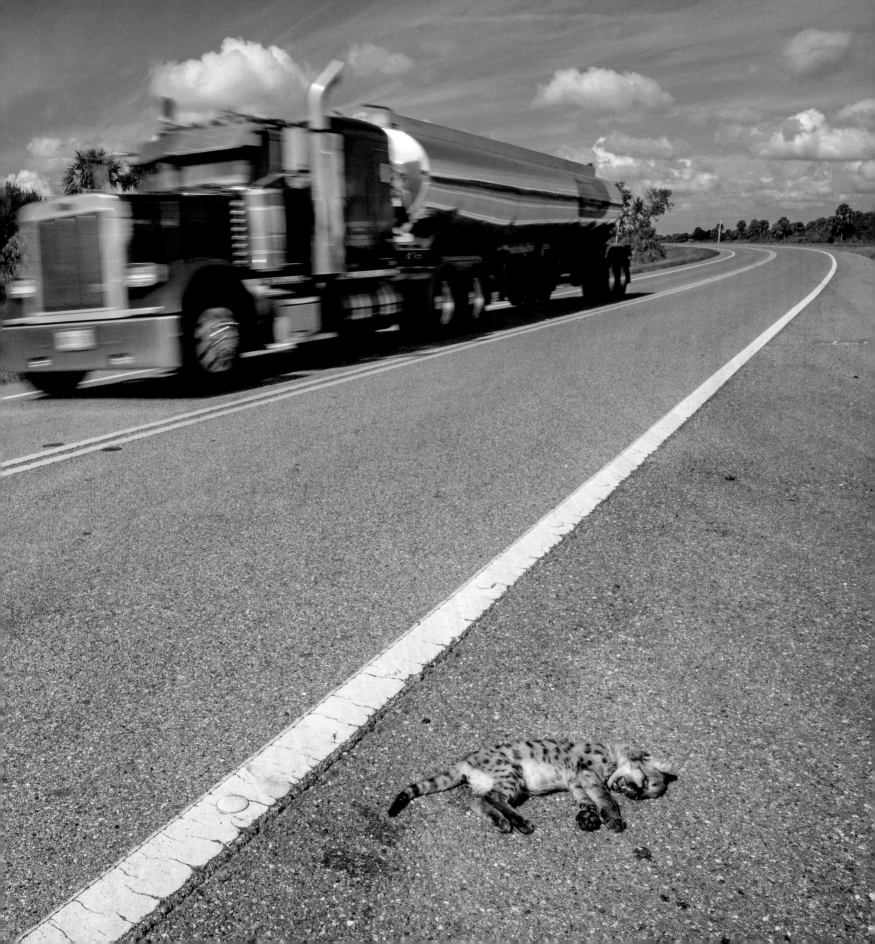

ANIMALS, HUMANS among them, are often drawn to edges. Native Floridians settled at the edges of the Everglades, along the rim of Paynes Prairie, beside springs, rivers, and estuaries. These were soft edges, boundaries where water met land, forest cleared, hunters could pivot to fish or game.

Nearly a century ago, the pioneering ecologist Aldo Leopold coined the term "edge effects" to describe the allure of edge spaces to wildlife, those borders where different types of food and vegetation come together in one place. "Game is a phenomenon of edges," he wrote in *Game Management* (1933): pheasants where field meets fencerow, wild turkeys at the edge of trails. The allure of edge spaces made them prime places to hunt.

Today, the wild borders of the world have hardened into edge cities and millions of miles of highway, making them prime places for animals to be extirpated. Car and truck strikes are responsible for the vast majority of known deaths of Florida panthers, as well as of black bears and Florida Key deer, among other animals. As many as a quarter of those killed in a given year are kittens, cubs, or fawns.

Fluffy spotted fur covers the roadkill carcass of a panther kitten at the edge of State Road 29 in rural Collier County in Southwest Florida. Was it scampering across the highway behind its mother? Did its mother see the strike? The dead kitten is a heartbreaking symbol of the extinction crisis under way across Florida and the globe. But it is more than symbolic. A limited genetic pool and small litters mean that each Florida panther killed sets back recovery for the entire popu-

lation—the 200 or so big cats that survive in a fraction of their historic range.

Two hundred tawny cats. Twenty-two million sun-bronzed people. Human population growth—now near 1,000 new Floridians each day—and sprawling development have sliced much of the state into razor-sharp edges. In South Florida, no small number of big-box centers, gated subdivisions, and six-lane highways were named for the waters, cypress trees, and panthers they replaced. In Central Florida, centuries-old longleaf pine forests spared by the timber industry were clear-cut for new towns and highway extensions in the 1980s—some in the middle of nowhere, further fragmenting the woods where bears roam to find food and mates.

Today, many Floridians see that pushing development to the edges is as dangerous for us as it is for animals. Draining and filling half of Florida's wetlands—which filter water and return it cleaner to aquifers and other sources—has left us vulnerable to drought and flood. During even minor droughts (major ones are inevitable), some edge cities do not have enough water for the fire hydrants, much less for the thin-legged wading birds that have come to rely on golf-course and storm-water ponds.

For the rivers, lakes, springs, and wetlands that remain, every inch closer we build to their edges sends more pollution into that waterway and ultimately to sea. There it kills sea grass, without which manatees starve. Along the coasts, every mangrove felled and estuary filled destroys a nursery for hundreds of aquatic animals, while gutting some of our best

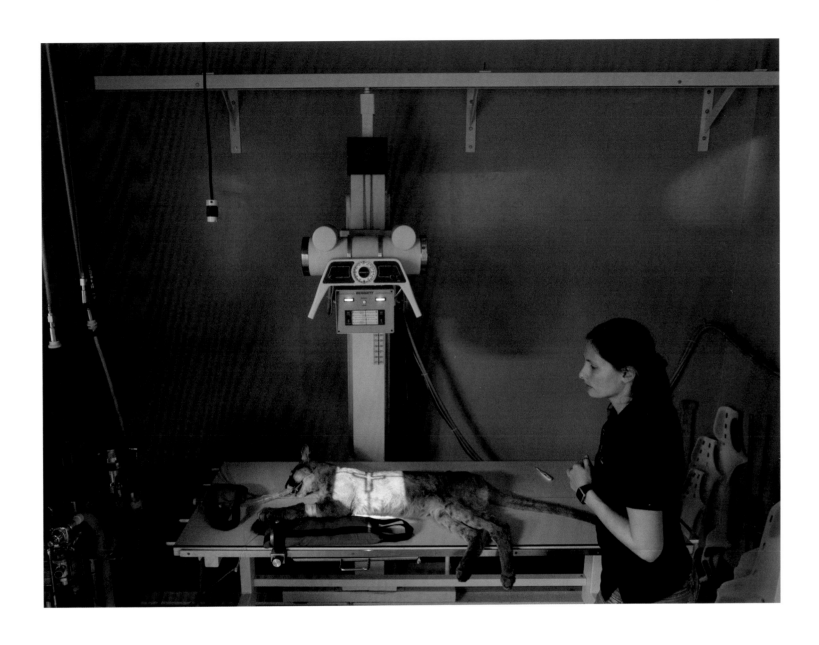

ABOVE: Veterinary technician Ashley Flaig at White Oak Conservation positions an x-ray machine to capture images of a panther kitten that was rescued when its mother, FP224, was injured by a car. **PREVIOUS PAGES:** A panther kitten lies dead on the side of State Road 29 east of Naples. Nearly 30 panthers are killed on roads each year, predominantly in Southwest Florida.

Land is scraped bare east of Naples to make way for a new housing development that cuts into the Florida Wildlife Corridor.

buffers against pollution and worsening storms. Extreme rains driven by climate change have led to record flooding and sewage spills in overdeveloped stretches where concrete and asphalt can't filter or drain dirty floodwaters. In building a sea of blacktop and removing so many shade trees, we have even worsened the heat. Extreme temperature has overtaken floods as the deadliest natural disaster in the nation, killing hundreds of Floridians in the past decade.

In the 20th century, rural leaders often lobbied for highway expansions and edge cities, arguing their

A THIRD MORE **FLORIDIANS ARE PROJECTED TO SQUEEZE INTO THE STATE BY 2070, BRINGING THE POPULATION TO 34 MILLION.** A RECENT ANALYSIS FOUND THAT UNDER CURRENT DEVELOPMENT PATTERNS, SUCH GROWTH WOULD PAVE OVER MORE THAN A THIRD OF THE STATE'S LAND.

regions deserved to reap the same growth opportunities as urban predecessors. Today, many see that the real prize is keeping Florida, Florida.

Led by commissioners in Citrus and Levy Counties, Florida's Nature Coast recently won a rare reprieve against toll roads that would have destroyed forest and farmland for just the kind of sprawl that is killing animals and quality of life in other parts of Florida. The region's land-water mosaic, stretching to Big Bend where the peninsula curves to the panhandle, is one of the least-developed coastlines in the contiguous United States. It is no accident that sea grasses and the manatees that rely on them still thrive in its waters while others elsewhere starve. Communities such as Cedar Key fought development of barrier islands while championing major land-conservation buys along the coast to ensure clean water flows to the Gulf of Mexico. The foresight has kept the water clean, preserved fishing heritage, and endowed a coastal edge to the Florida Wildlife Corridor, which envisions protecting 18 million wild acres (7.3 million ha) across the state.

More than half the corridor, mapped by scientists to give Florida's animals the connected habitat they need to survive, is already saved in perpetuity, in public parks, forests, and private holdings like cattle ranches and timberlands. Completing the corridor will help make Florida's animals and their habitats whole again, softening the edges we have made so deadly sharp. The Florida Legislature's unanimous support for the Florida Wildlife Corridor Act in 2021 and the Department of Transportation's 2022 decision to rethink a major extension of Florida's Turnpike based on strong local opposition reflect widespread public support for this humane vision of Florida's future.

A third more Floridians are projected to squeeze into the state by 2070, bringing the population to 34 million. An analysis by the University of Florida, the state's Department of Agriculture, and 1000 Friends of Florida found that under current development patterns, such growth would pave over more than a third of the state's land. It would double Florida's water use—when we have already drained and pumped more freshwater from wetlands and aquifers than can be replaced by the nearly 60 inches (150 cm) of rain that falls each year. But it doesn't have to be that way. By building denser, more verdant cities and conserving the wild edges between them, the same study showed, we can ensure safe spaces for wildlife—and resilient, healthier places for ourselves. More natural shorelines, less slime. More timber rows, fewer retail rows. More meandering streams, less concrete. More shade trees, less searing blacktop. More family farms, less roadkill. A Florida with softer edges where water meets land, forest meets field, and panther kittens follow their mothers safely back into the wild. ●

CYNTHIA BARNETT is an award-winning environmental author and journalist who has reported on water and climate change around the world. Her latest book, *The Sound of the Sea: Seashells and the Fate of the Oceans,* was named one of the best science books of 2021 by NPR's *Science Friday* and one of the best nonfiction books of the year by *Kirkus Reviews,* the *Tampa Bay Times,* and others.

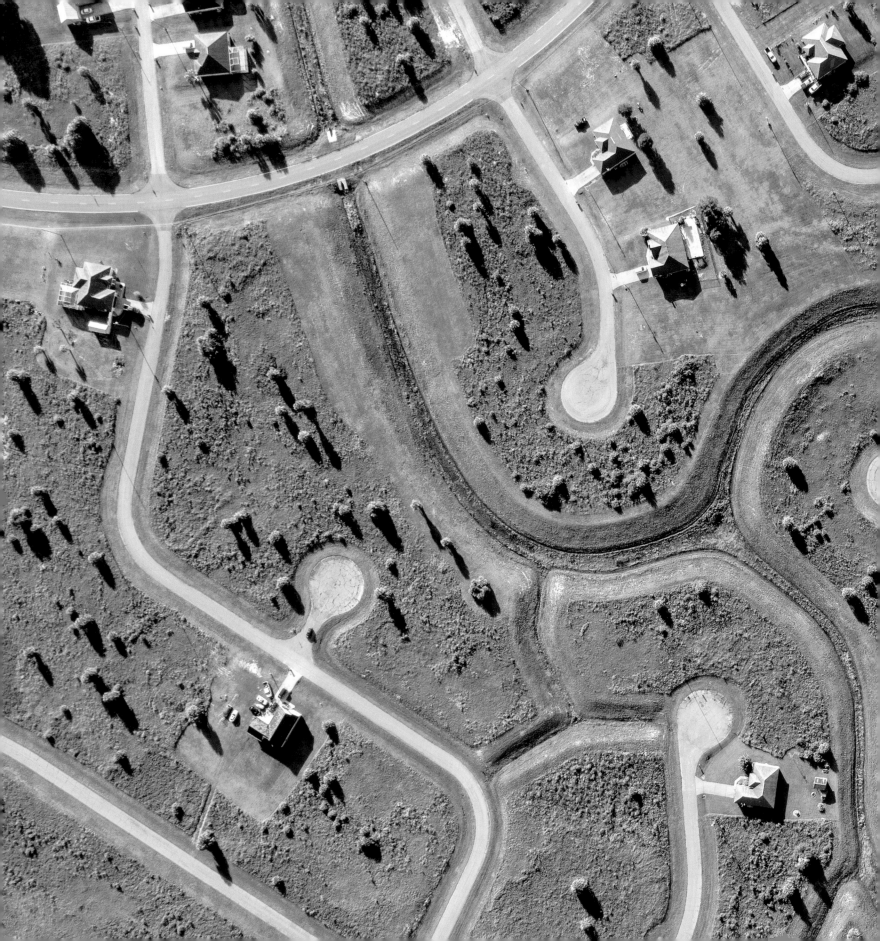

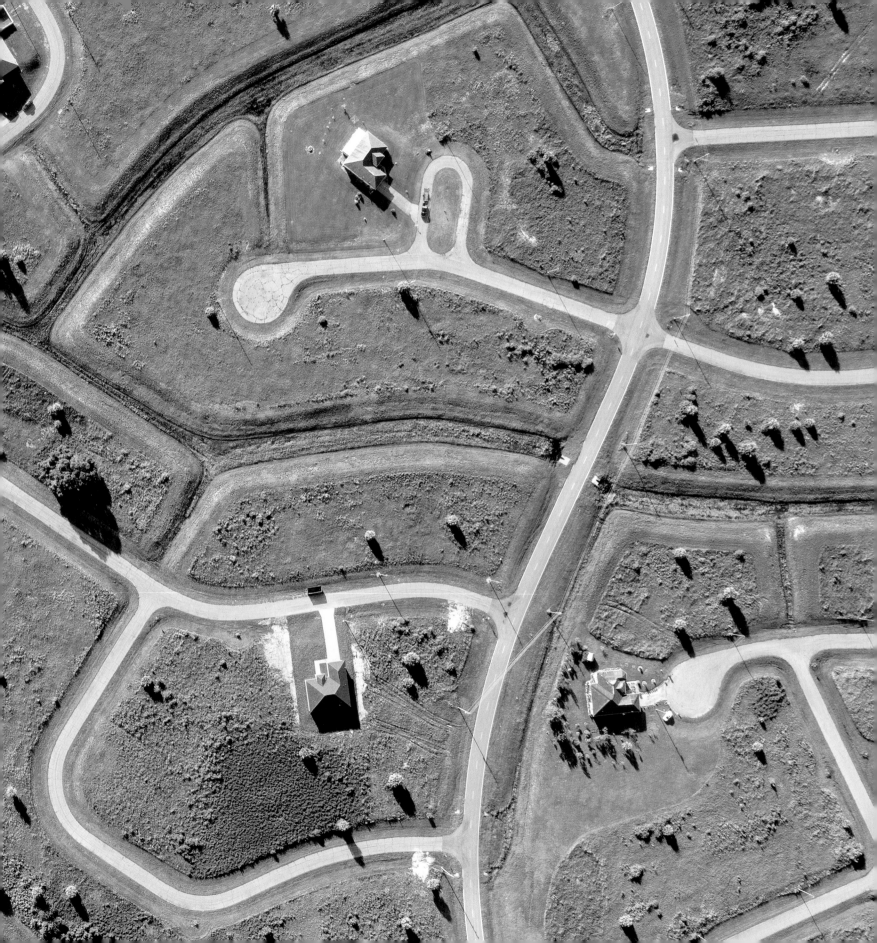

ABOVE: New housing developments cut into the Florida Wildlife Corridor near Naples, where rapid population growth sprawling inland from the coast continues to erode panther habitat. **OPPOSITE:** A mother and two kittens move through the side yard of a home in Golden Gate Estates, a low-density development east of Naples where losing hobby livestock or pets to panthers is not uncommon. As people move into panther territory, the chance for conflict increases. The owners of this house move their pets into enclosures at night and bought a livestock guardian dog to help them peacefully coexist with panthers and other wildlife. **PREVIOUS PAGES:** Low-density development squeezes the Florida Wildlife Corridor near LaBelle, where a bottleneck of rural and natural land provides one of the last undeveloped green connections spanning both sides of the Caloosahatchee River.

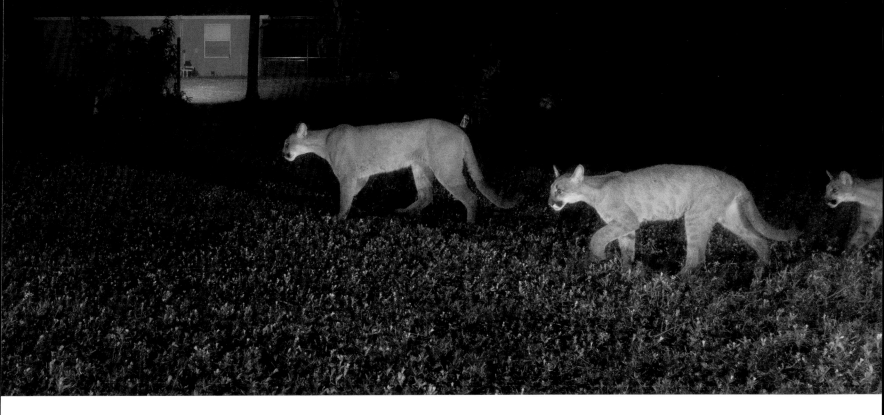

FP224

FLORIDA PANTHER 224 embodies the struggle of a panther growing up in Southwest Florida, close to development. Biologists from the Florida Fish and Wildlife Conservation Commission found and named her in 2013 as a nine-month-old kitten hit by a car in the rural community of Golden Gate Estates, east of Naples. After her recovery, she was released into road-less wilderness 30 miles (50 km) east near the heart of Big Cypress National Preserve. But she walked right back to her original home range in Golden Gate Estates.

In 2017, she was hit by a car again. That time, she was known to have three young kittens, two male and one female. Biologists were able to successfully catch the two males using baited traps. The female kitten was found dead on the side of nearby Interstate 75.

FP224 underwent surgery for a broken leg, and she and her surviving kittens were taken to White Oak Conservation for rehabilitation.

In April 2018, they were returned as a family back into the wild at Picayune Strand State Forest. It was the first time a family of pumas has been rehabilitated and released together. In the months that followed, both young males were killed on Southwest Florida roads. FP224 went back to her original home around Golden Gate Estates, where she continues to produce kittens amid the high-risk reality of living close to people. ●

Veterinarians and wildlife technicians carry the two sedated kittens of FP224 from a transport van into the animal hospital for a medical exam at White Oak Conservation.

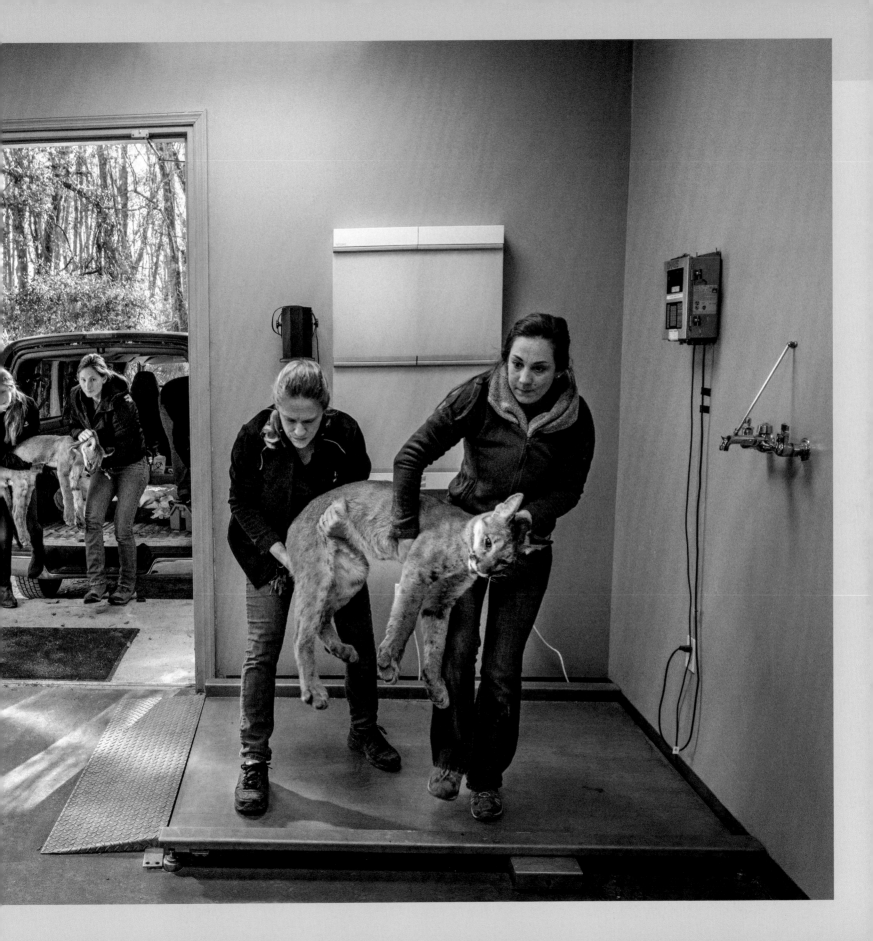

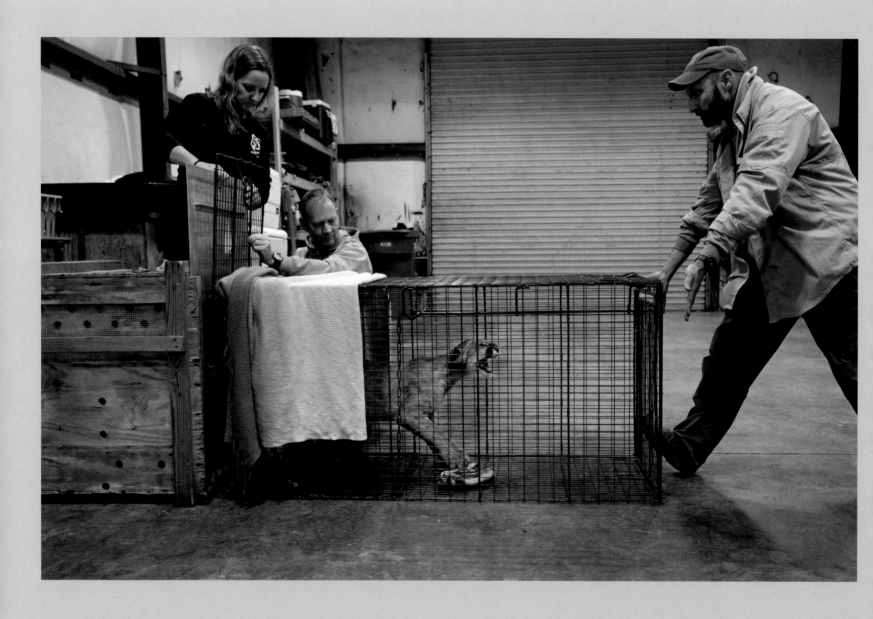

ABOVE: Biologists from the Florida Fish and Wildlife Conservation Commission caught two kittens in baited traps shortly after their mother, FP224, was injured by a vehicle in eastern Naples. In this photo, one of the kittens is being released from the trap into a wooden crate to be transported to White Oak Conservation for care while their mother is rehabilitated.

OPPOSITE: After arriving at White Oak Conservation, west of Jacksonville, the kittens are evaluated for their readiness to be reunited with their mother and released back into the wild together.

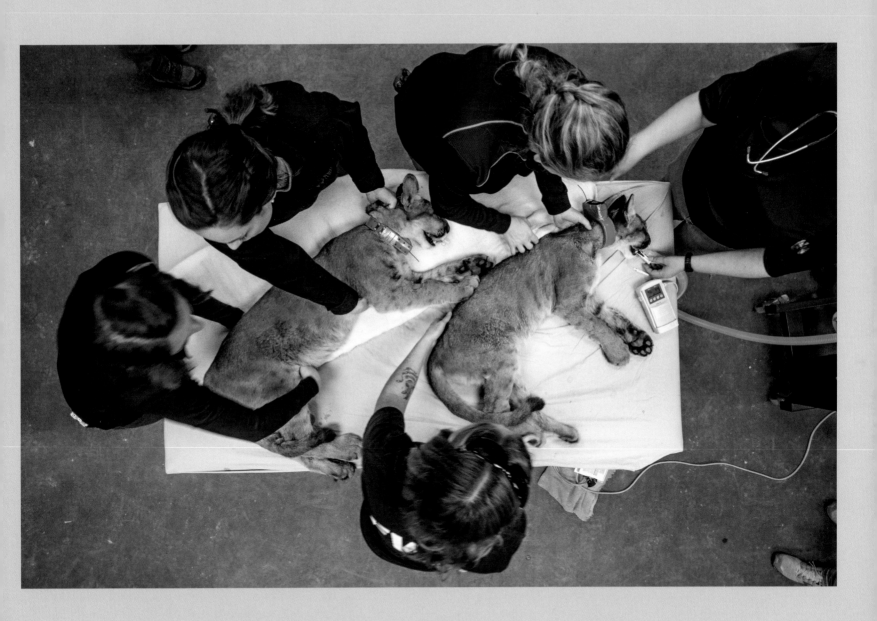

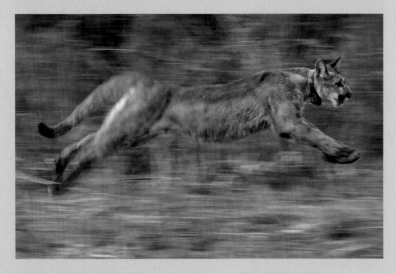

TOP: With her kittens looking out from flanking crates, FP224 strides into the wide-open habitat of Picayune Strand State Forest. **BOTTOM:** Last to leave the crate, one of FP224's kittens races after its mother and siblings. Together, they are the first panthers to be rehabilitated and returned to the wild as a family. Tragically, both kittens were killed by vehicles within their first year of release. **RIGHT:** FP224 continued her recovery and produced subsequent litters, including these three kittens held by veterinarian Lara Cusack.

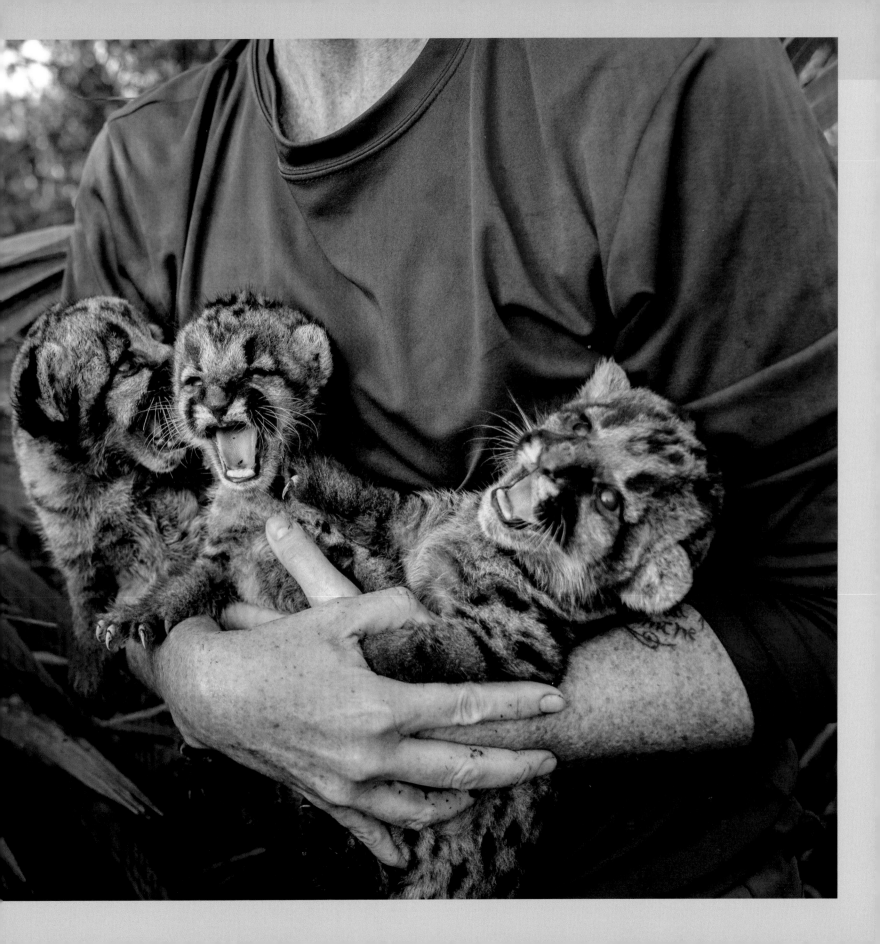

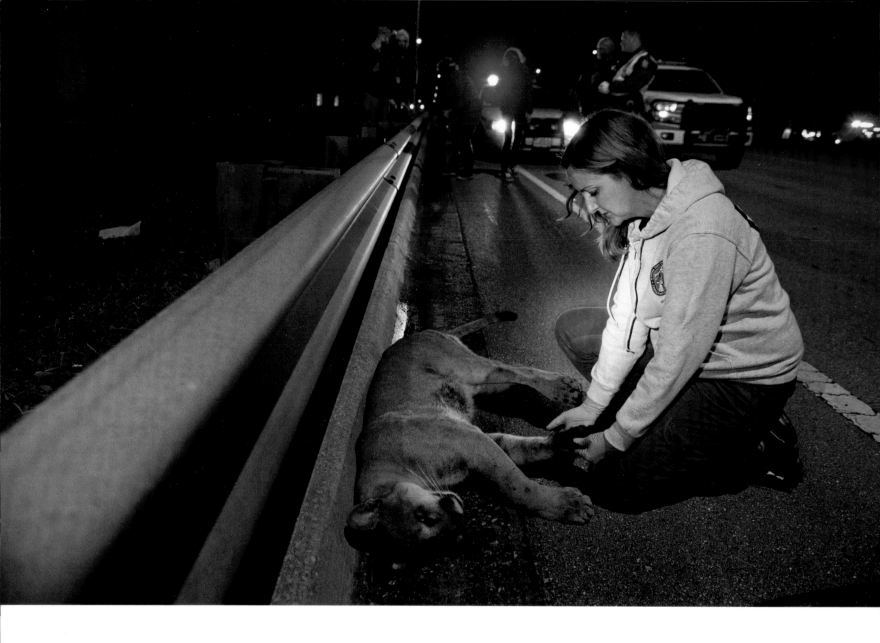

ABOVE: Florida Fish and Wildlife Conservation Commission (FWC) veterinarian Lara Cusack examines a young male panther killed by a vehicle on a busy six-lane road in the suburbs of eastern Naples, in an area where houses and shops have recently replaced forests. The panther was collected for a necropsy. **OPPOSITE:** Veterinarian Hollis Stewart removes a female panther from its freezer bag on a necropsy table at the FWC field office in Gainesville. Only four female panthers have been documented north of the Caloosahatchee River since 1973, and two of them in spring 2022 were roadkills. The necropsy revealed this female found north of the river was pregnant with two unborn female kittens.

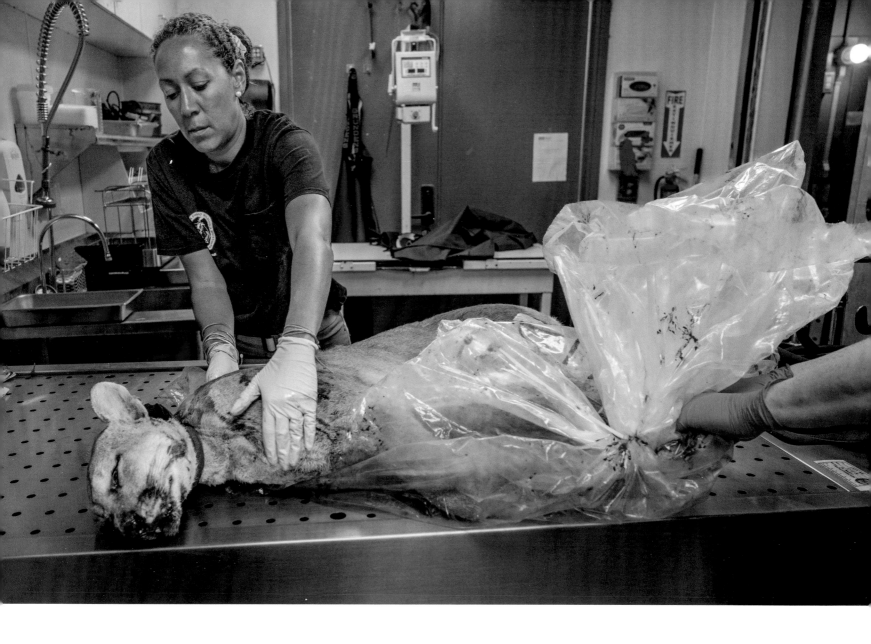

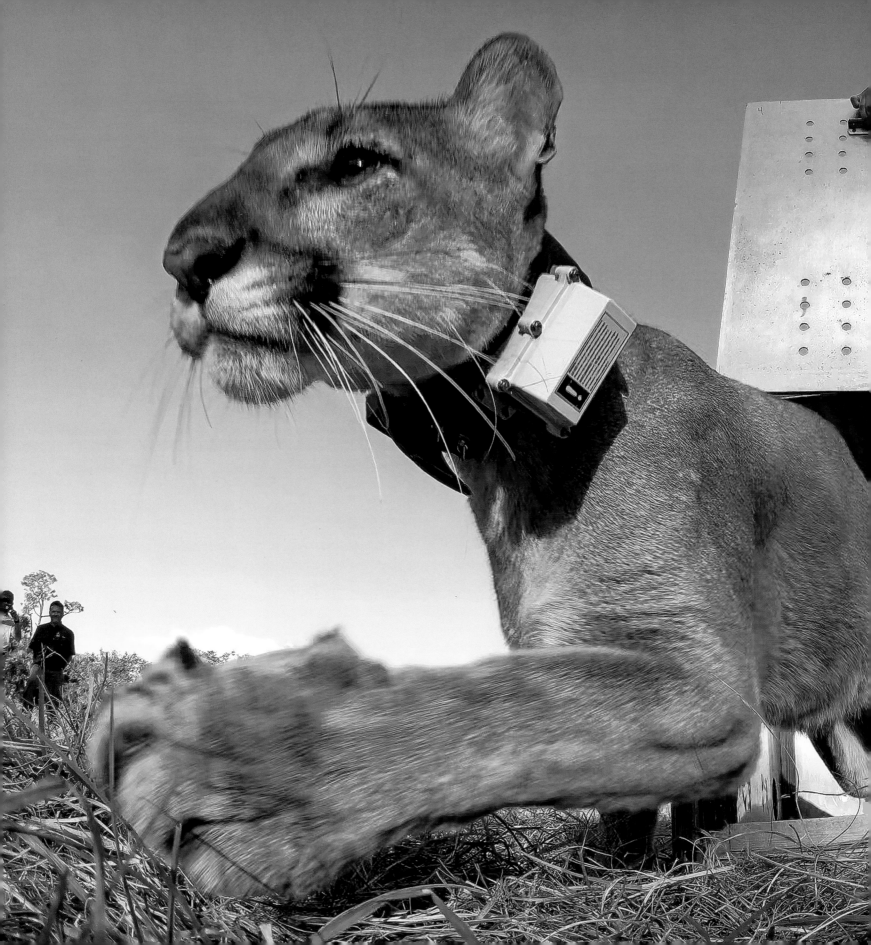

Not all vehicle strikes are fatal. This panther, FP250, was nicknamed "Tres" for his three broken legs. After surgical repairs at the Animal Specialty Hospital of Florida in Naples, he was sent to ZooTampa and later White Oak Conservation for rehabilitation and eventual release back into the wild near his native home range in South Florida. This photo was taken with a remote camera while veterinarian Lara Cusack opened the transport crate door.

NO. 036 | CONNECTED LANDS

This camera trap site was selected to show how wildlife use adjacent properties as one connected habitat. This barbed-wire fence between Audubon's Corkscrew Swamp Sanctuary and an adjacent cattle ranch functions to contain cattle but doesn't impede the movements of panthers and other wildlife. The sanctuary is more than 20 square miles (52 sq km) in size, but an adult male panther needs access to a territory 10 times larger. Throughout most of Florida and the Southeast, accommodating a 200-square-mile (520 sq km) territory requires multiple properties working together to find solutions.

A female panther steps through a barbed-wire fence, entering Audubon's Corkscrew Swamp Sanctuary from an adjacent cattle ranch, with one of her kittens following, partially hidden behind her haunches.

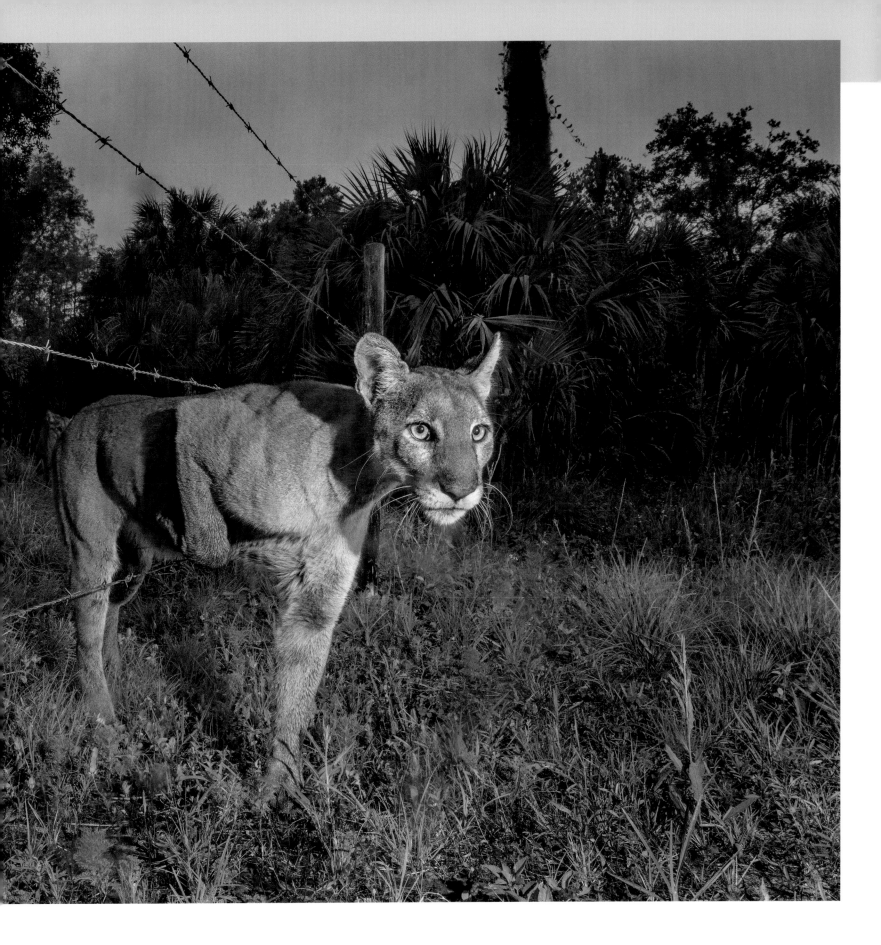

CLOCKWISE FROM BOTTOM LEFT: An alligator crawls under the fence; cattle on the adjacent ranch are contained; Osceola turkey gobblers move freely from one property to the next; a Florida black bear prepares to step through from the sanctuary onto the neighboring ranch.

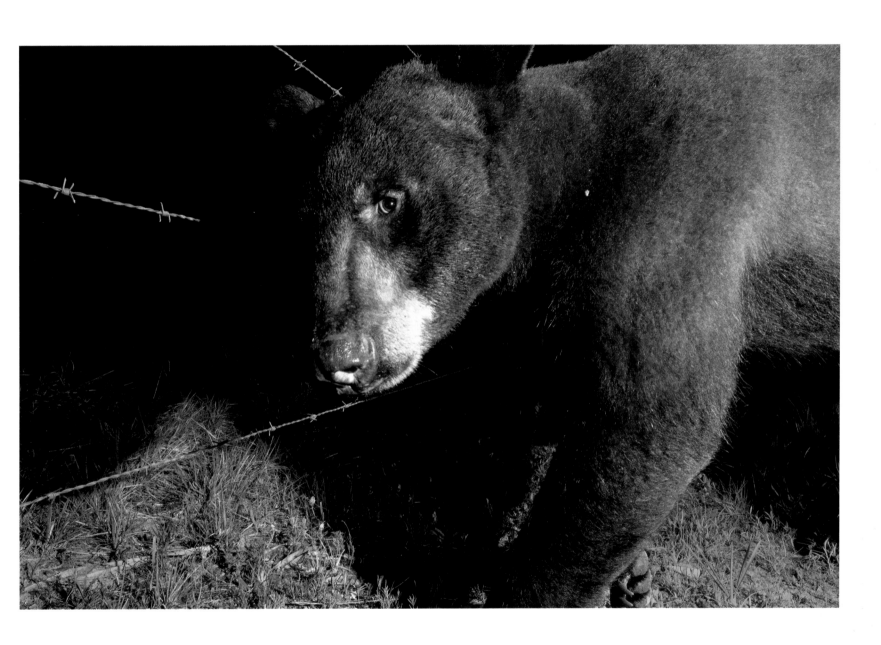

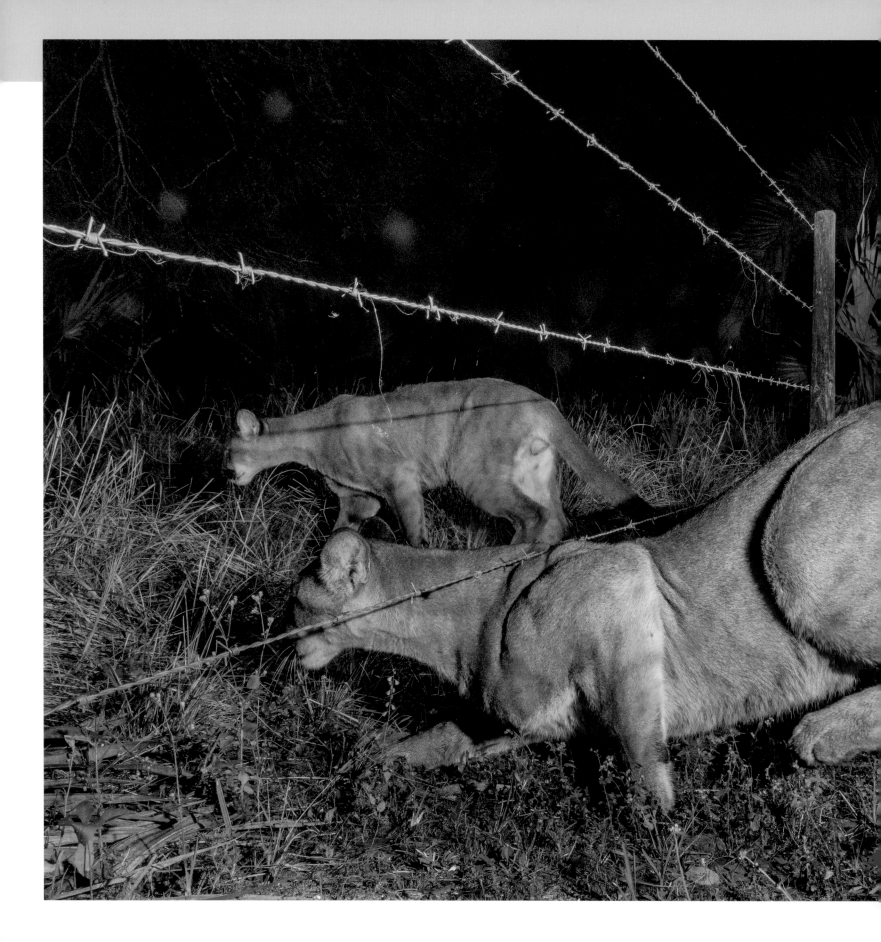

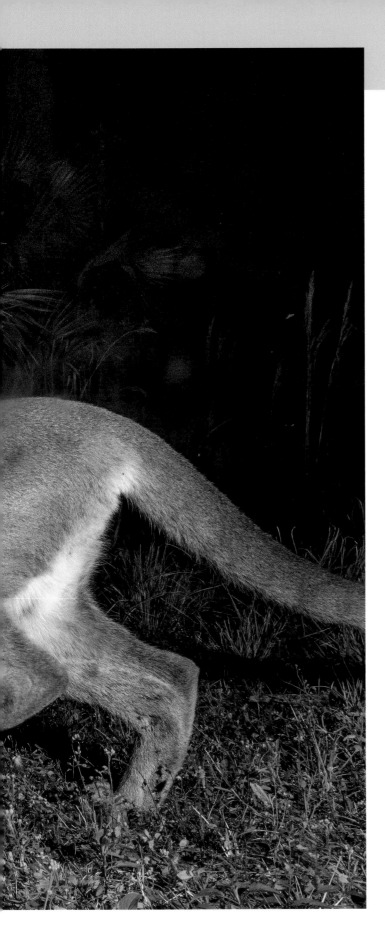

Still showing their spots, two growing kittens cross under the fence from Audubon's Corkscrew Swamp Sanctuary onto the adjacent ranch. The splotches in the sky are residue from a resident bobcat that had sprayed the camera lens port with urine before crossing between the sanctuary and ranch. Although humans make a distinction between the two properties, for wildlife, they are both home territory.

ABOVE: Cougar McBride, a contractor with the Florida Fish and Wildlife Conservation Commission, uses specialized hounds to hunt for and chase panthers and bobcats up trees. The dogs are bred and trained to only hunt and tree cats, a method scientists use to selectively catch panthers and fit them with tracking collars. **OPPOSITE:** This adult male panther is peering down at the dogs from an oak tree in Dinner Island Ranch Wildlife Management Area. A biopsy dart was used to quickly collect a tissue sample for a genetic study helping to assess the health of the panther population.

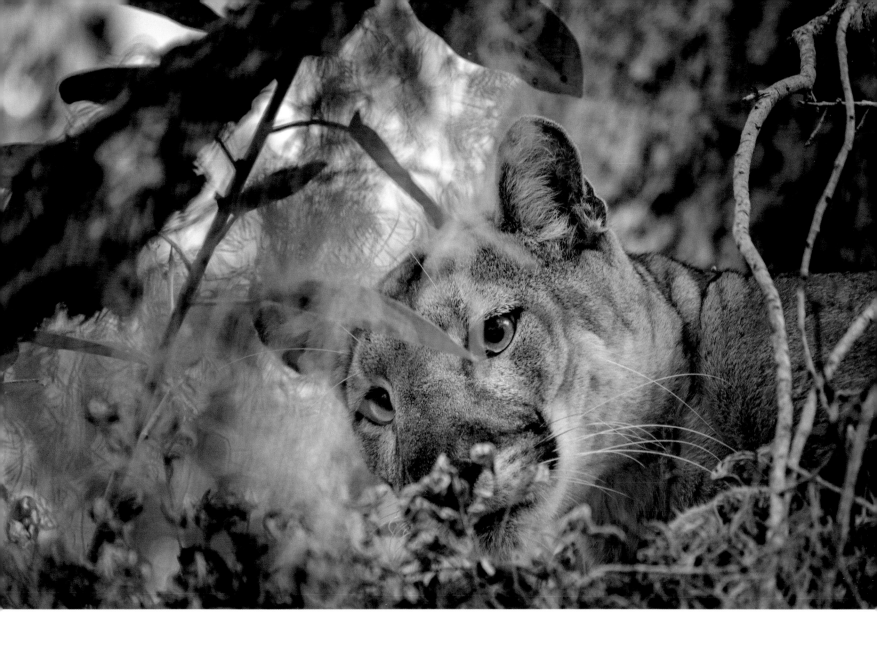

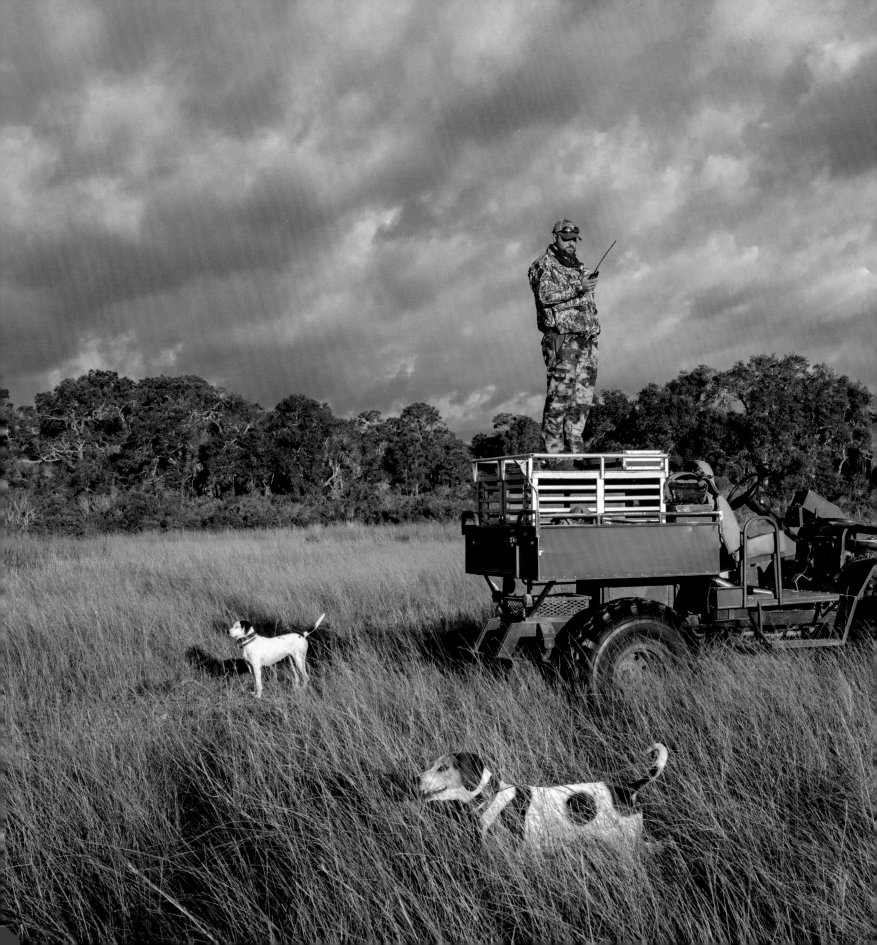

Cougar McBride uses a GPS radio to keep track of his hounds as they hunt for panthers at Dinner Island Ranch Wildlife Management Area. Tracking panthers with hounds is a skill his grandfather Roy McBride first brought from Texas in the 1960s. Supported by the World Wildlife Fund, the elder McBride proved a remnant population of panthers was still surviving in Florida. This finding kicked off five decades of conservation work under the 1973 Endangered Species Act.

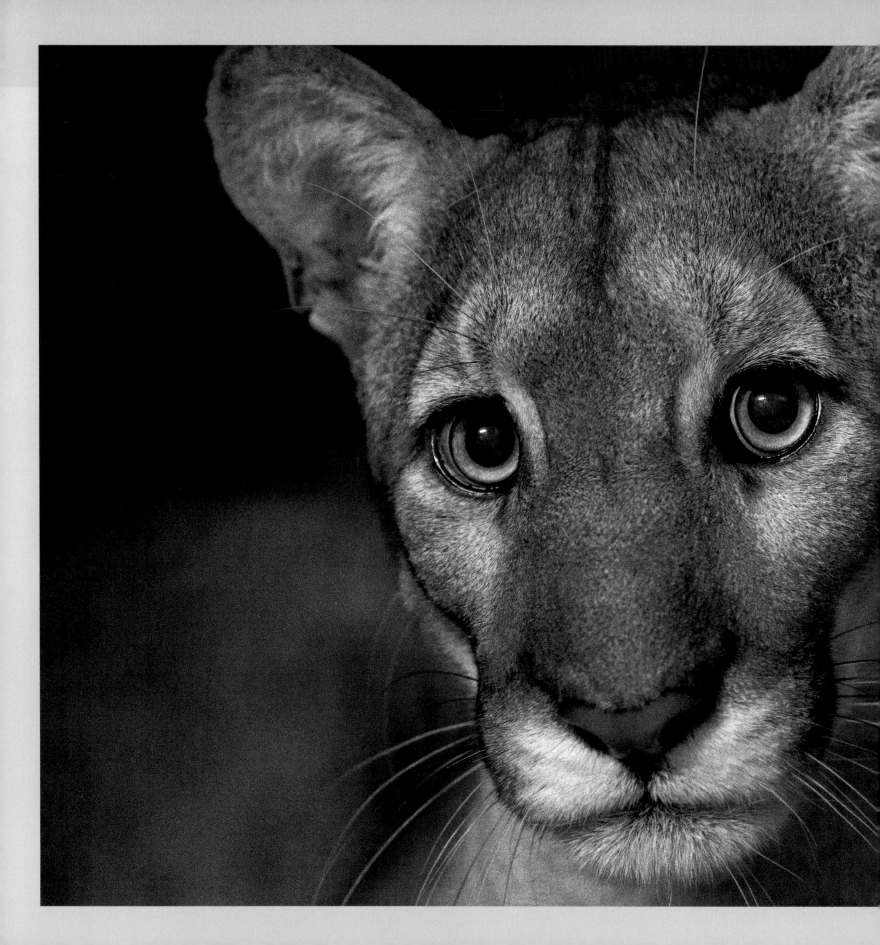

SURVIVORS

PANTHERS BORN IN FLORIDA today must contend with the pressures of living in a state with galloping population growth. Panther territory, once set apart from suburban living, is increasingly cheek to jowl with human development. That proximity brings peril, especially in Southwest Florida east of Naples, where expanding roads and traffic are constantly squeezing the wildlands.

The leading documented cause of death for panthers is collision with cars and trucks on the expanding web of roadways that cut through the Florida Wildlife Corridor. Vehicle collisions claim the lives of nearly 30 panthers each year. When a female panther killed or injured by a car leaves behind offspring, the kittens are often unable to survive on their own. For orphaned kittens and other panthers who have suffered from conflict with people and cannot be returned to the wild, Florida's network of accredited zoos offers sanctuary.

The panthers featured in the following pages live at six different zoos across the state. Each has a story that underscores the plight of their extended family in the wild. ●

WALTER | ZOOTAMPA

Walter was found in the Northern Everglades west of Lake Okeechobee in 2017, with his left front foot caught in a snare trap presumably put out by a landowner trying to control predators like coyotes. After multiple surgeries at ZooTampa, it was determined that Walter's foot could not be repaired, and he could not return to the wild. He was given a new permanent home at the zoo and named for a donor who helped fund his care. His keepers say that Walter enjoys the sunshine and taking naps on the top platform in his habitat, which he shares with fellow panthers Lucy and Micanopy (page 164).

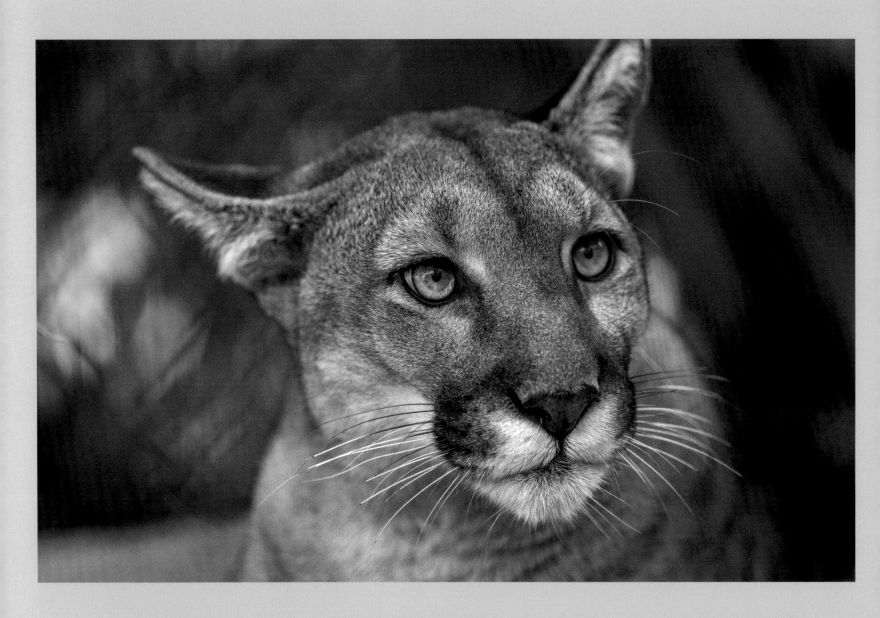

ATHENA | NAPLES ZOO

Athena was born into a litter of four kittens in 2017 being observed by National Park Service biologists in Big Cypress National Preserve. Biologists later noticed that the mother had moved three of the kittens but had left Athena at the original den site when she was just a few weeks old. Attempts to reunite Athena with her family were unsuccessful, leading to the decision to remove her from the wild. Research suggests that a kitten needs to live at least six months with its mother to be a candidate for successful reintroduction into the wild. Athena was rehabilitated behind the scenes before being given a permanent home at Naples Zoo.

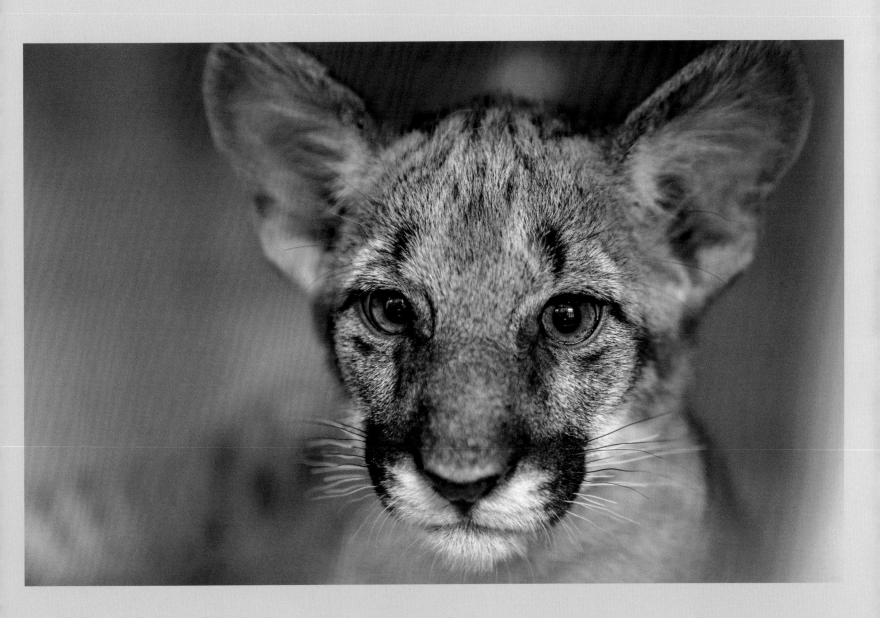

CYPRESS | WHITE OAK CONSERVATION

Cypress and his brother, Pepper, were born in 2019 near Immokalee to FP256, who was wearing a tracking collar. The state panther team observed that FP256 was so severely affected by the neurological disorder feline leukomyelopathy (FLM) that she would likely not survive, and certainly not successfully raise kittens. The two kittens were initially hand-raised at ZooTampa and monitored for signs of FLM before being provided a long-term home at White Oak Conservation near Jacksonville. Researchers are still investigating the source of the disease that ultimately claimed their mother.

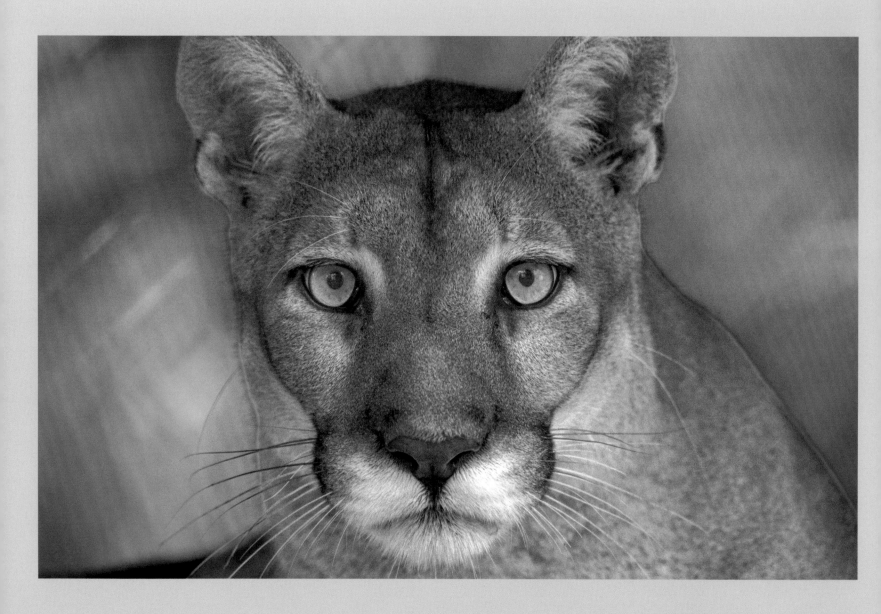

**SAKATA | HOMOSASSA SPRINGS
WILDLIFE STATE PARK**

As a two-month-old kitten in 2016, Sakata was discovered abandoned and sleeping in a field at the Sakata Research Station near Fort Myers. Biologists tried to locate his mother and concluded that the kitten had likely become lost in a rare circumstance when two mothers with kittens crossed paths and Sakata attempted to follow the wrong mother. Sakata's mother was never found, and the lost kitten was taken to Naples Zoo for medical care before finding a permanent home at Homosassa Springs Wildlife State Park, joining Yuma, another male panther who was rescued as an orphan.

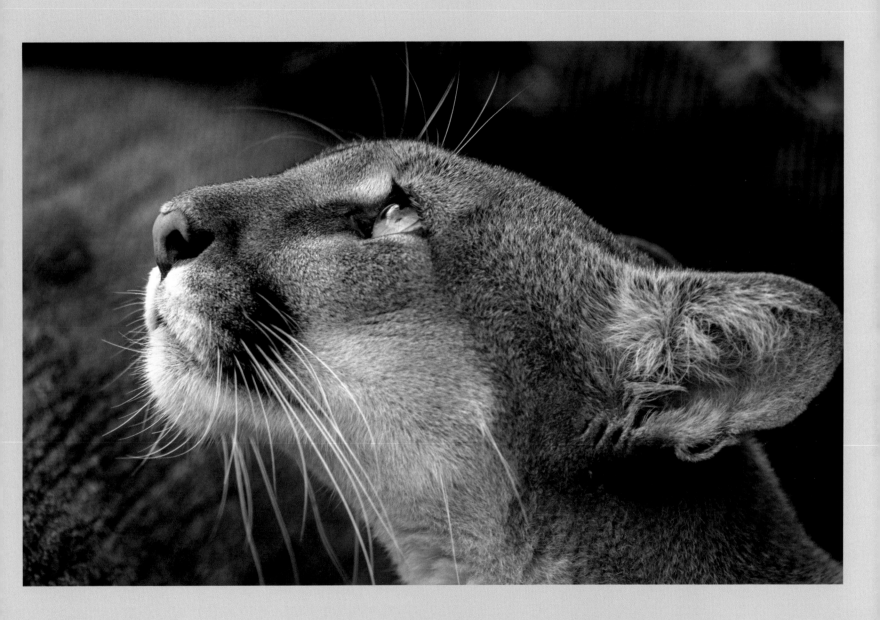

MAHALA | ZOO MIAMI

In 2014, Mahala was found hiding in a bougainvillea bush beside a tennis court in Naples. Her mother had been hit by a car nearby, sustaining only minor injuries, and was seen walking away from the area with her other kittens. After multiple attempts to reunite the lone kitten with her family, biologists rescued her, as she was too young to survive in the wild on her own. In 2015, she was given a home at Zoo Miami, where she lives today. Soon after, her mother was hit by another car and died. It is not known whether Mahala's siblings survived.

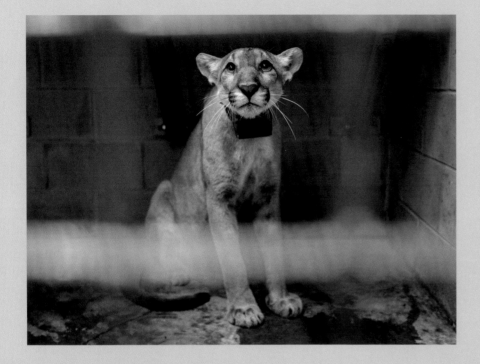

ABOVE: **MICANOPY | ZOOTAMPA**

Micanopy was removed from the wild in 2016 because he was preying on pets in a rural neighborhood of Immokalee. In this photo, he is being kept for a one-month quarantine to ensure he hadn't contracted feline leukemia from eating domestic cats, which could endanger the wild panther population. He was returned to the wild as far from people as possible but came back to residential areas. The Interagency Florida Panther Response Team decided his behavior was a public safety concern and permanently removed him from the wild. He was a young cat who possibly lost his mother early and learned to hunt domestic animals for easy food. ZooTampa saved Micanopy from euthanasia by welcoming him back a second time.

RIGHT: **SASSY | PALM BEACH ZOO**

When her mother was killed by a car on the Tamiami Trail near Naples in 2015, Sassy was too young to survive on her own. Florida Fish and Wildlife Conservation Commission biologists successfully trapped her near where her mom was struck and took her to Naples Zoo for medical care. They were not able to catch her two siblings. They found one dead from starvation, and the other likely suffered the same fate. After Sassy was nursed back to health, she was provided a permanent home in a new panther habitat at Palm Beach Zoo, where she actively climbs a catwalk to get from one part of her exhibit to another.

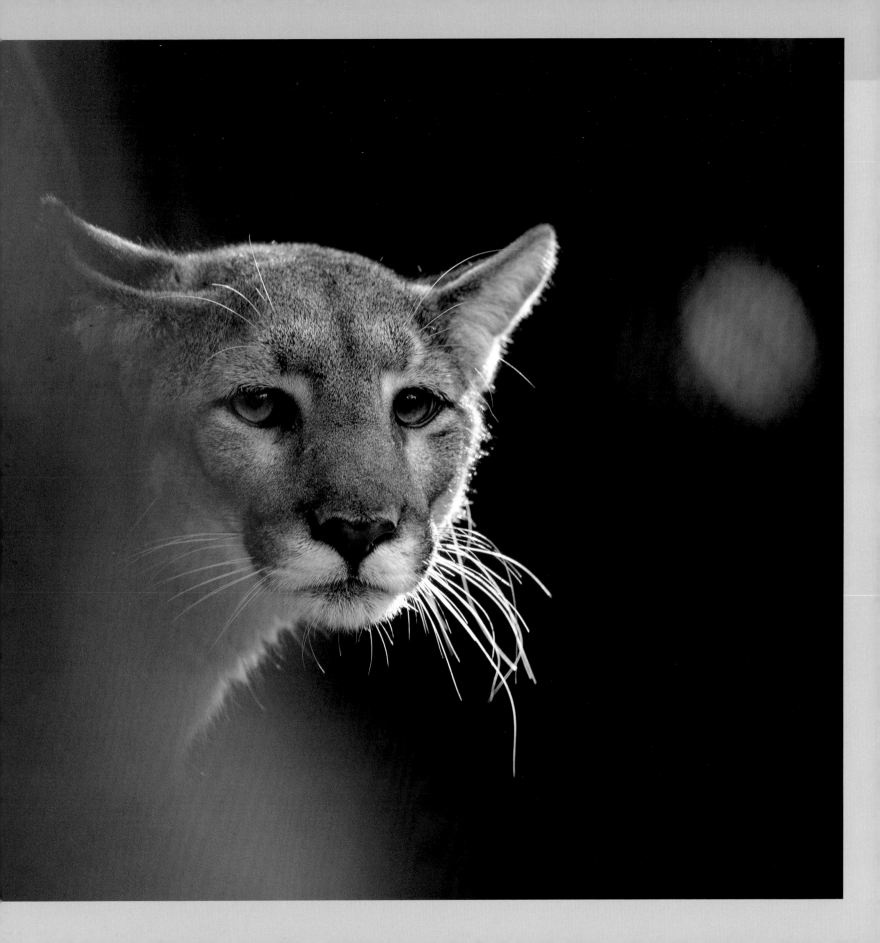

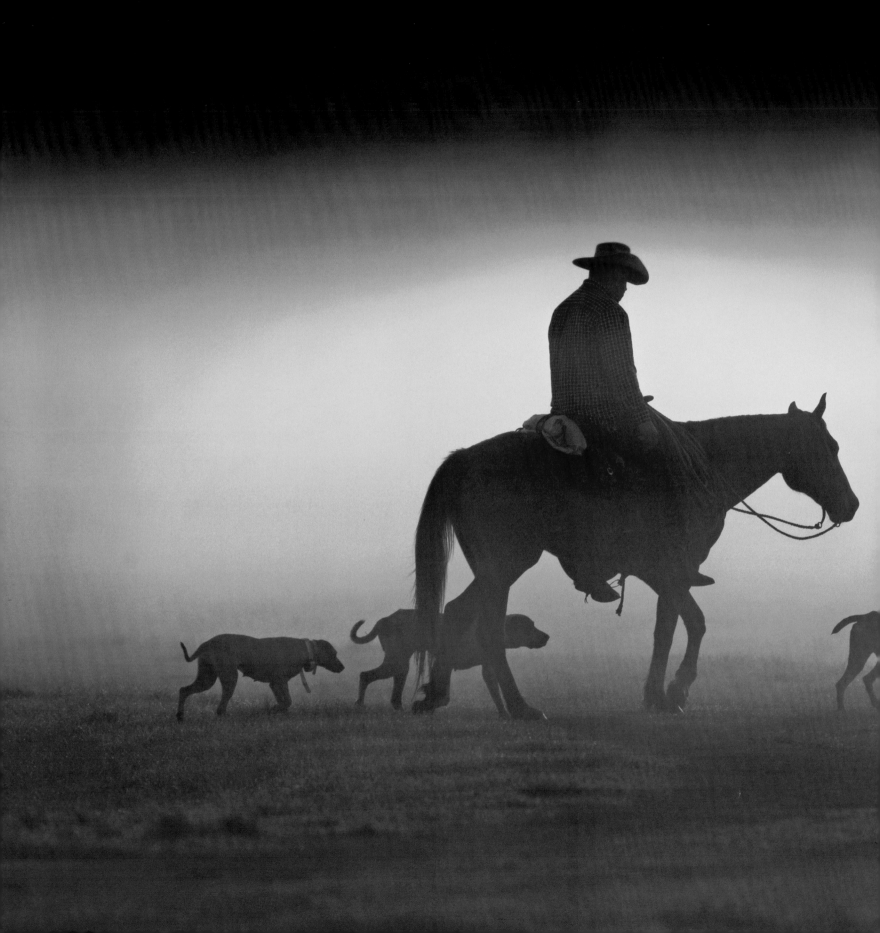

4

ON
COMMON
GROUND

EARLY IN LIFE I LEARNED a lesson about protecting the land, and it has guided my outlook ever since. My father died unexpectedly when I was 21, and my family was forced to sell a small cattle ranch in the middle of our Central Florida town to help pay the estate tax. We watched hundreds of offices and condos spring up seemingly overnight on our former homestead. It bothered me that I didn't know what had happened to the abundant wildlife that had once lived there, and I prayed it had relocated to habitable land. The development overwhelmed the existing water and sewer system, resulting in flooded homes and damage to the ecosystem. I realized that this destruction would happen on a larger scale if ranchers and landowners like myself didn't conserve their land. I vowed to never sell another piece of land, and to fight to preserve the green spaces and precious natural habitat left on the ranches of Florida.

A lifelong rancher, I get up before sunrise every morning to start a physical, hands-on day of work. My daily activities revolve around the cattle-working season. I start each day taking care of what didn't get finished the day before, often related to those unexpected circumstances that define my workaday world: a repair after a car took out a mile of fencing on a major highway; cattle that need to be moved because of drought or flood, or that need hay because of a frost that morning; wildfires to extinguish. One constant amid these labors is the presence of wildlife. Job to job, ranch to ranch, you see how many animals—whether a white-tailed deer, an Osceola turkey, a bald eagle, or a crested caracara falcon—coexist with the cattle,

coexist with humans. They all need the same basics to thrive: food, shelter, and clean water. That is true, too, for Florida panthers, but they also have a need to roam long distances. If we don't maintain a statewide wildlife corridor and preserve vast ranchlands, they won't survive.

I MOSTLY SEE PANTHER TRACKS around our grove lands during the day. Panthers do most of their traveling at night to hunt, but I have spotted several males in the vicinity of our Central Florida ranch at odd hours. In 2019, I saw a panther alongside a fence line right at sunset. It was stalking a group of hogs rooting in a grass pasture. The next morning, I saw a sow carcass not far from where I had seen the panther the night before.

Ranchers in my area typically do not find any livestock maimed or killed by panthers; more likely, only a few hogs and varmints are missing. Panthers are known to kill only intermittently and save their food supply for future feedings. By contrast, coyotes kill nightly, sometimes up to three times a night, and often waste their food. We don't have any challenges with the panthers on our ranches because we have an abundance of feral hogs and varmints that seem to be their preferred food source.

The general public in Florida has embraced the mission to save the Florida panther, much as it rallied around the plight of the manatee beginning in the 1980s. These causes don't just bolster appreciation for a specific species; they raise awareness of the state's natural beauty as well.

ABOVE: Florida cattleman Cary Lightsey sorts his herd in pens on his home ranch near Lake Kissimmee while working with cattlemen Kenny Rainey and Freddie Griffin, in the background. PREVIOUS PAGES: Bobby Yates, a foreman with the Seminole Tribe of Florida, crosses a pasture at the Brighton Reservation with his dogs at dawn.

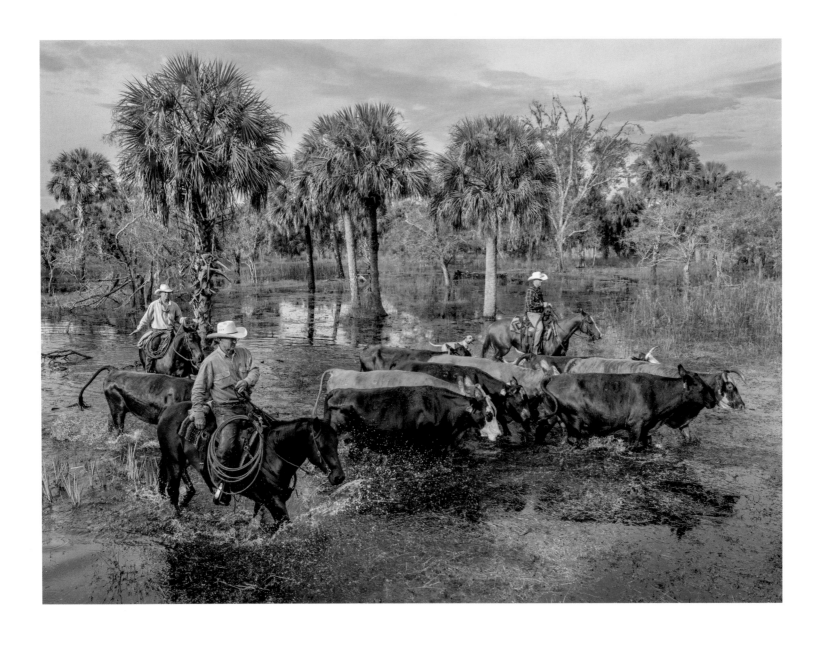

Multigenerational Florida ranchers Doyle Carlton III (foreground) and his son Dale (background right) and cowboy Brian Alexy move a herd across Horse Creek Ranch east of Sarasota. The Carlton family recently protected this family ranch through a conservation easement with state funding following the creation of the Florida Wildlife Corridor Act.

Many cattle ranchers have become champions of preserving Florida's rare ecosystems and wildlife and have chosen to keep their ranchlands intact. This is particularly true of ranchers who have held onto their properties for a century or more, through to the fourth and fifth generations, and who have a deep-seated commitment to keeping these historic properties prospering with many generations of their families living and working on the same piece of land. I would think that 80 percent of our state's ranchers today would love to do a conservation easement on their land, as long as funds are available to buy the development rights and the restrictions to continue cattle ranching aren't too severe. In fact, the waiting lists for our state conservation programs show nearly 200 ranchers seeking conservation easements with Florida Forever and the Rural and Family Land Protection Program. These landowners alone would protect more than a million acres (400,000 ha) from development. But there has not yet been enough state funding to realize the opportunity to conserve their properties.

That funding needs to come soon. My neighbors and I are constantly getting calls from real estate developers, and plans for a retirement community the size of a new city are targeting ranches around the corner from ours right now.

ALTO "BUD" ADAMS, a personal hero of mine, showed how it could be done. He was an early proponent of the wide-scale conservation of land, and one of a handful of people who realized early on that a wildlife corridor was essential to the survival of our native species.

As I rode through his ranches with him, looking at his marvelous wildlife and cattle photography, he taught me how cattle and wildlife can live together. He would say cattle and wildlife enhance and help one another to survive: Cattle need birds to help remove flies and insects from their hides; cattle graze and clear out areas of dense forest where deer and turkeys can roam. Those birds that eat insects on and around cattle are a source of food for panthers. Mr. Bud, as he was known, knew what it took to operate a sustainable ranch before anyone knew what that meant. He talked about leaving a small carbon footprint on this Earth, even while running one of the largest cattle ranches in the United States.

For my wife, Marcia, and me, our children, grandchildren, and future great-grandchildren were a big influence on our decision to do conservation easements on 92 percent of our ranchlands in Florida. We wanted to make sure that our descendants have a chance to see what old Florida looked like and to live our generations-old cattle-ranching lifestyle. Saving the Florida panther is at the center of our objective to keep our traditions alive. ●

CARY LIGHTSEY is a sixth-generation cattleman and a pioneering conservationist. With his older brother Layne and their families, he owns more than 18,000 acres (7,280 ha) and leases another 17,000-plus (6,880 ha) acres of pasture and farmland just south of Orlando and in southern Georgia. They have preserved thousands of environmentally sensitive acres of wetlands and areas populated by endangered plant and animal species.

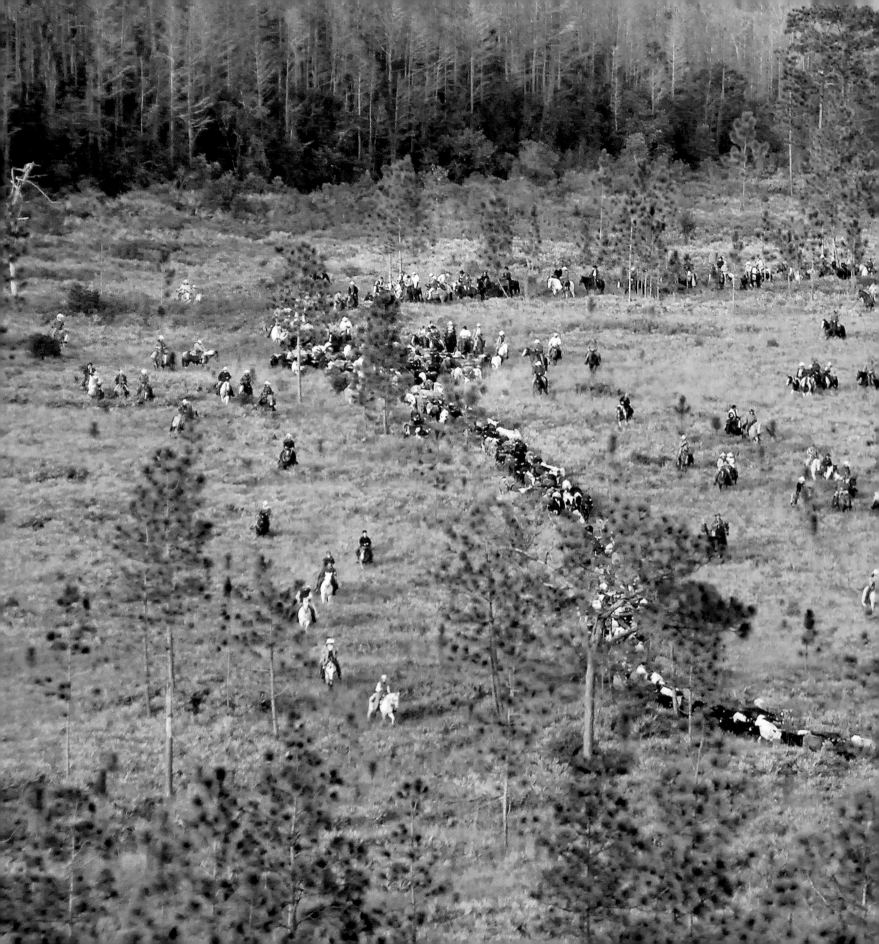

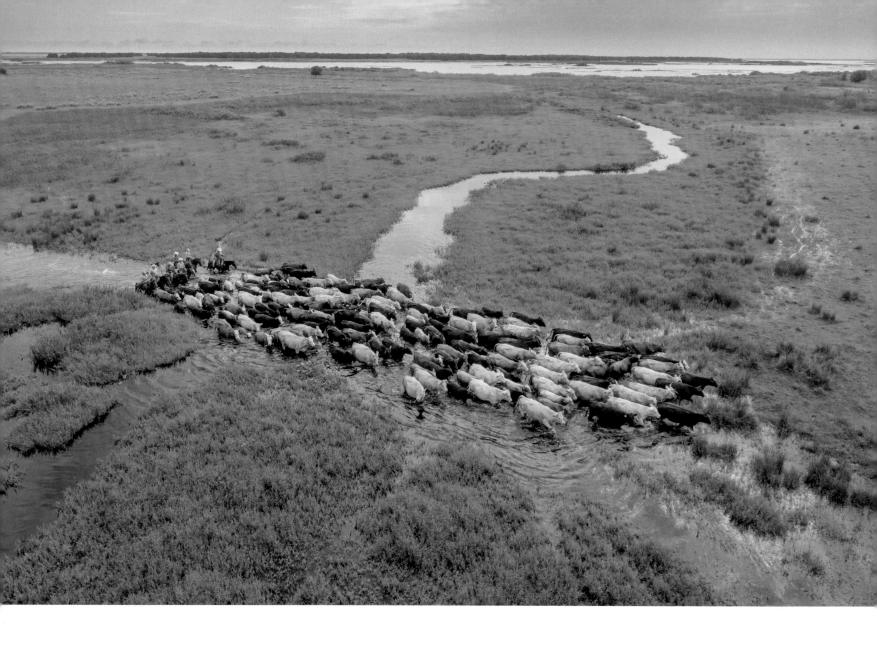

ABOVE: Cowboys move a herd of cattle across Otter Slew on the way to cow pens on the Lightsey Ranch near Lake Kissimmee (pictured in the background). The Lightsey family has been ranching in Florida since the 1850s, and they have recently protected more than 90 percent of their land with conservation easements, benefiting the Florida Wildlife Corridor and protecting the Everglades Headwaters from development. **OPPOSITE:** Cattle are moved into pens for sorting at Buck Island Ranch, an active research ranch owned by Archbold Biological Station. Cattle on Florida ranches spend most of the year grazing in open pastures, with around one cow per five acres (2 ha), and are brought into pens a few times a year for medical checks, parting, and shipping. **PREVIOUS PAGES:** A herd of 500 cattle, driven by nearly as many riders, weaves through pine flatwoods in front of a cypress strand in Three Lakes Wildlife Management Area. Participants in the Great Florida Cattle Drive of 2006 drove cattle for a week across the Kissimmee Prairie, camping under the stars, to commemorate Florida's history of ranching. The first Great Florida Cattle Drive was organized in 1995 to commemorate 150 years of Florida statehood. Subsequent drives in 2006 and 2016 were not able to follow the original route because so many ranches had been lost to development.

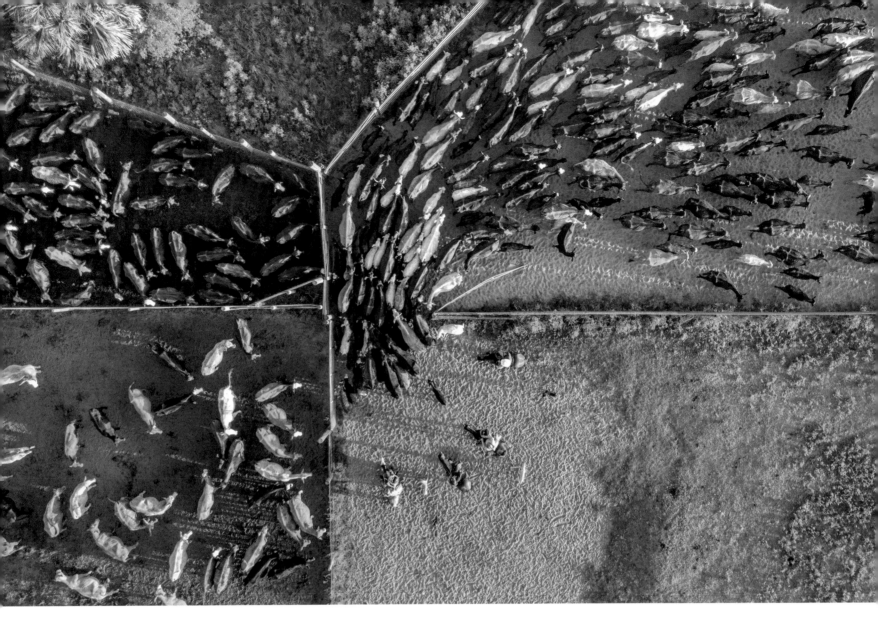

ABOVE: At the time of this portrait in 2008, legendary Florida rancher Freddie Griffin was the cattle foreman at Lykes Ranch. He retired after 40 years, and today, at age 82, he still works every day on horseback for ranches throughout the Florida Wildlife Corridor. **OPPOSITE:** Peyton Chandley, representing the eighth generation of Lightsey ranchers in Florida, helps move cattle through the parting chutes at one of her family's ranches in the Northern Everglades, where she regularly works between classes for her animal science degree at the University of Florida.

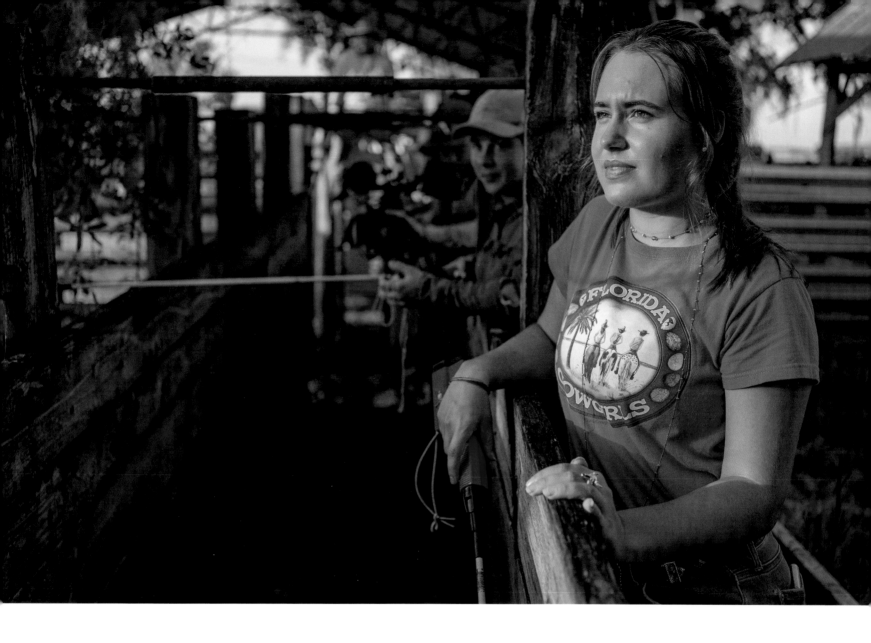

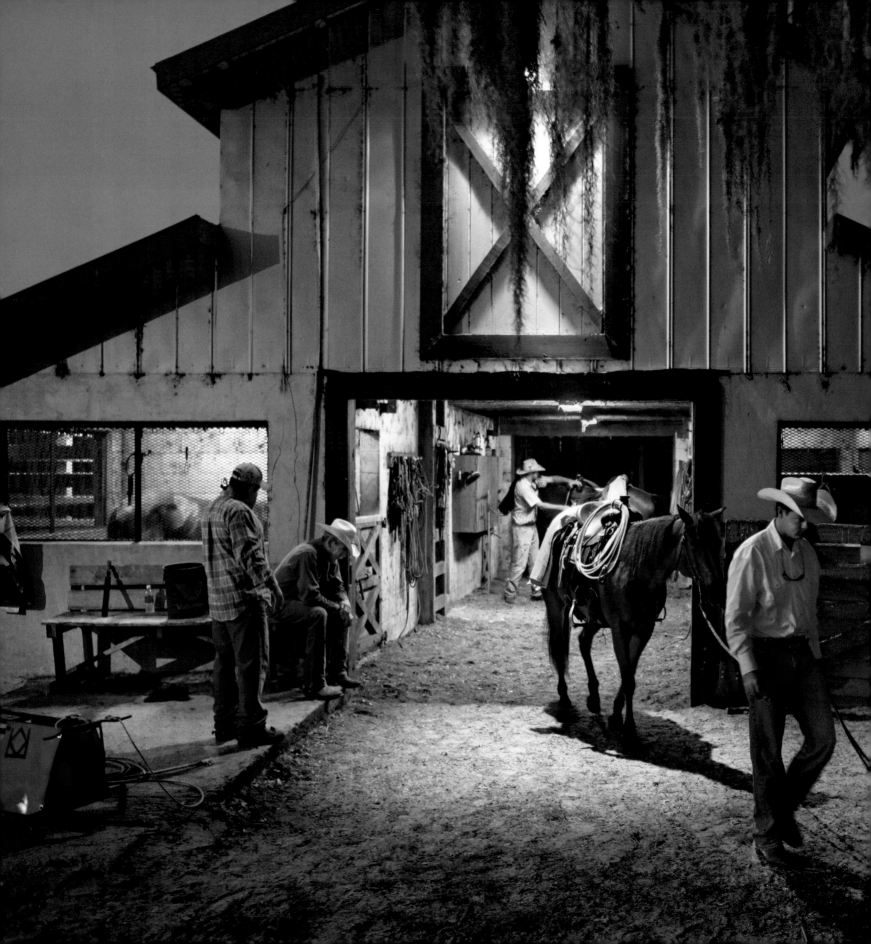

Florida ranchers like Bobby Joe Fulford, leading his horse from the stables at his ranch along the Okaloacoochee Slough, are underappreciated heroes of the Florida Wildlife Corridor. Every day before dawn, they ride on horseback, quietly serving as guardians of land that represents one-sixth of the state and provides essential habitat for panthers and other wildlife.

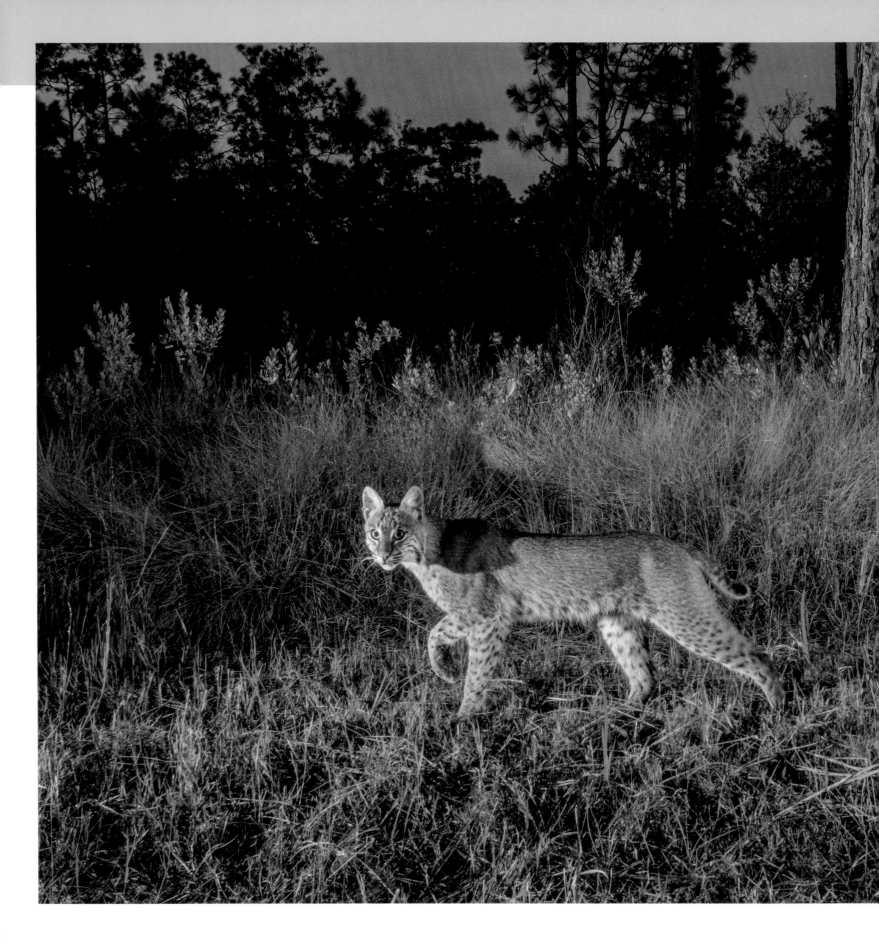

CTF-028 | LYKES RANCH

In the panther's core range in South Florida, there are four million acres (1.6 million ha) of contiguous public land, which, combined with adjacent ranches, have provided for the species' recent rebound. The land that represents the next stage for the panther's recovery north of the Caloosahatchee River comprises mostly private ranches, interspersed by a smaller proportion of public preserves.

The historic Lykes Ranch encompasses more than 300,000 acres (121,400 ha), including property in the Florida Wildlife Corridor just north of the Caloosahatchee River, providing vital habitat for the northward recovery of the Florida panther. This camera trap was placed along a trail of longleaf pines to celebrate the diversity of wildlife it supports.

Working with partners like the Nature Conservancy, state of Florida, and U.S. Fish and Wildlife Service, Lykes Ranch has already protected more than 48,460 acres (19,600 ha) in conservation easements.

This camera trap site on Lykes Ranch was selected to highlight the rare longleaf pine, the cutthroat grass habitat, and the wildlife it supports, such as this bobcat hunting in evening twilight.

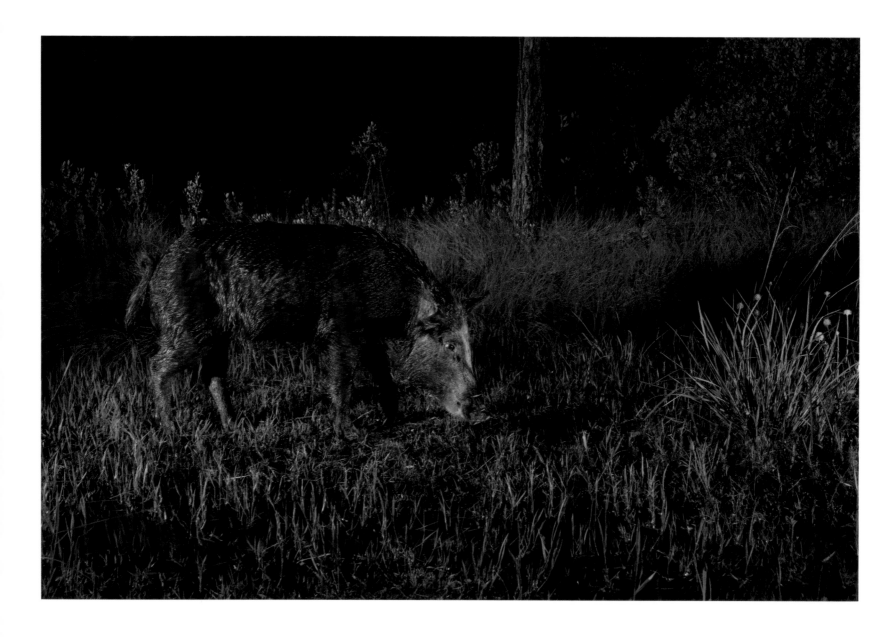

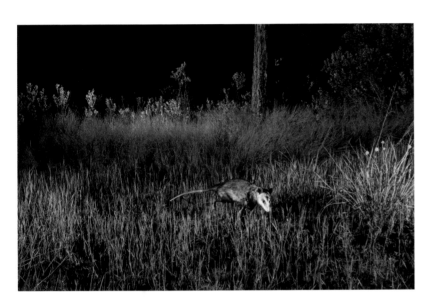

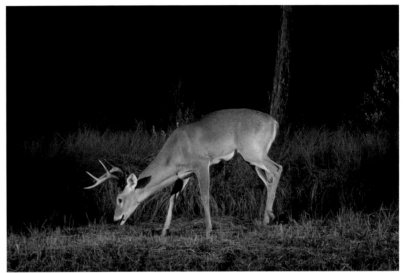

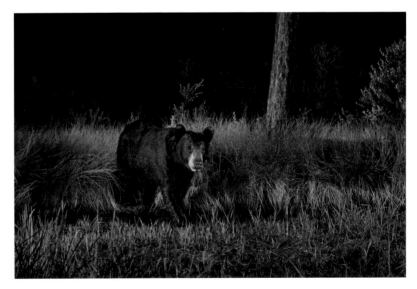

CLOCKWISE FROM OPPOSITE: A few of the animals that share this trail beneath the longleaf pines are the wild hog, an invasive species that came from Spain in the 1500s; Virginia opossum, the only native species of marsupial in North America; white-tailed deer, which human hunters and panthers alike seek; and Florida black bear.

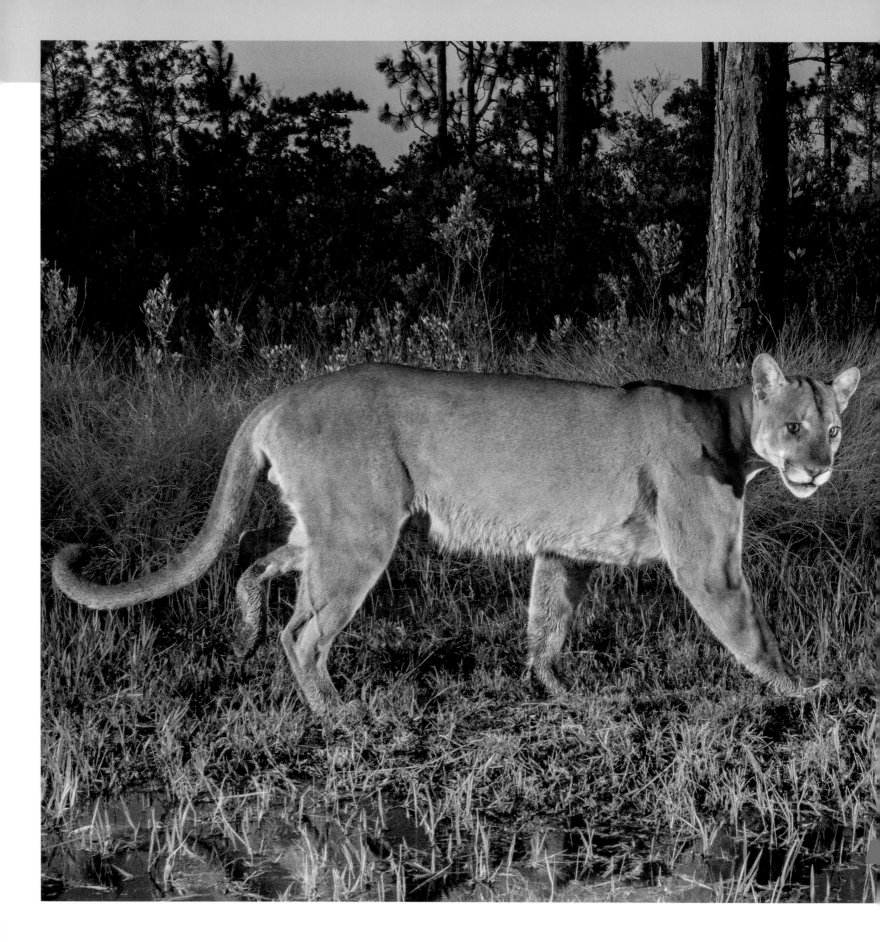

This male Florida panther passed by the camera trap on an early evening in June 2020. During the time a camera was monitoring this trail, a male panther came through approximately once a year, likely patrolling a vast territory that extends to many adjacent ranches and public conservation lands.

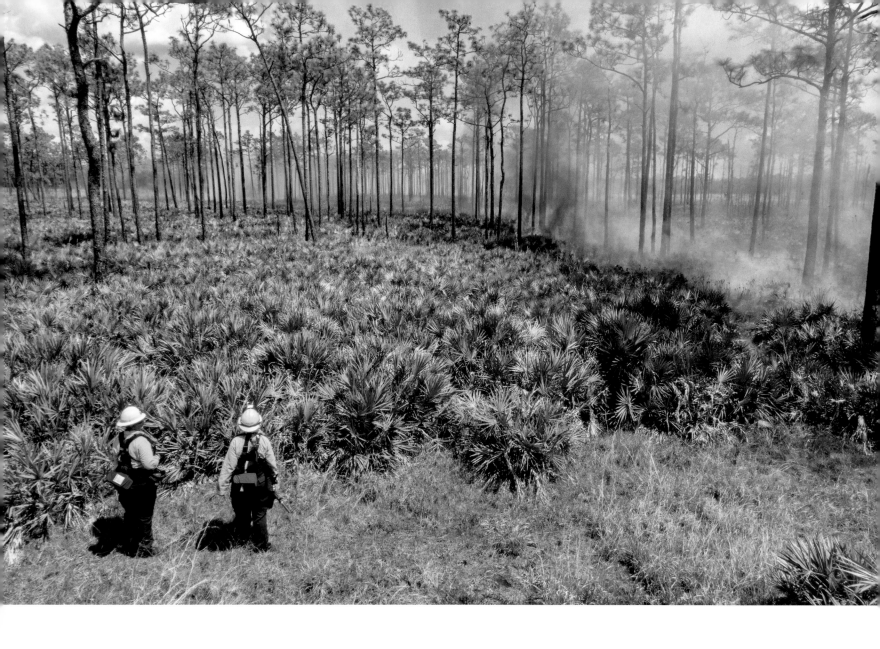

ABOVE: Prescribed fire, pictured here at the Nature Conservancy's Disney Wilderness Preserve, is an important tool for maintaining the health and biodiversity of pine forests in Florida and the Southeast. Historically, fires occurred frequently, usually caused by lightning near the beginning of the rainy season in late spring and early summer. Fire has also been used to maintain the health of the palmetto flatwoods, supporting a diversity of wildlife. OPPOSITE: David Ward Jr. (left) and David Ward III hunt for quail on their family's Quail Creek Ranch in south-central Florida. Land conserved and managed for hunting is a vital component of the Florida Wildlife Corridor.

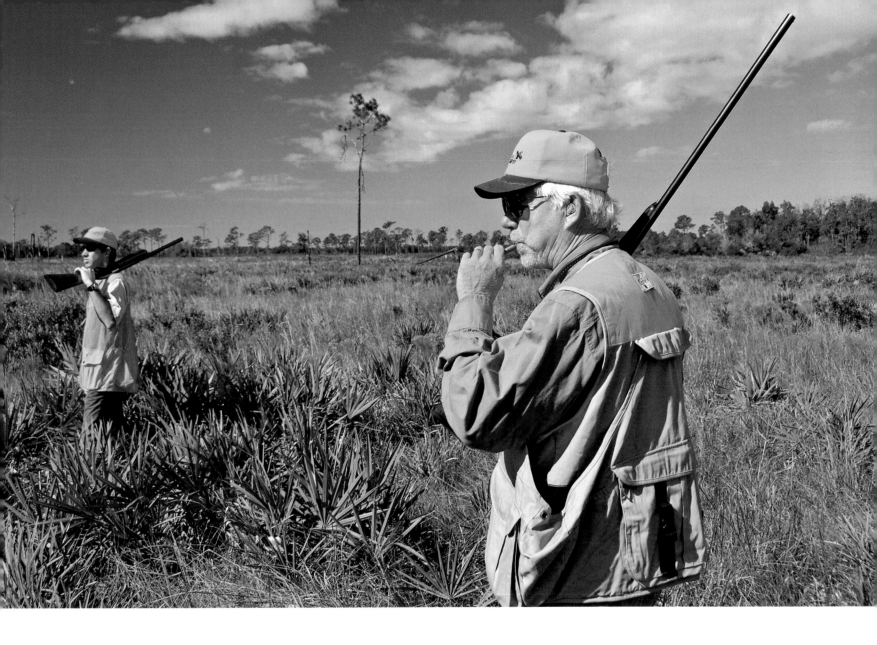

Smoke filters through an oak hammock on Limestone
Creek Ranch, west of the Peace River, while purposely
set fire burns through the adjacent pine flatwoods.
Fire in the higher and drier pine habitat will typically
stop on its own when it reaches the edges of lower
and wetter habitats, including oaks and cypresses.
Many Florida ranches sustain a mosaic of plant
communities ideal for supporting wildlife and panthers.

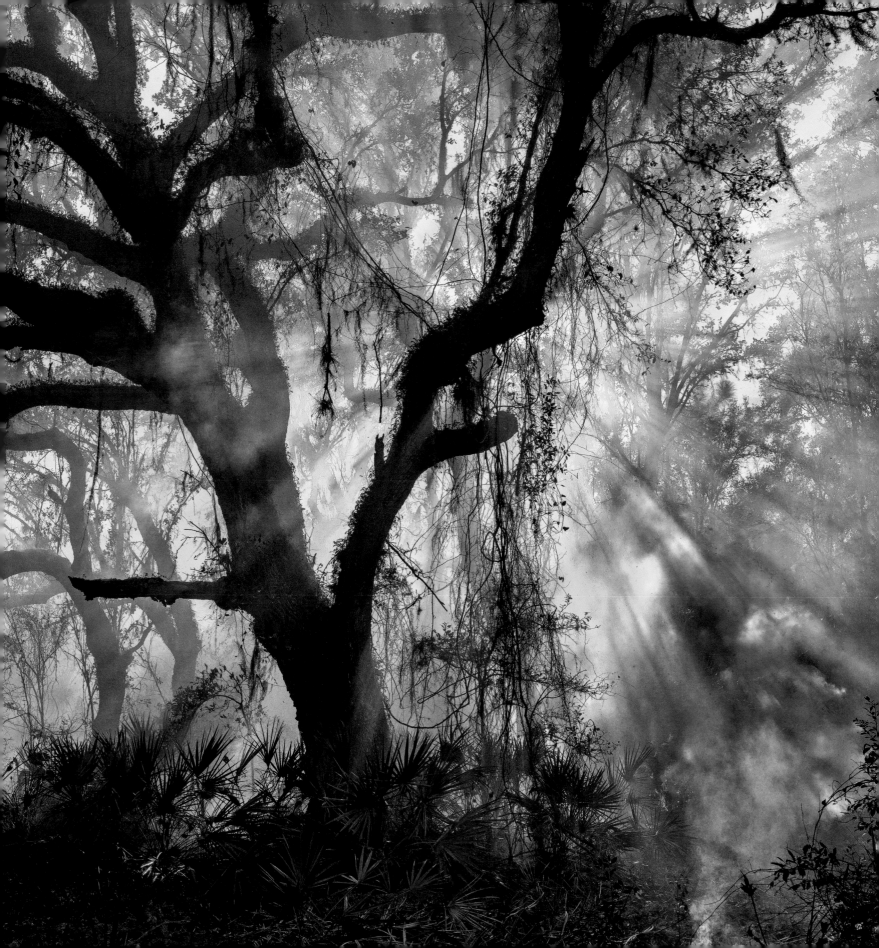

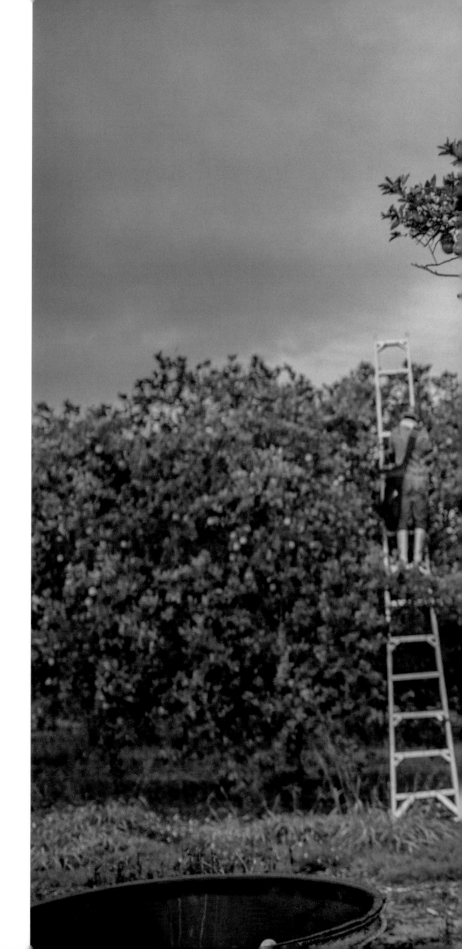

Other forms of agriculture provide important habitat for panthers, including citrus groves. Lino Perez picks oranges on Cypress Creek Grove, a location in the Florida Wildlife Corridor just north of the Caloosa-hatchee River so important for panther movements that the Nature Conservancy privately funded an easement to ensure it will never be developed.

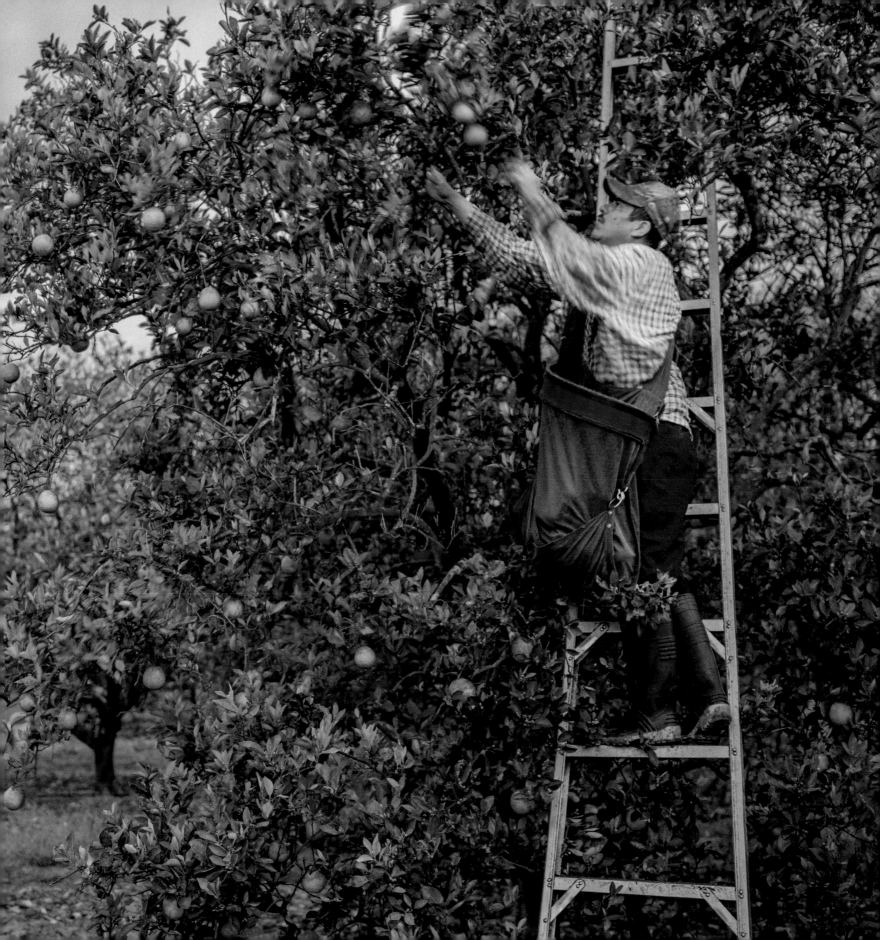

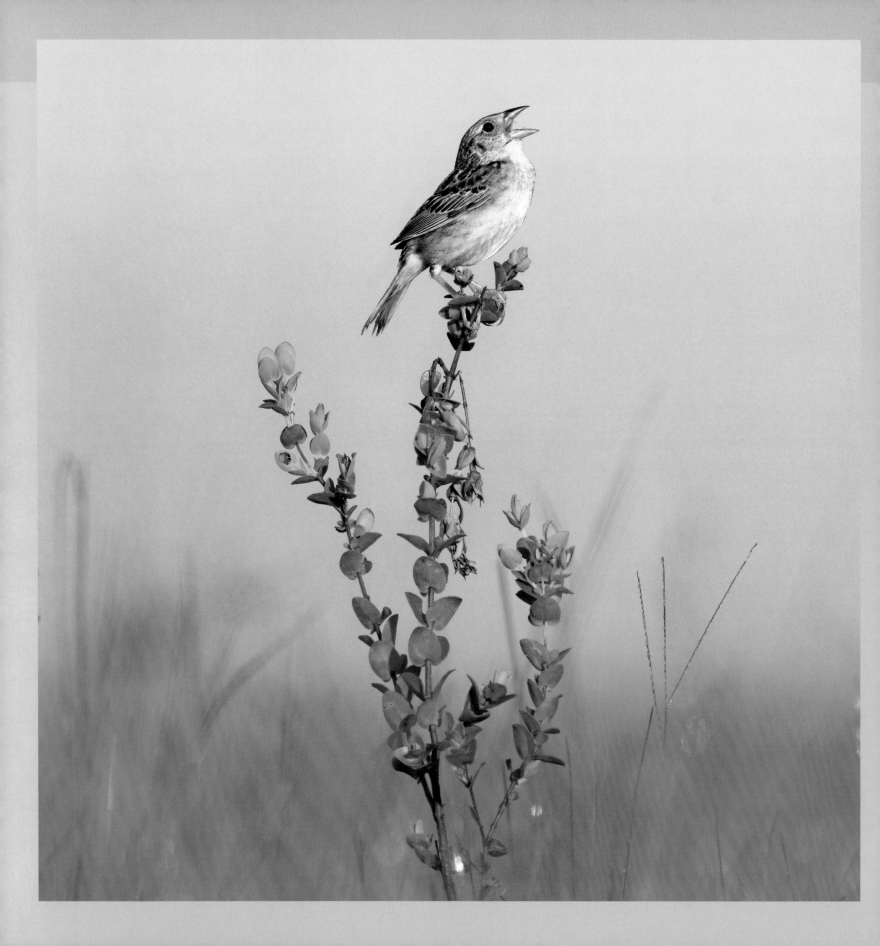

SAVING THE GRASSHOPPER SPARROW

CRAIG PITTMAN

ASHLEIGH BLACKFORD HAS seen her share of dramatic bird releases over the years. She vividly recalls California condors soaring high into the sky and San Clemente loggerhead shrikes fluttering free. The tiny Florida grasshopper sparrow, on the other hand, merely hopped out of an open screen and skittered along the ground, says Blackford, a U.S. Fish and Wildlife Service biologist.

Still, it was a thrilling moment to witness: One of the most endangered birds in the continental United States—one that just two years ago seemed doomed to extinction—had begun a remarkable comeback.

No more than five inches (13 cm) long, Florida grasshopper sparrows have a flat head, short tail, and black and gray feathers that camouflage their nests built in the low shrubs and saw palmettos of the state's grassy prairies. Their name comes from their call, which consists of two or three weak notes followed by an insectlike buzz.

The Florida grasshopper sparrow was first described in 1902 by U.S. Army surgeon Major Edgar A. Mearns. Back then, the birds were widespread across central and southern Florida. By the 1970s, though, most of the prairies that form their habitat had been ditched, drained, and converted to pastures or sod production. By 1986, the sparrow population had plummeted to a mere thousand. By 2013, fewer than 200 of the little songbirds remained.

To save the species, federal officials decided to launch a captive-breeding program. The eggs went into incubators at a pair of breeding facilities, and on

ABOVE: Rancher David "Lefty" Durando (right) works with biologist Erin Myers from the U.S. Fish and Wildlife Service to identify, conserve, and restore dry prairie habitat and compatible pastures to support sparrows. **OPPOSITE:** A Florida grasshopper sparrow, among the most endangered birds in North America, sings from a perch at the newly protected Corrigan Ranch in the Everglades Headwaters south of Orlando.

May 9, 2016, the first four captive-bred Florida grasshopper sparrows hatched.

In September 2020, their progeny—that season's young birds—took flight for the first time. About 65 percent of them had one or both captive-bred parents.

It was what the scientists had been waiting for: They'd proven that the offspring of captive-bred grasshopper sparrows could thrive on their own and boost the wild population. ●

CRAIG PITTMAN has written numerous books about Florida, including *Cat Tale,* a nonfiction book about saving the Florida panther.

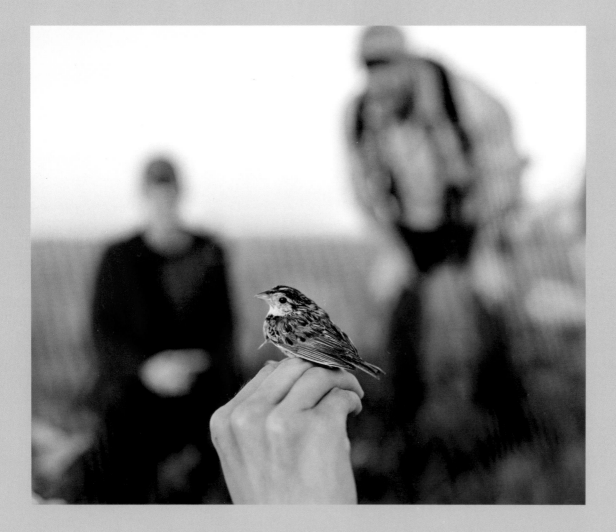

ABOVE: Biologists catch sparrows such as this one using mist nets. Once caught, they band them to monitor the population and bird movements. **RIGHT:** Two Florida grasshopper sparrows fly out of their release aviary into Florida dry prairie habitat south of Orlando. These birds were raised through a conservation breeding program that has boosted the wild population and is providing new hope for the survival of the species.

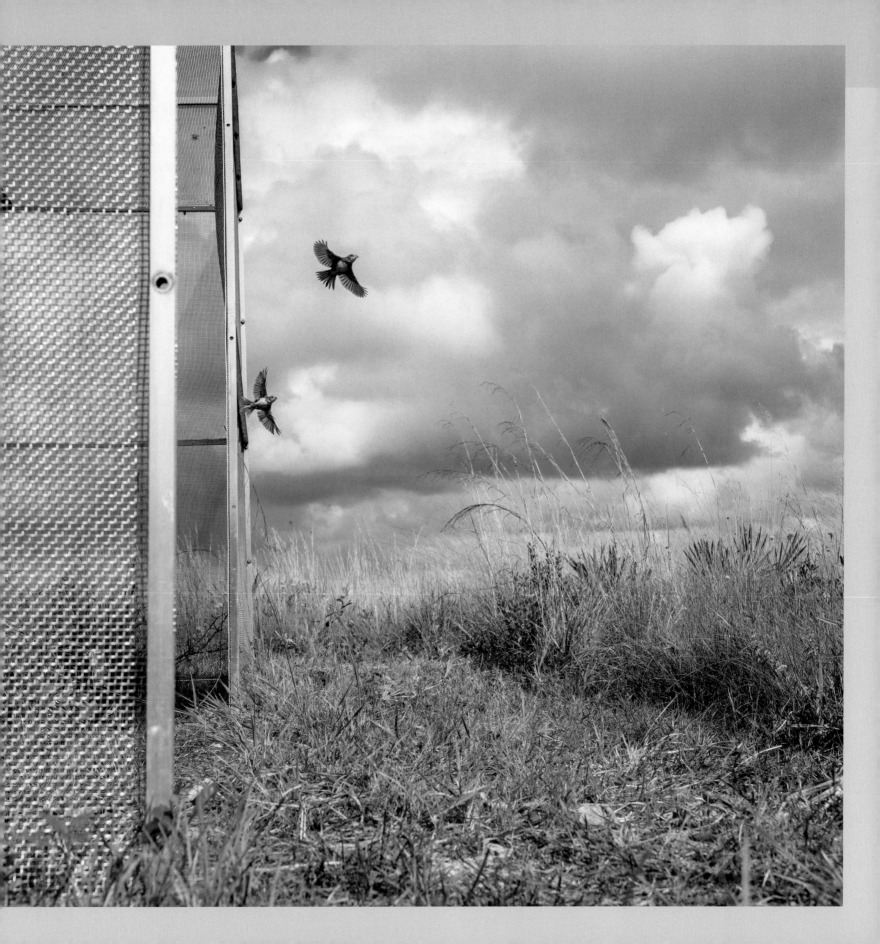

Flocks of white ibises fly low over the Green Swamp north of Tampa. Like cattle ranches, working forests are an essential component of the Florida Wildlife Corridor. Florida's large-scale working forests, predominantly in northern Florida and the panhandle, buffer and connect major public lands while sustaining millions of acres of wildlife habitat. Well-managed forests also supply clean rainwater to rivers, streams, and estuaries downstream.

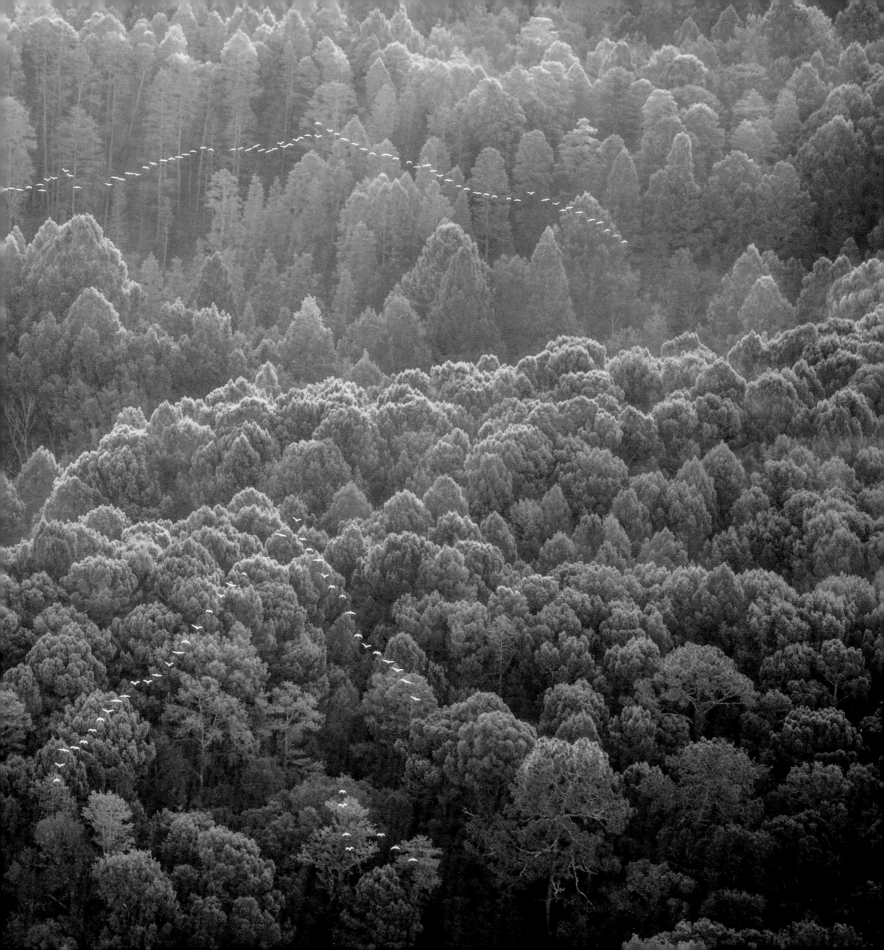

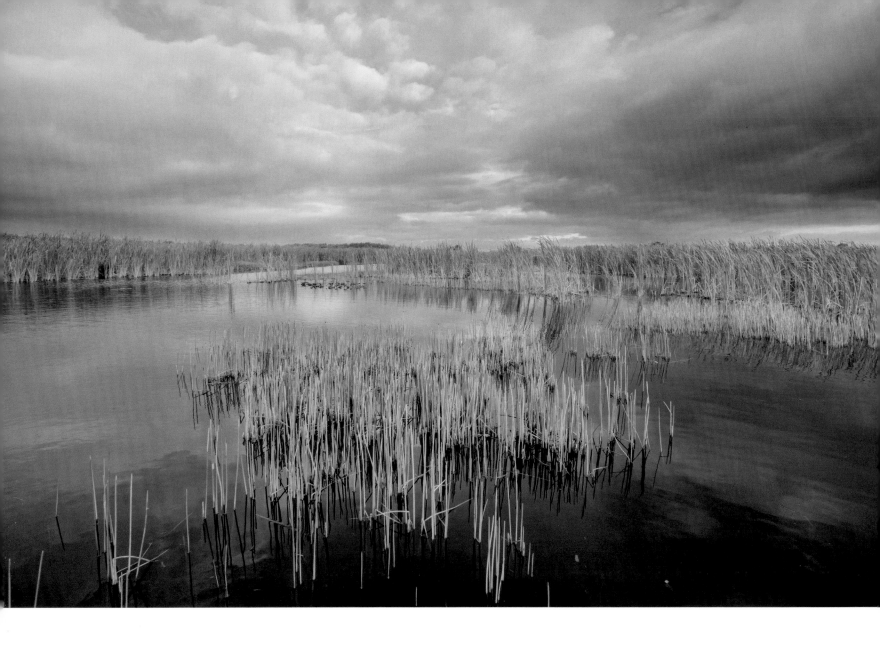

The Everglades Headwaters is a place where land and water conservation connect. Protecting this landscape is essential for the panther's northward recovery and for the health and restoration of the Everglades, Florida's biggest watershed.

ABOVE: Lake Okeechobee is the largest lake by surface area wholly contained in the United States, but it is polluted by excess nutrient runoff from agriculture and development. A solution for restoration is dispersed water storage, which involves protecting more land in its watershed and rehydrating historic wetlands that were drained during the past century. **OPPOSITE:** One of the biggest drainage projects was the Kissimmee River, formerly a winding eight-mile-wide (13 km) floodplain that was cut into a deep, straight canal, accelerating decades of pollution into Lake Okeechobee. Adam Bass, director of conservation for Conservation Florida, steers his mud boat through a recently restored section of the Kissimmee, where clean water and wildlife have returned. **FOLLOWING PAGES:** The Poinciana Parkway south of Orlando includes a bridge where it crosses the forested floodplain near Reedy Creek in the Everglades Headwaters. If more roads were built like this, where they cross the Florida Wildlife Corridor, it would facilitate the safe passage of both water and wildlife.

SAFE PASSAGE

VEHICLE COLLISIONS ARE the leading documented cause of death for panthers, killing nearly 30 every year. One way to mitigate losses is building wildlife crossings where busy roads intersect the Florida Wildlife Corridor.

Before transportation agencies will make the investment in wildlife crossings, habitat corridors on both sides of the road need first to be permanently protected. The land can be protected as a public preserve or through a permanent conservation easement on a working farm or ranch.

One model of success is a section of Interstate 75 known as Alligator Alley. This is where the interstate crosses the Everglades between Naples and Miami, and where most of the photos in this section were taken. Long stretches of highway cut through public lands, including Big Cypress National Preserve, which was established, in part, to protect panthers. That motivated officials to install fencing and build more than 30 wildlife crossings along most of its length. The design is effective. Rare instances when large wildlife are killed by cars occur when accidents or storms have compromised the fencing. ●

A Florida panther crosses safely beneath Alligator Alley from Picayune Strand State Forest to the south onto Florida Panther National Wildlife Refuge. The combination of wildlife underpasses and tall fencing along the road has nearly eliminated deaths of panthers and other large animals on this stretch of interstate highway.

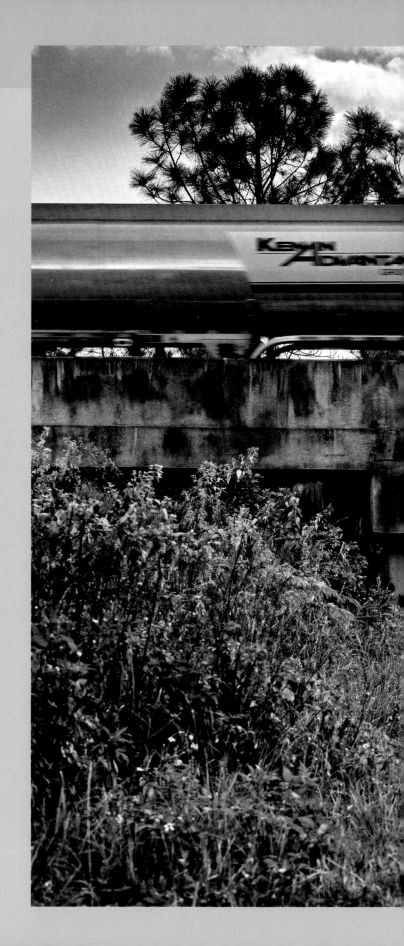

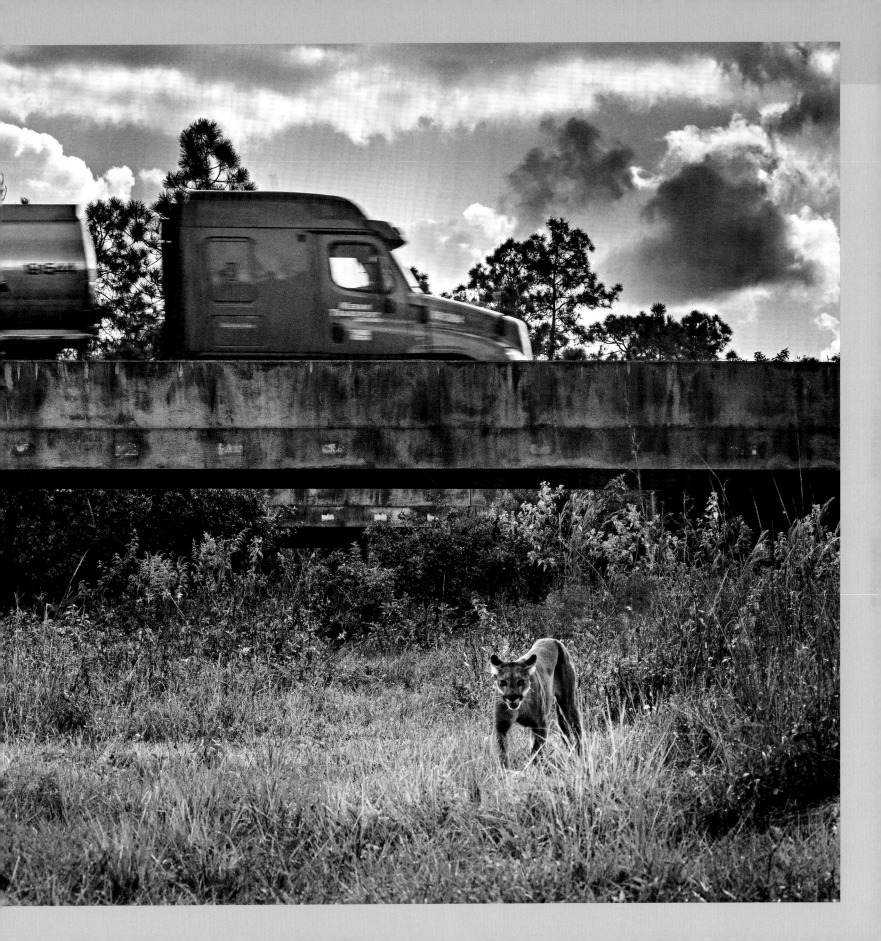

ABOVE: Workers erect new eight-foot-tall (2.4 m) fencing along a previously unfenced section of Interstate 75 east of Naples to help steer panthers and other wildlife off the road and toward wildlife crossings. **OPPOSITE:** This aerial photo reveals the design of the wildlife crossing pictured on page 202 and the following pages. Notice the placement of the fences to help funnel wildlife safely beneath the highway.

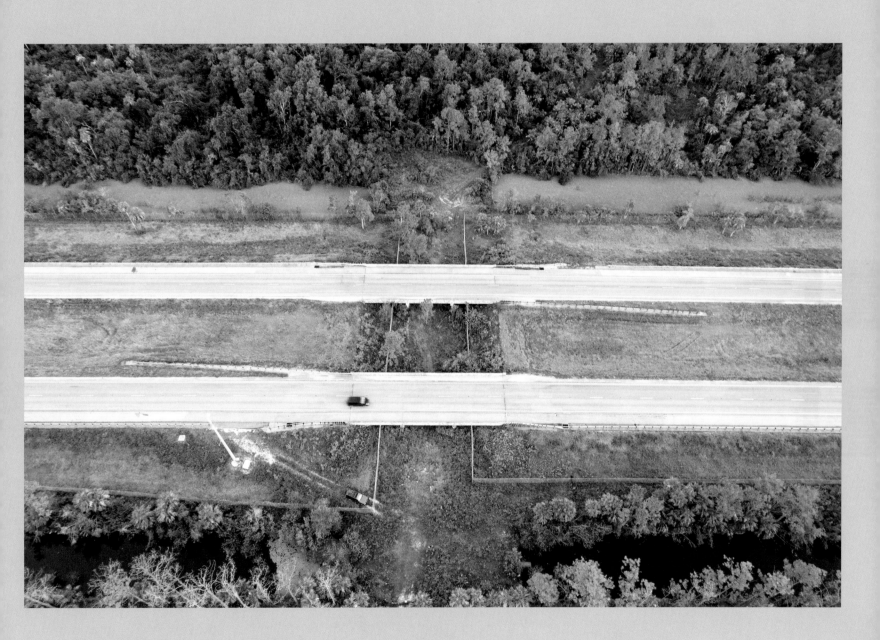

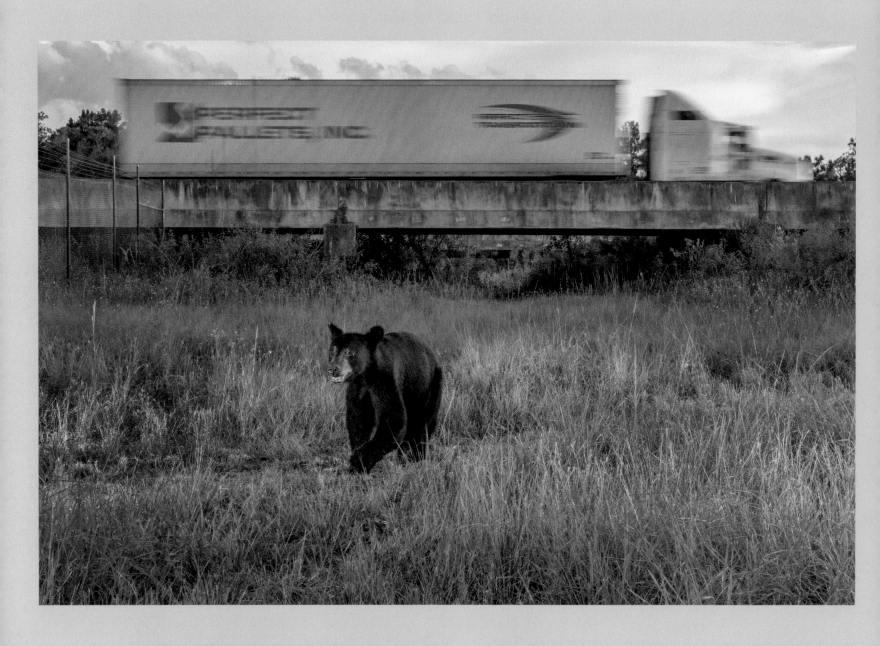

ABOVE: The camera trap focused on this underpass documents the variety of wildlife using it, including deer, bobcats, alligators, turkeys, otters, coyotes, and black bears. Animals would often walk quickly or run at the sound of cars and trucks racing by.
OPPOSITE: Over several years monitoring this site, the camera detected a panther coming through approximately once a month, most often at night. It was encouraging to see how well wildlife crossings can work to help protect people and wildlife.

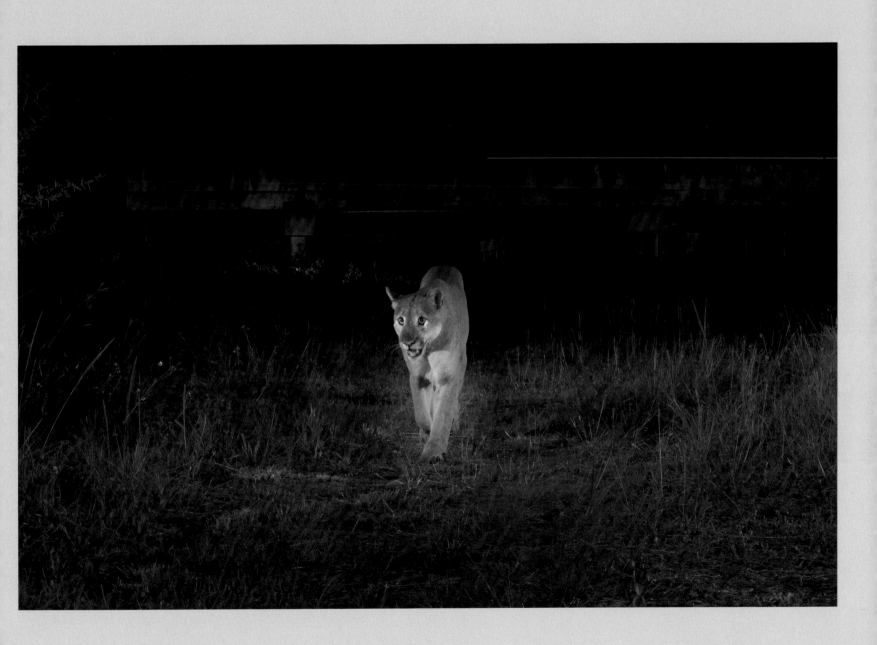

An innovation by the Florida Department of Transportation is to convert existing bridges over canals into wildlife crossings by simply adding a walkable ledge beneath the road. This panther is moving beneath State Road 80 east of LaBelle, from one cattle ranch with a conservation easement onto another. Having the land on both sides of the road in permanent conservation status is a prerequisite before a wildlife crossing can be built. This was taken by a specialized camera that uses invisible infrared light to minimize the disturbance of wildlife.

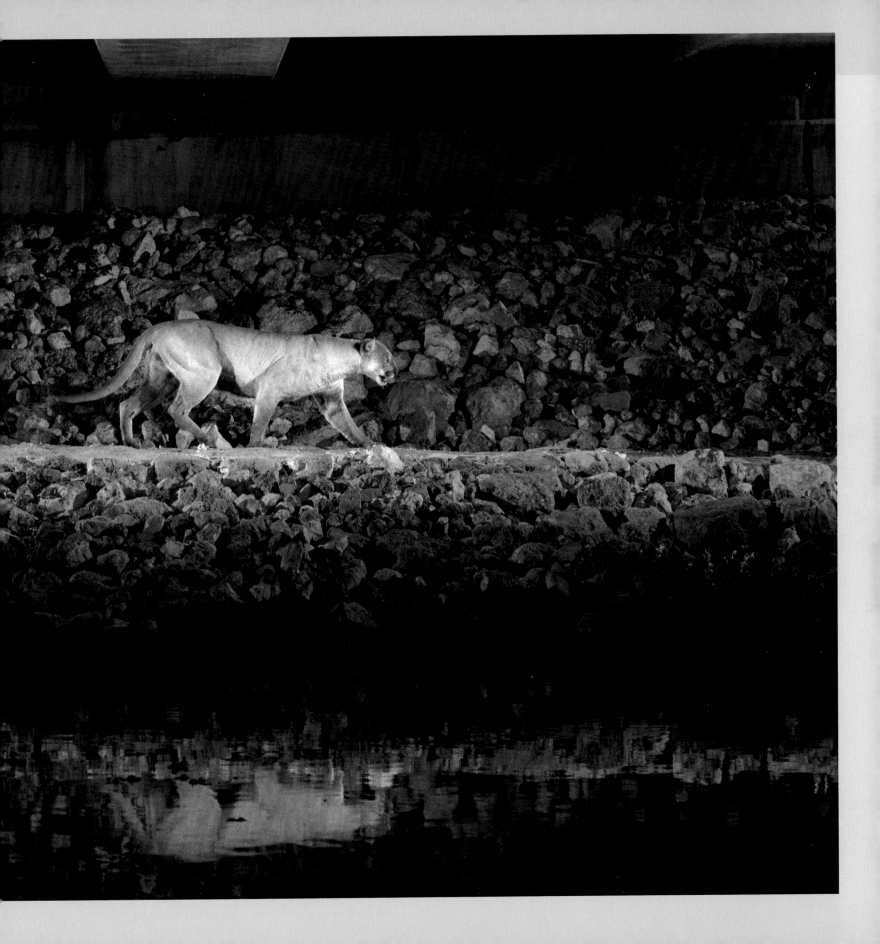

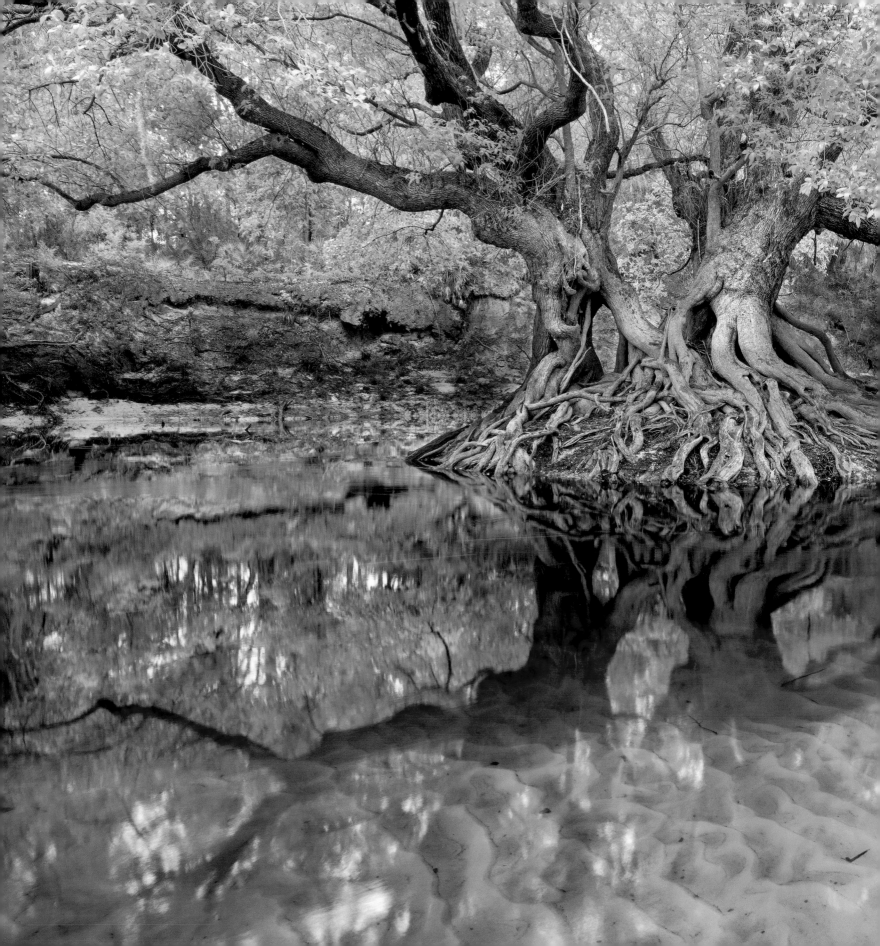

5

THE
PATH
FORWARD

THEY MIGHT HAVE once been unlikely allies, but the business leaders, conservationists, and cattle ranchers who gathered under a hammock of oak trees at the Nature Conservancy's Disney Wilderness Preserve in the Everglades Headwaters were celebrating a common cause: the Florida Wildlife Corridor Act, signed into law by Governor Ron DeSantis on a sweltering day in July 2021.

During the spring of that year, the Path of the Panther team, with support from the National Geographic Society and conservation partners, led the charge to focus state leaders on the urgent need to protect the Florida panther and its habitat, the Florida Wildlife Corridor. Floridians had already made clear their overwhelming support of conservation in a 2014 ballot initiative that pledged a portion of the state's excise tax revenue to be spent on invigorating natural resources. The unanimous passage of the Florida Wildlife Corridor Act advanced a bipartisan vision for the state that made protection of wild places a priority for both the public and policymakers.

But the act's passage was just an initial step in creating a permanently protected patchwork of lands. Hard work is ahead: Our team and partner organizations are using the framework of the new legislation to accelerate the pace of land conservation and achieve the permanent protection of the corridor. In the first

year since signing the Florida Wildlife Corridor Act, the state and federal governments have committed nearly $1 billion toward protecting the corridor. Iconic places such as the Coastal Headwaters, Chaparral Slough, Corrigan Ranch, Devil's Garden, and Horse Creek Ranch, all pictured in this chapter, are among the first to be conserved with this new investment.

At stake is the survival of the Florida panther; it will not rebound from endangered status without expanding its range throughout Florida and beyond. Of the Florida Wildlife Corridor's 18 million acres (7.3 million ha), eight million acres (3.2 million ha)—mostly working farms and ranches—remain vulnerable to development.

Conservationists know land protection must happen quickly. Recent studies suggest that Florida must accelerate the pace of conservation to keep up with habitat losses to residential and commercial development and to ensure that more parts of the corridor are connected. The immediate goal: protection of just under a million acres (400,000 ha) of corridor land by 2030. Rising to the challenge will require robust commitments from public and private leaders.

Fortunately, wildlife corridors are growing in recognition, nationally and globally. In the past few years, nearly a dozen U.S. states have adopted wildlife corridor legislation. And as the story of the panther shows us, wildlife corridors can become a shared framework that brings people together around the common ground of sustaining life on Earth. ●

PREVIOUS PAGES: An Ogeechee tupelo spreads its branches over the tannic waters of the Suwannee River in North Florida, just south of Georgia's Okefenokee Swamp. Studies have shown that panthers would thrive there. But a lot of work remains to protect enough of the Florida Wildlife Corridor so that panthers will have a path to return to North Florida and beyond.

TORI LINDER is a conservationist and impact producer. She is the managing director of the Path of the Panther project.

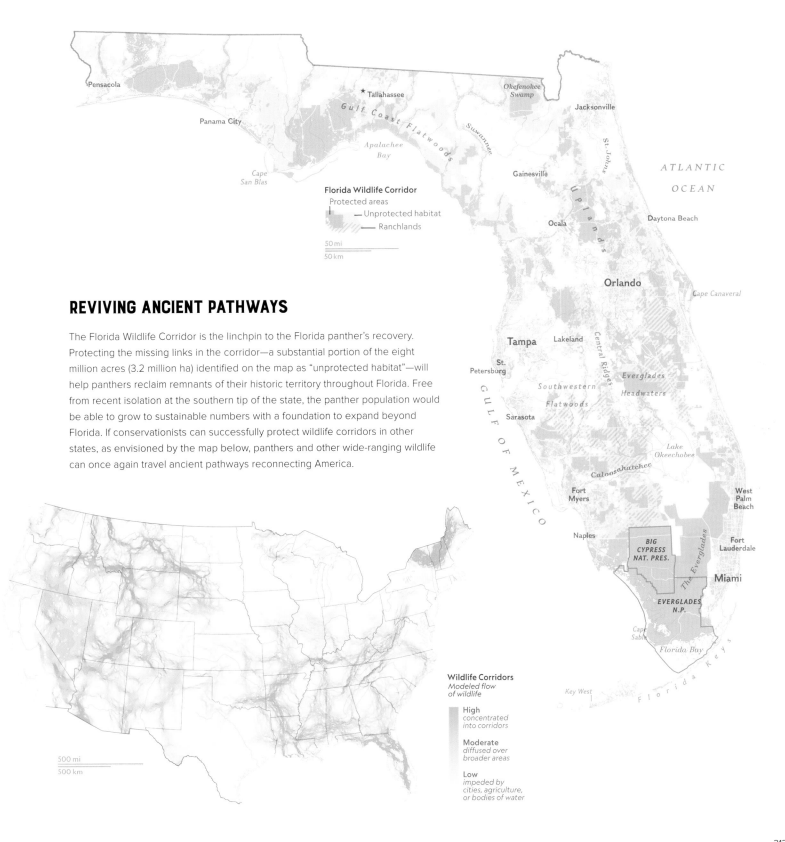

REVIVING ANCIENT PATHWAYS

The Florida Wildlife Corridor is the linchpin to the Florida panther's recovery. Protecting the missing links in the corridor—a substantial portion of the eight million acres (3.2 million ha) identified on the map as "unprotected habitat"—will help panthers reclaim remnants of their historic territory throughout Florida. Free from recent isolation at the southern tip of the state, the panther population would be able to grow to sustainable numbers with a foundation to expand beyond Florida. If conservationists can successfully protect wildlife corridors in other states, as envisioned by the map below, panthers and other wide-ranging wildlife can once again travel ancient pathways reconnecting America.

Florida Wildlife Corridor

Protected areas
— Unprotected habitat
— Ranchlands

50 mi
50 km

Wildlife Corridors
Modeled flow of wildlife

High
concentrated into corridors

Moderate
diffused over broader areas

Low
impeded by cities, agriculture, or bodies of water

500 mi
500 km

COASTAL HEADWATERS

Since signing the Florida Wildlife Corridor Act in June 2021, the state of Florida has been actively investing in new land protection. One newly protected property is in the Coastal Headwaters project. Working with partners including the Conservation Fund, Trust for Public Land, and owners of timberlands in northwestern Florida, the state is helping to fund conservation of wildlife habitat and waterways, such as Coldwater Creek, for the benefit of people and Gulf estuaries downstream.

FOLLOWING PAGES

EVERGLADES HEADWATERS

Sabal palms line pastures and prairies on the newly protected Todd Clemons Ranch in the Everglades Headwaters north of Lake Okeechobee and adjacent to restored sections of the Kissimmee River. This land was conserved through an easement with the Florida Department of Agriculture.

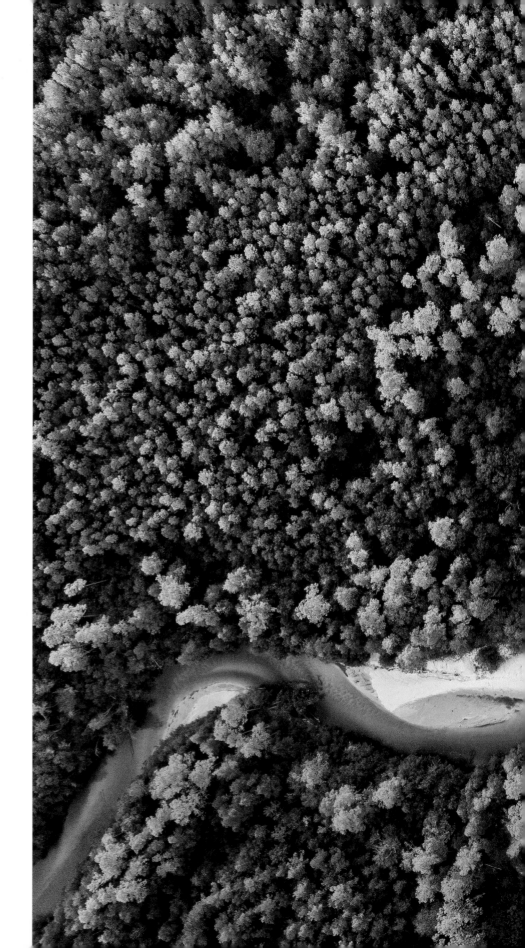

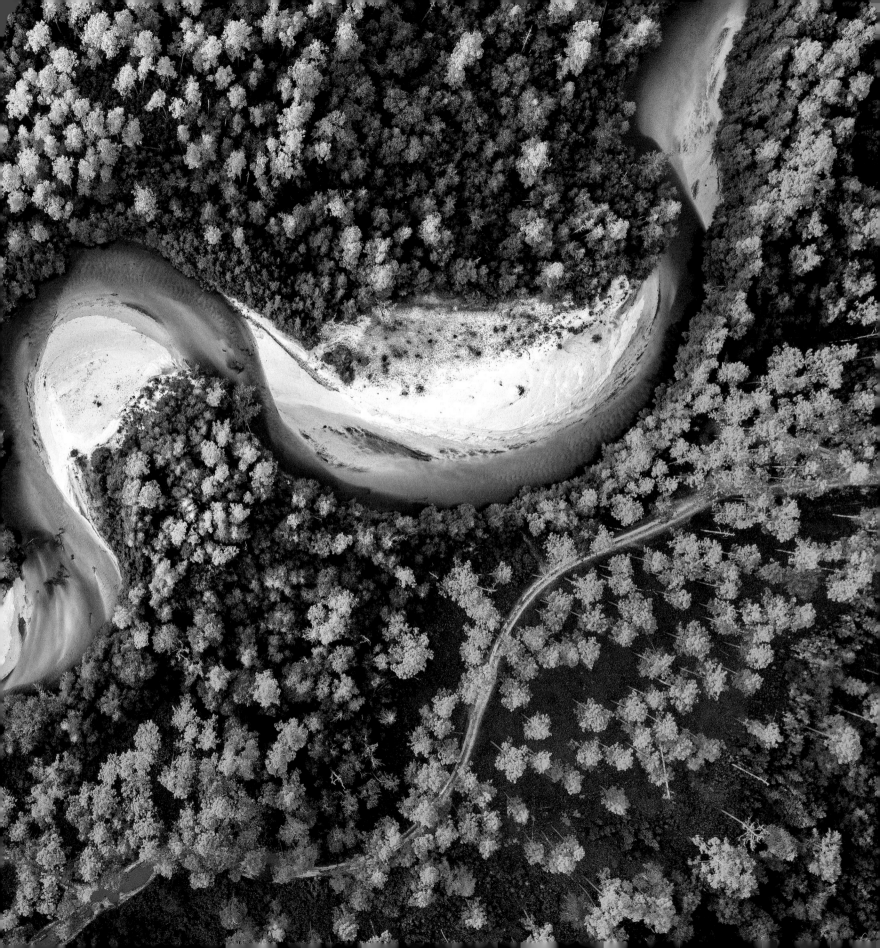

BLACKWATER RIVER STATE FOREST

Working timberlands in the Florida Panhandle combine with state and national forests to provide millions of acres of contiguous wildlife habitat. The state of Florida purchased this pine plantation north of Pensacola in 2021 to expand the adjoining Blackwater River State Forest. The U.S. Forest Service and National Fish and Wildlife Foundation's Acres for America program, in partnership with the Conservation Fund, provided additional funding. The planted slash and loblolly pines will soon be restored to native longleaf pines.

KISSIMMEE RIVER VALLEY

The Kissimmee River, which flows from Lake Kissimmee to Lake Okeechobee, is the main artery of the Everglades Headwaters and the centerpiece of a conservation opportunity more commonly seen in the western United States hidden in the East. This photo shows where the drainage canal cut in the 1960s has been returned to meandering river with a wide floodplain. Earthworks for the 20-year-long restoration project were completed in 2021. Conservation of the Kissimmee River Valley is vital to the health of Everglades water and the northward recovery of the Florida panther.

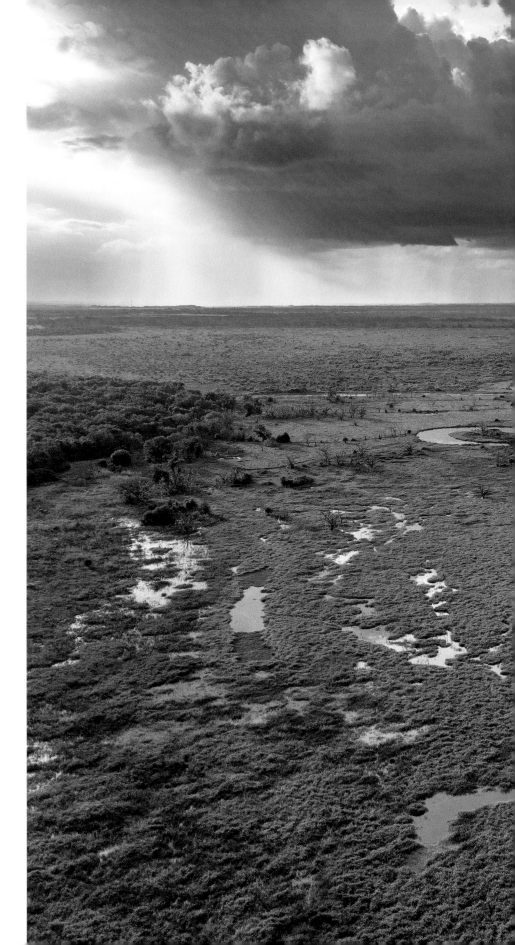

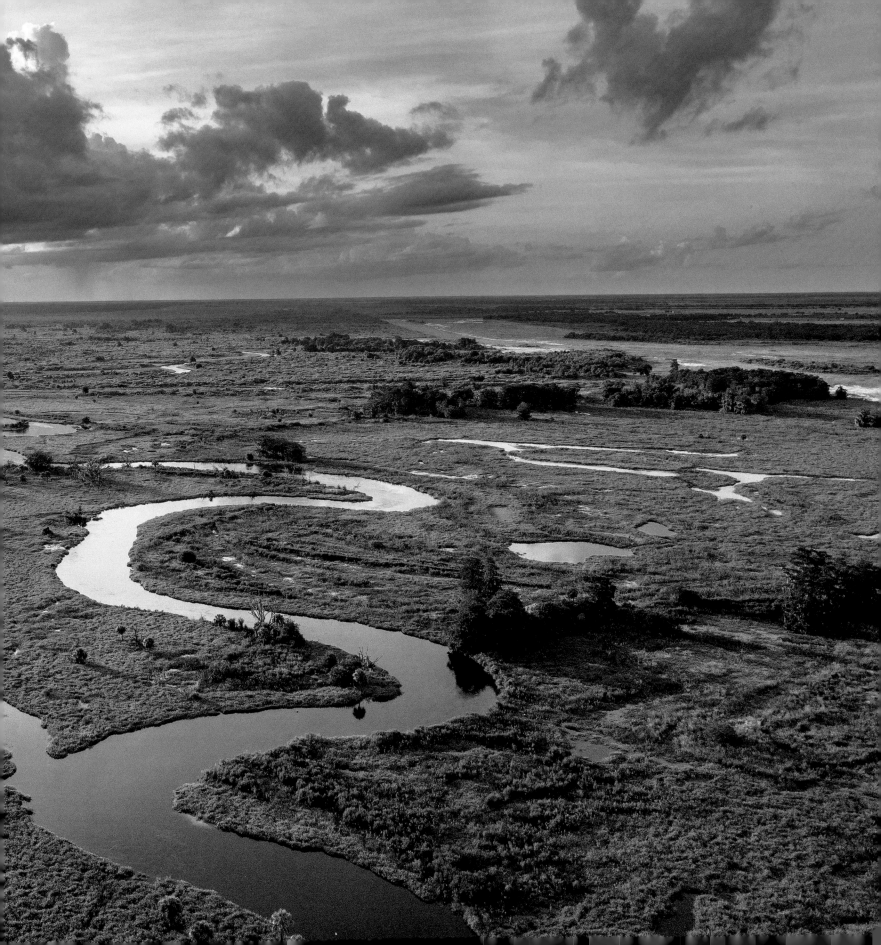

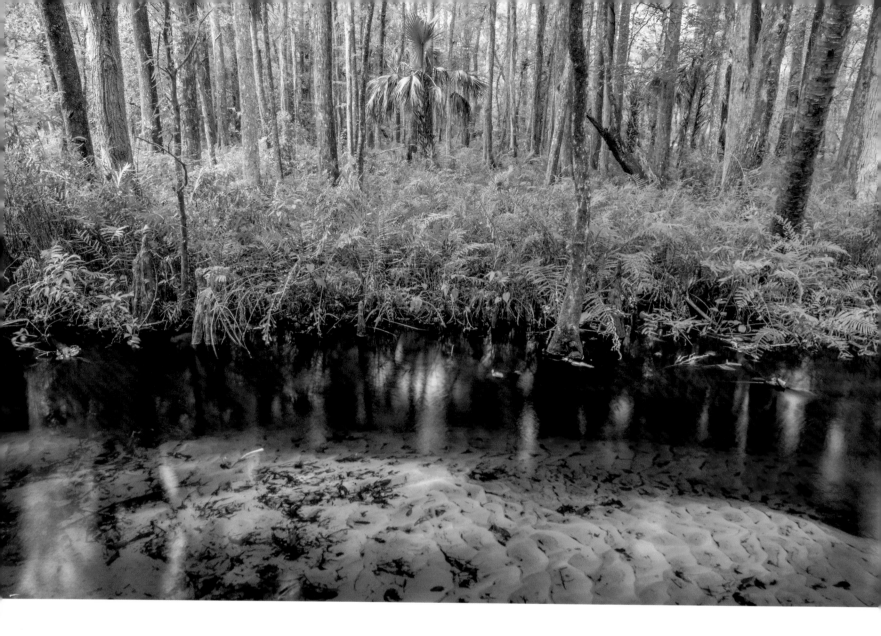

KISSIMMEE–ST. JOHNS RIVER CONNECTOR

Funds following the Florida Wildlife Corridor Act helped protect Wedgworth Farms, in the Kissimmee–St. Johns River Connector Florida Forever project. As the name suggests, this landscape connects Florida's two largest watersheds, the Everglades and St. Johns, which together provide drinking water for more than half of Florida's population. Rain that falls here flows in both directions: south toward Miami and north toward Jacksonville. Much more conservation is needed in this region, which faces constant pressure by development expanding south of Orlando.

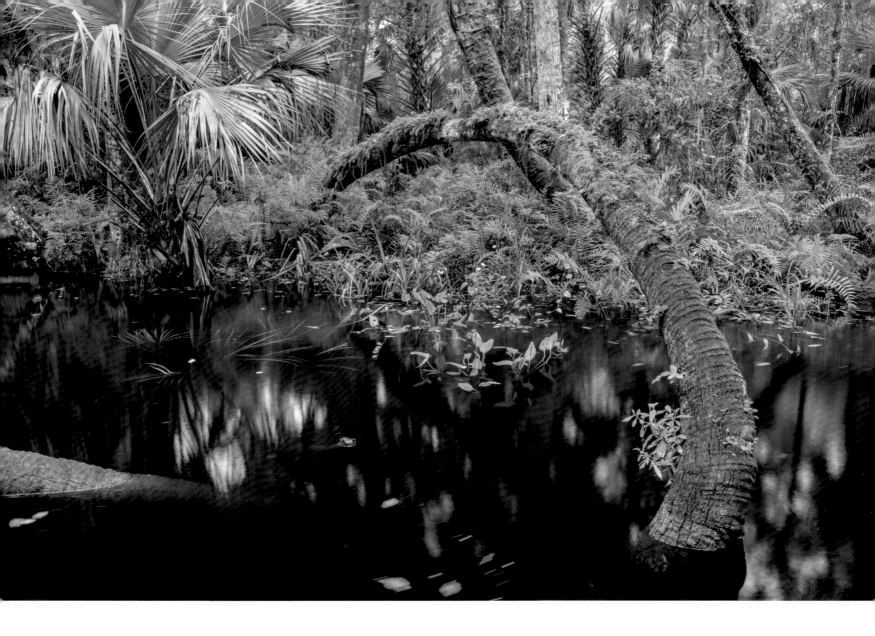

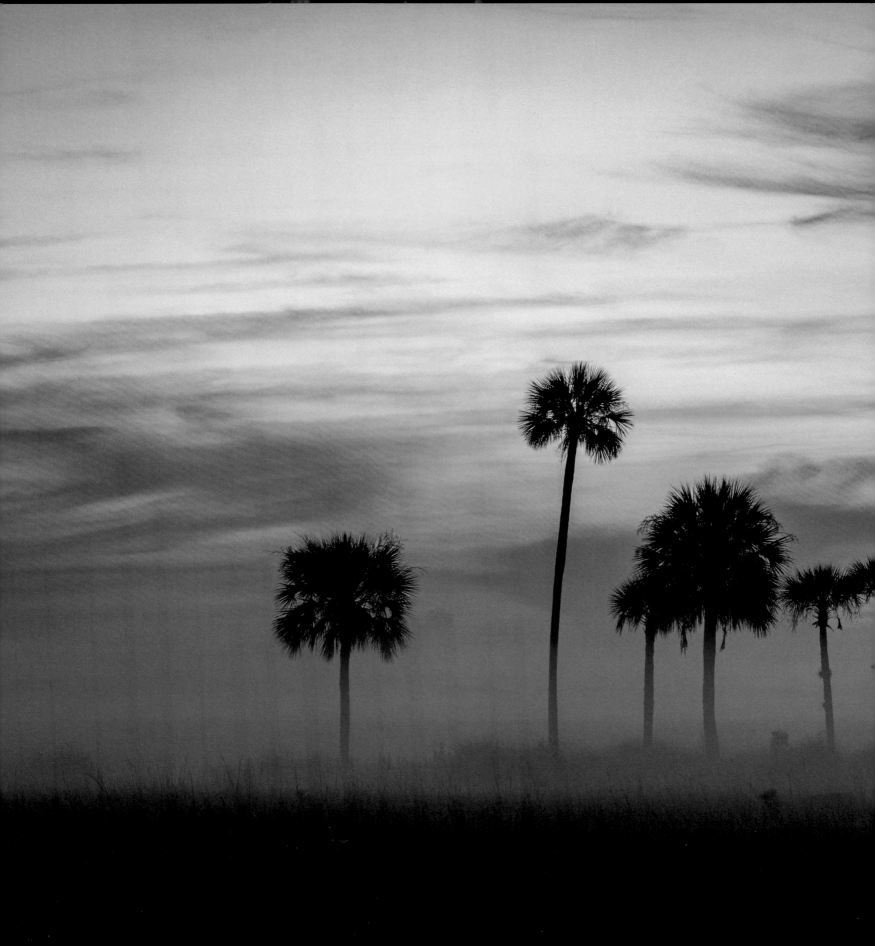

KISSIMMEE PRAIRIE

Predawn light glows through ground fog and a cluster of palms at Corrigan Ranch, which the state of Florida purchased in 2022 with support from the Florida Conservation Group, National Wildlife Refuge Association, U.S. Fish and Wildlife Service, and U.S. Air Force. The property is an extension of Kissimmee Prairie Preserve State Park, close to the Kissimmee River and within the Avon Park Sentinel Landscape. Its purchase protects a critical population of Florida grasshopper sparrows as well as habitat for the potential return of the Florida panther to the Kissimmee Prairie.

FOLLOWING PAGES

DEVIL'S GARDEN

Another piece of the Florida Wildlife Corridor was saved when the state bought this mosaic of uplands and wetlands east of Fort Myers on Alico Ranch, in the core of Florida panther territory. The new wildlife management area is adjacent to Okaloacoochee Slough State Forest, which connects, through a patchwork of state preserves and ranches, to Big Cypress National Preserve, Florida Panther National Wildlife Refuge, and Everglades National Park.

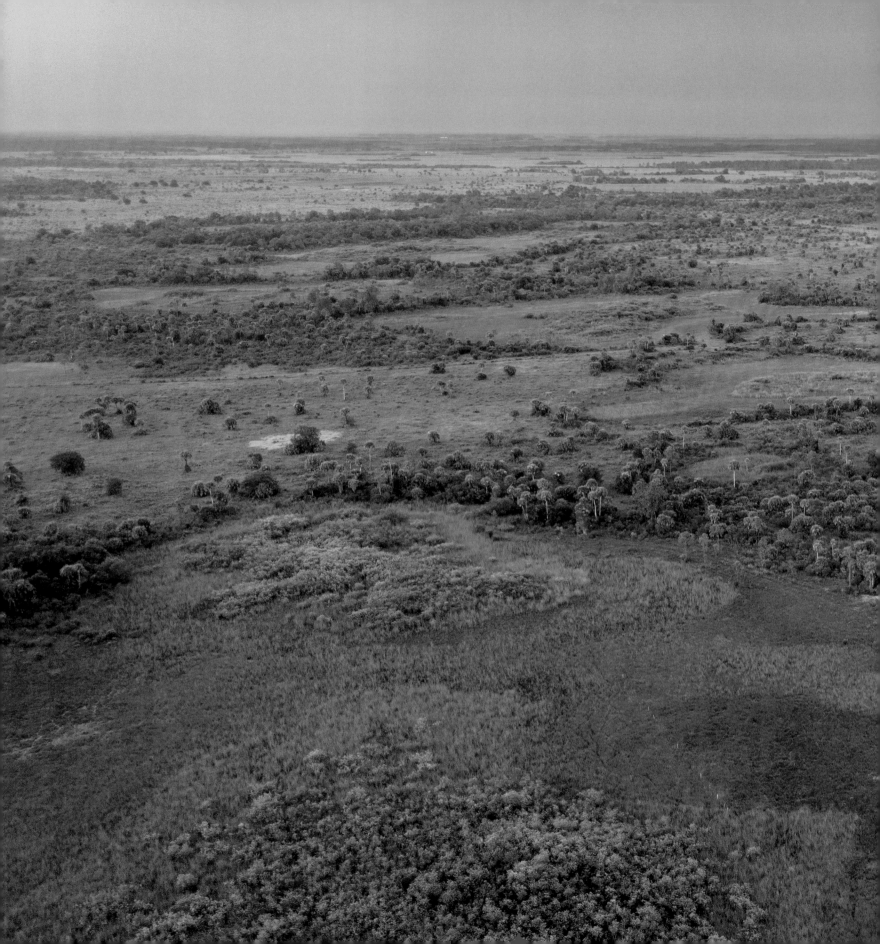

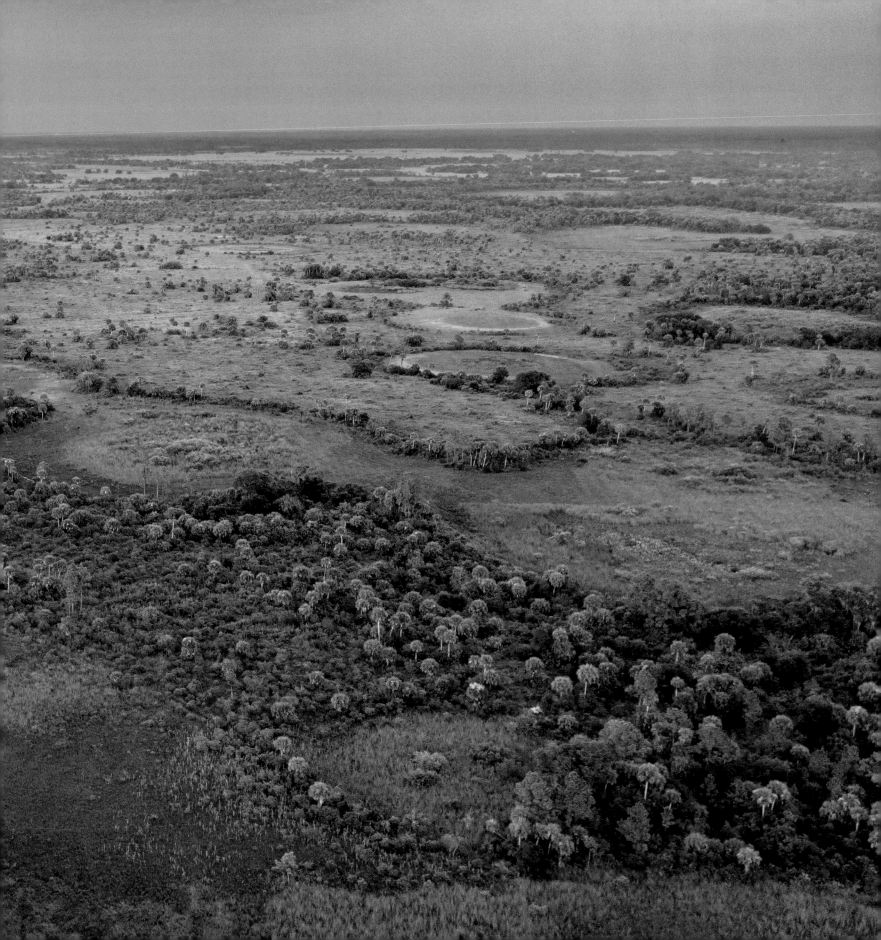

HORSE CREEK RANCH

The Florida governor and cabinet approved the protection of Horse Creek Ranch in 2022, through a Florida Forever conservation easement, in partnership with the Southwest Florida Water Management District and Florida Conservation Group. The property is the first protected landscape in what could become a new hub of conservation lands in the Peace River Valley, where a major threat to habitat is strip mining for phosphate. Horse Creek Ranch protects more than five miles (8 km) of frontage on both sides of Horse Creek, which is an important tributary to the Peace River and Charlotte Harbor estuary.

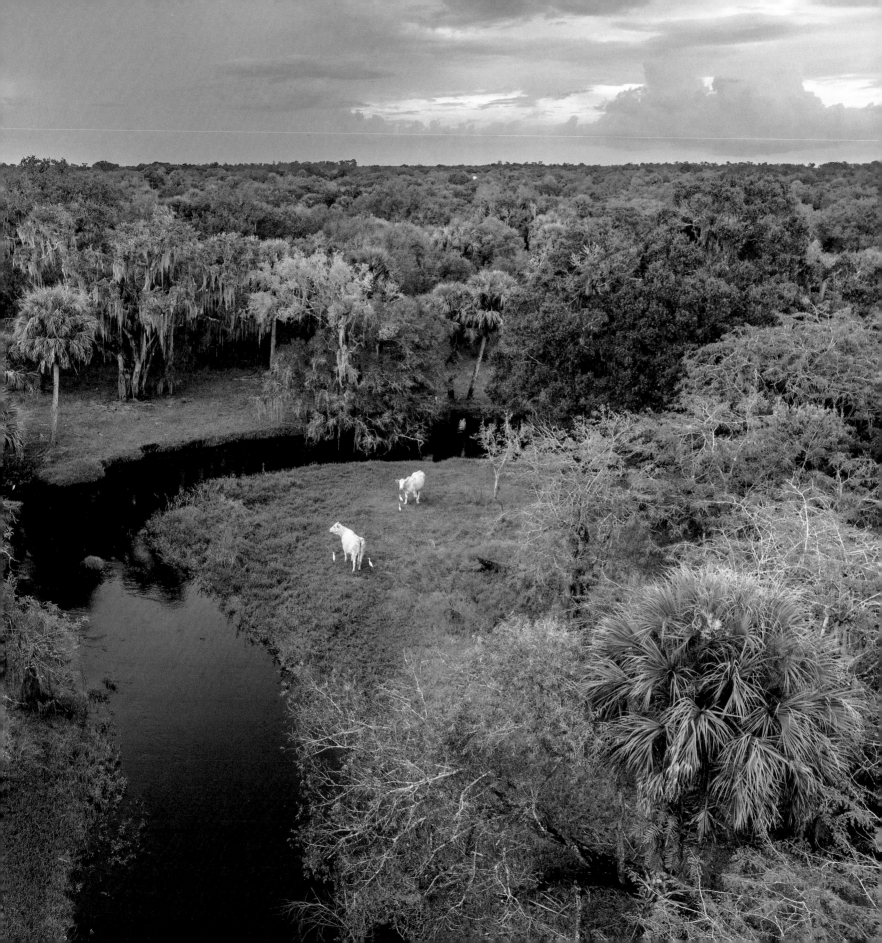

CHAPARRAL SLOUGH

ABOVE: The Chaparral Slough is an 11-mile-long (18 km) landscape on Lykes Ranch that was protected by an easement from the Florida Department of Environmental Protection in 2022. This project is the last major parcel in a series of conservation easements led by the Nature Conservancy that now connects conservation lands south of the Caloosahatchee River north to Fisheating Creek. **OPPOSITE:** Lykes Ranch cowboy Ryan Stallins moves a herd of beef cattle across the Chaparral Slough. In this newly protected corridor, and throughout the Greater Everglades, ranchlands are vital for helping the panther reclaim its historic territory farther north in the state.

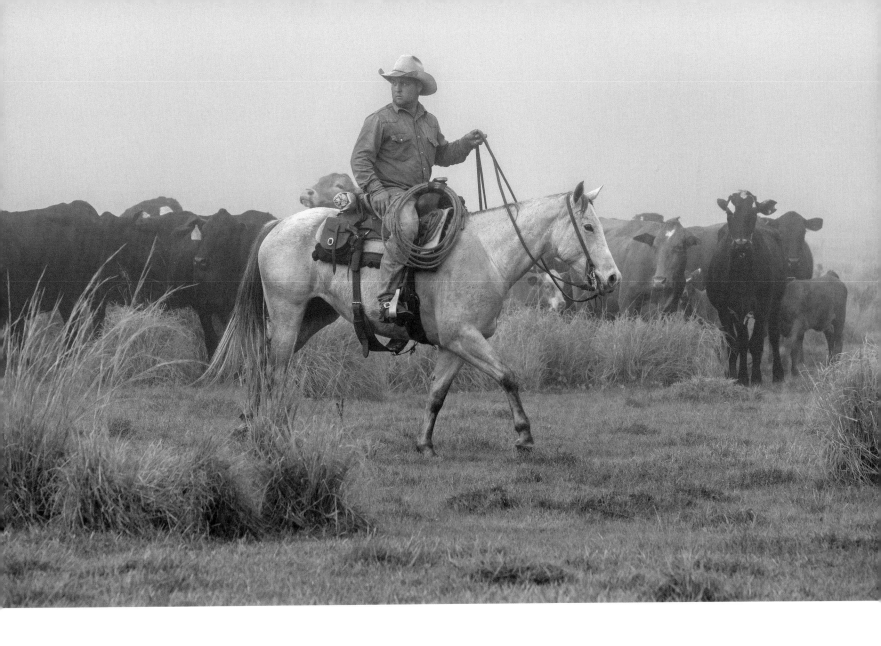

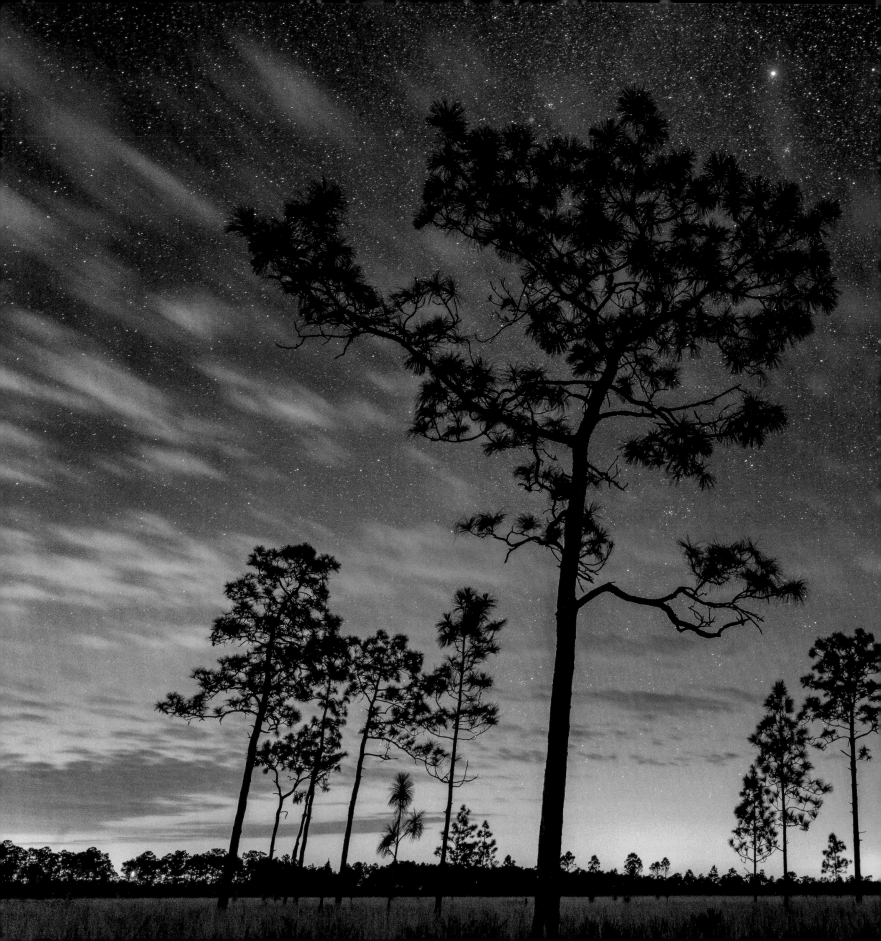

DELUCA PRESERVE

The night sky shines above DeLuca Preserve with the glow of Florida's Turnpike on the horizon. The 27,000-acre (10,930 ha) property south of Orlando was recently planned as the site of a new city called Destiny. But in 2021, the previous owner, Elisabeth DeLuca, donated the property to the University of Florida Foundation, which protected it with a conservation easement with Ducks Unlimited. The scale of the conserved landscape expands the territory of the Everglades Headwaters, which is the next frontier for the panther's recovery.

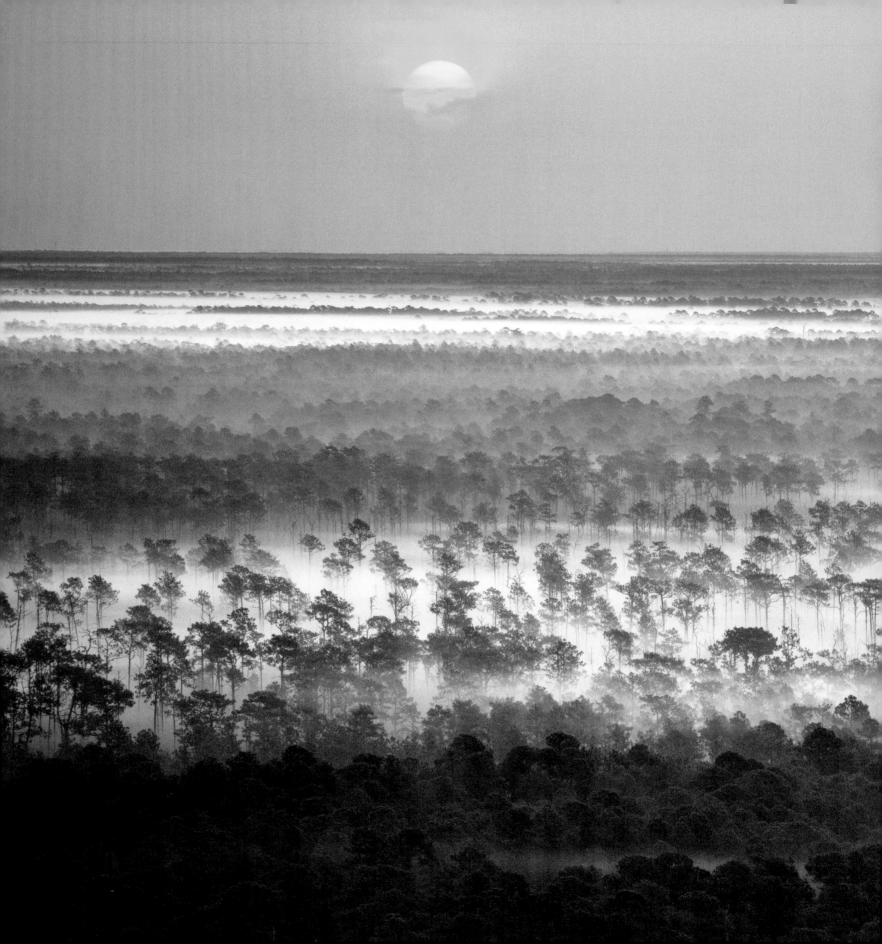

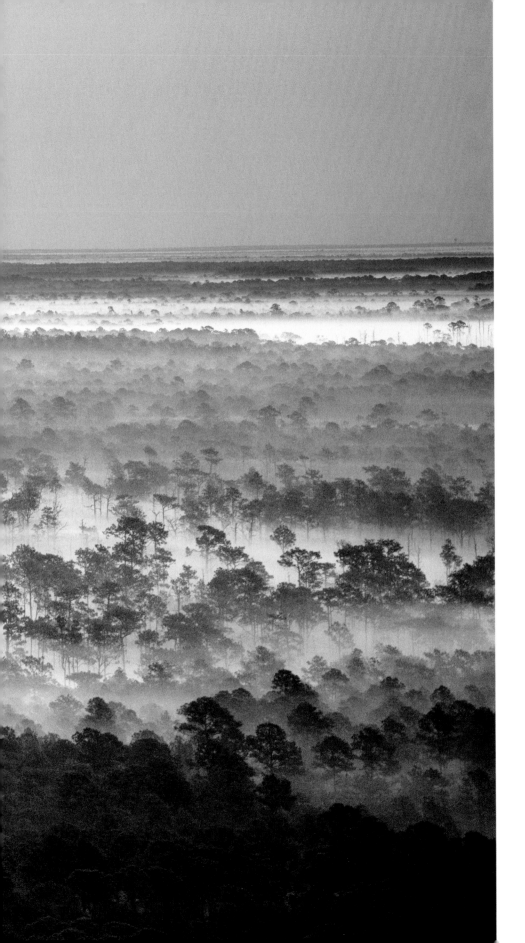

NORTHWEST FLORIDA
SENTINEL LANDSCAPE

The sun rises over an ancient pine forest
in Eglin Air Force Base, a 400,000-acre
(161,870 ha) military installation that is the
hub of the 8.7-million-acre (3.5 million ha)
Northwest Florida Sentinel Landscape.
The new Sentinel boundary encom-
passes nearly all the Florida Panhandle,
from east of Tallahassee west to the
Alabama line, in collaboration with the
U.S. Department of Defense, Department
of Agriculture, Department of the Interior,
and multiple state and local partners. At
its core is the largest contiguous swath
of longleaf pine habitat left on the
planet, a globally significant storehouse
of biodiversity. If we can protect enough
of the Florida Wildlife Corridor for
panthers to return to these northern pine
forests, the recovery of the species may
then be complete.

ABOUT THE PATH OF THE PANTHER PROJECT

IN COLLABORATION WITH the National Geographic Society and a network of other partners, the Path of the Panther project works to inspire the conservation of the land the panther needs to survive—the Florida Wildlife Corridor. Our team of conservationists, filmmakers, and advocates produced an impact media and conservation campaign that contributed to the unanimous passage of the Florida Wildlife Corridor Act in 2021.

The Path of the Panther project and its home organization Wildpath have partnered with Grizzly Creek Films to make the feature-length documentary *Path of the Panther*, premiering on Disney+ and National Geographic alongside this book in 2023.

We are now championing a plan to protect a million acres (400,000 ha) of the Florida Wildlife Corridor by 2030. Together we can reconnect wild places across the Earth for the benefit of people and wildlife. Please join the movement at *pathofthepanther.org*.

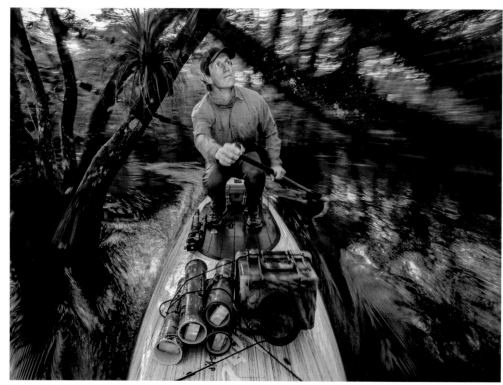

Carlton Ward Jr., National Geographic Explorer and founder of the Path of the Panther project, paddles to a camera trap site in the Fakahatchee Strand.

Lauren Yoho, social media manager

Jeff Reed and Rick Smith, filmmakers

Tori Linder, managing director and impact producer

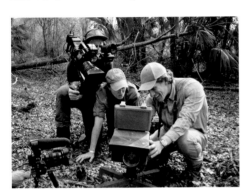

Filmmaker Danny Schmidt, biologist Jen Korn, Carlton Ward Jr.

Malia Byrtus, field programs manager

Katie Bryden, director of video storytelling

Palm Beach Zoo volunteers Brooke Sexton, Sherry Currens

Lisa Baylor, director of operations

Eric Bendick, film director

George McKenzie Jr., camera trap technician

Alex Freeze, field assistant

Eldridge Ward, camera trap assistant to her father

ACKNOWLEDGMENTS/CREDITS

The photography in this book, and the project behind it, has been a team effort made possible by many people and partners.

I will start by thanking my family for supporting me in this work across several years. Our own path with the panther has not been easy; the pursuit had me spending three out of four weeks away from home. Two of my children, Nell and Carlton III, were born during the project, and my wife, Suzie, while working full-time, cared for them and their big sister, Eldridge, largely on her own. You are my motivation, and your love makes my work possible. To my brother, parents, and extended family, thank you for your ongoing love and support.

Thank you to my team at Wildpath for being the foundation for the Path of the Panther project, including Tori Linder, Lisa Baylor, Katie Bryden, Malia Byrtus, Lauren Yoho, Sara Sheehy, and George McKenzie Jr., with special thanks to Malia, Lauren, and George for leading efforts to manage and maintain our network of more than 20 photo and video camera trap systems spread throughout the southern half of Florida, many of which captured the photos in this book. Thank you to all the field assistants and volunteers who have paid your dues in the swamp. Credit for the camera trap photos is shared with all of you.

To the lead sponsors for the book, the National Geographic Society and Bellini Better World: Thank you for believing in this story and helping share it. Thank you to my editors at *National Geographic* magazine, Kathy Moran and Alexa Keefe, who helped shape the story, and to writer Douglas Main for his series on the panther for *National Geographic* and the essays in this book. Thank you to David Griffin for leading the photo edit and design, and to editor Victoria Pope for crafting the story. Thank you to contributing authors Carl Hiaasen, Jeff Klinkenberg, Cynthia Barnett, Betty Osceola, Cary Lightsey, Craig Pittman, and Tori Linder for lending your voices to the book and cause.

The photographs were made possible by partnerships with many agencies, organizations, and landowners, including the U.S. Fish and Wildlife Service, Florida Fish and Wildlife Conservation Commission, Florida Department of Transportation, Florida Department of Environmental Protection, Florida Forest Service, National Park Service, U.S. Department of Defense, University of Georgia, Virginia Tech University, University of Florida, Illinois College, National Geographic Society, the Nature Conservancy, Audubon Florida, WILD Foundation, Live Wildly Foundation, International League of Conservation Photographers, Florida Cattlemen's Association, Bergeron Everglades Foundation, JB Ranch, Babcock Ranch, Florida Wildlife Corridor Foundation, Archbold Biological Station, Palm Beach Zoo, Seminole Tribe of Florida, Miccosukee Tribe of Indians of Florida, Lightsey Cattle Company, Hendrie Ranch, and many more.

The hope for the Florida panther is built on decades of commitment by countless people. Thank you to all the individuals: landowners, cowboys, scientists, and other Floridians who have brought the panther back from near extinction to the verge of statewide recovery. You are my heroes. I am grateful to each of you and for the privilege of telling your stories.

Thank you to the leaders across America who are seeing the unifying value of protecting wildlife corridors, and to Florida lawmakers for setting a global example through your commitment to the Florida Wildlife Corridor Act.

Special thanks to the National Geographic Society for five grants across 10 years supporting work on the Florida Wildlife Corridor and Path of the Panther projects, including leadership and commitment from Jill Tiefenthaler, Gary Knell, Ian Miller, Jonathan Baillie, Kalee Kreider, Kaitlin Yarnall, Rachael Strecher, Enric Sala, Lisa Shipley, Mike Beckner, Andrew Courtney, John Francis, Rebecca Martin, Catherine Workman, Luisa Arnedo, Dustin Renwick, Vanessa Serrao and the Impact Story Lab, Emily Kelly, and others. Thank you to mentors and role models Michael "Nick" Nichols and Michael Fay for your example of what is possible when storytelling and science are combined for impact—and to all fellow explorers who inspire me daily.

Thank you, Eric Bendick, and the teams at Grizzly Creek Films, Wildpath, and Common Pictures for five years of commitment to making the *Path of the Panther* film, and to the executive producers and supporters who invested in its mission.

The broader Path of the Panther project has been made possible by hundreds of organizations and individuals who have partnered with our team to shape and tell this story. Learn more at *pathofthepanther.org/partners*.

MAPS CREDITS: Florida maps, pages 23 and 213: 1000 Friends of Florida, Florida Fish and Wildlife; Florida Natural Area Inventory. U.S. map, page 213: Marty Schnure, National Geographic Explorer. Sources: R. Travis Belote, the Wilderness Society; USGS.

ILLUSTRATIONS CREDITS: All photographs by Carlton Ward Jr. except the following: 30 (LE), Bonita Springs Historical Society, and 30 (RT), State Archives of Florida/Donn Dughi.

TEXT CREDITS: Chapter 1: "Lord of the Forest" by Douglas Main was adapted from "Return of the Florida Panther," *National Geographic,* April 2021. © 2021 National Geographic Partners, LLC. Chapter 1: "To the Rescue" by Douglas Main was adapted from "A Mysterious Neurological Disease Is Afflicting Endangered Florida Panthers," *nationalgeographic.com,* April 7, 2021. © 2021 National Geographic Partners, LLC. Chapter 2: "Ghosts of the Everglades" by Douglas Main was adapted from "Discovery Reveals Secrets About How Ghost Orchids Reproduce," *nationalgeographic.com,* July 25, 2019, and "Florida's Rare Ghost Orchids Are Getting Cut Off From Water," *nationalgeographic.com,* October 25, 2019. © 2019 National Geographic Partners, LLC. Chapter 4: "Saving the Grasshopper Sparrow" by Craig Pittman was adapted from "Bringing Back the 'Most Endangered Bird' in the U.S.," *nationalgeographic.com,* January 25, 2021. © 2021 National Geographic Partners, LLC.

ABOUT THE NATIONAL GEOGRAPHIC SOCIETY

THE NATIONAL GEOGRAPHIC SOCIETY is a global nonprofit that uses the power of science, exploration, education, and storytelling to illuminate and protect the wonder of our world.

Since 1888, the National Geographic Society has driven impact by identifying and investing in a global community of Explorers: leading changemakers in science, education, storytelling, conservation, and technology. National Geographic Explorers help bring our mission to life by defining some of the most critical challenges of our time, uncovering new knowledge, advancing new solutions, and inspiring transformative change throughout the world.

Explorer Carlton Ward Jr. is a conservation photographer focused on protecting Florida's hidden wild. He founded the Florida Wildlife Corridor project in 2010, naming a statewide network of public and private lands that provide connected green spaces for the benefit of wildlife and people. He has since trekked 2,000 miles (3,200 km) during two expeditions supported by National Geographic, advocating for the corridor's protection. In 2015, he launched the Path of the Panther project with National Geographic and other partners, inspiring the passage of the Florida Wildlife Corridor Act in 2021. Through stories and campaigns with local organizations, Ward continues to work toward the conservation of hundreds of thousands of acres of land and water across his home state.

To learn more about the Explorers we invest in—like Carlton Ward Jr.—and the efforts we support, visit *natgeo.com/impact*.

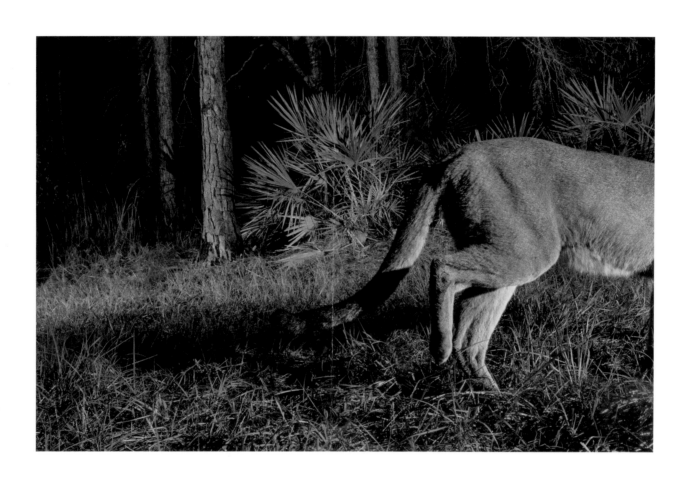